STUDIO LIGHTING
SOLUTIONS

EXPERT PROFESSIONAL TECHNIQUES FOR ARTISTIC AND COMMERCIAL SUCCESS

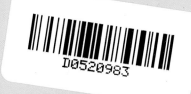

JACK NEUBART

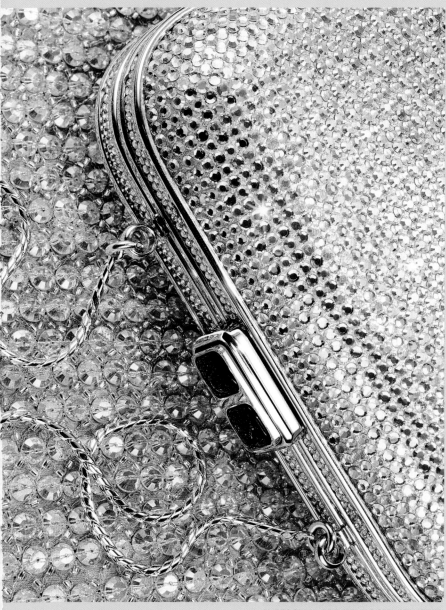

PHOTOGRAPH COPYRIGHT © SPENCER JONES.

AMPHOTO BOOKS

an imprint of Watson-Guptill Publications / New York

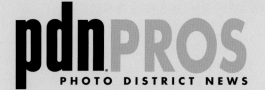

pdn.PROS

PHOTO DISTRICT NEWS

First published in 2005 by Amphoto Books
An imprint of Watson-Guptill Publications
A division of VNU Business Media, Inc.
770 Broadway
New York, NY 10003
www.wgpub.com
www.amphotobooks.com

Library of Congress Control Number:
2005928207

ISBN 0-8174-5907-3

Printed in the United Kingdom
1 2 3 4 5 6 7 8 9 10/13 12 11 10 09 08 07 06 05

SENIOR ACQUISITIONS EDITOR: Victoria Craven
SENIOR DEVELOPMENTAL EDITOR: Stephen Brewer
DESIGNER: Alexandra Maldonado
SENIOR PRODUCTION MANAGER: Ellen Greene

Amphoto books are available for promotions,
premiums, text book adoptions,and other special
sales opportunities. For details contact Amphoto
Books Special Markets, 770 Broadway, New York,
NY 10003, www.amphotobooks.com,
or call 1-800-451-1741.

DEDICATION

This book is dedicated to the memory of automotive photographer Jeff Nadler, one of the most amiable photographers I'd ever had the pleasure to work with, if only too briefly.

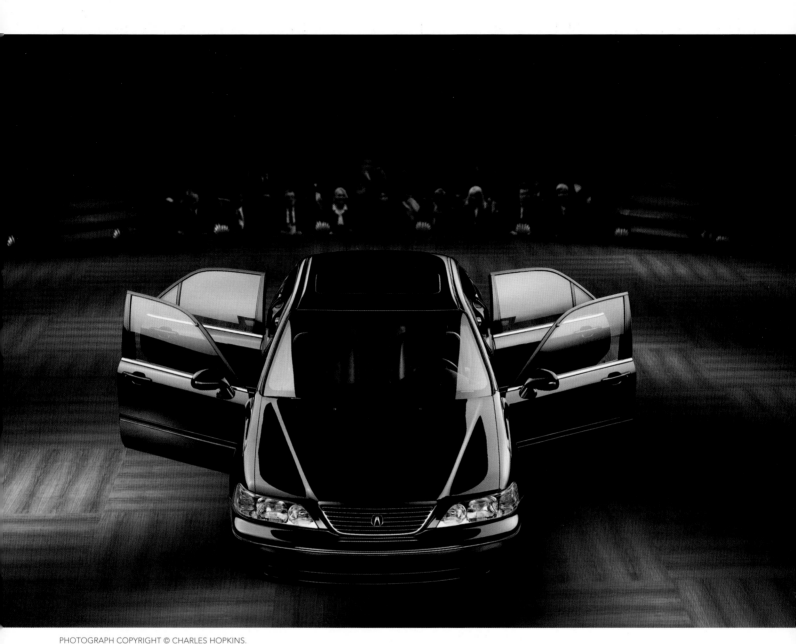

PDN *Photo District News* is the leading publication for professional photographers and creatives, offering up-to-date information on technologies, techniques, market forces, and trends to those who take pictures and those who use pictures. This award-winning monthly magazine for the professional photographer has been covering the professional photographic industry for over two decades. Every month, *PDN* delivers unbiased news and analysis, interviews, and portfolios of the latest photographic work. *PDN* delivers the information photographers need to survive in a competitive business—from marketing and business advice to legal issues, photographic techniques, new technologies, and more. PDNpros is its first book series.

contents

FOREWORD by Holly Hughes, Editor-in-Chief, *Photo District News* 6

PREFACE 8

CONTRIBUTING PHOTOGRAPHERS 10

FOOD AND BEVERAGES 14

AROUND THE HOUSE 44

FASHION AND JEWELRY 74

SCI-FI 92

RETRO 112

NATURE 130

CARS 152

GLOSSARY 170

INDEX 174

FOREWORD

Photography can be an isolating profession. Even when your studio is full of art buyers, stylists, and models, and an anxious client is hovering over your shoulder, the act of taking pictures inevitably comes down just to you and the subject before you. It's up to you and you alone to find the inspiration to figure out how you're going to say everything you need to say in a single powerful frame.

Since *Photo District News* magazine was launched 25 years ago, its mission has been to break down the isolation photographers experience and to create a sense of community. In our pages and on our Web site, photographers share their inspiration and aggravations, their problems and their advice. The idea is simply this: When photographers view one another as fellow professionals rather than competitors, they can learn from one another's experiences, and the whole community is strengthened. What better source can you have for advice about running a successful business, coping with new imaging technologies, or finding the best way to light a difficult shot, than a fellow photographer who has faced the same challenge before?

Over the years, one of *PDN's* most consistently popular columns has been "Technically Speaking." It is a first-person, step-by-step account of how a photographer lit, produced, and shot a commercial assignment. It exemplifies the best of *PDN*: photographers talking to their peers about how they used their technical knowledge to meet a creative challenge. In his tenure as *PDN's* "Technically Speaking" columnist, Jack Neubart has talked to literally hundreds of photographers from every specialty—location, fashion, architecture, still lifes, beauty, you name it. Time after time, he gets photographers to reflect not only on the lights they used and how they used them, but on the series of decisions they made in order to bring their vision to life.

For this first book in the PDNpros series, Jack has chosen to focus on studio lighting. Shooting in the studio brings unique challenges. The studio is a controlled environment—there's no chance a sudden shift in the clouds will wreck the shoot. But the studio is also a blank slate: the photographer has to build all the lighting from the ground up, carefully and precisely. Every image you see in this book—from Jock McDonald's offbeat portraits to Richard Izui's sleek car shots to Nick Koudis's digital wizardry—is a testament to its creator's ingenuity and attention to detail.

Poring through these pages, I found many fresh and arresting images I had never seen before. I also found many well-loved photos that I thought I knew, but the details and diagrams Jack and his interviewees have added made me look at them again with a new understanding and appreciation.

What this book offers is more than an exhaustive compendium of lighting techniques and insights into the properties of light and shadow. It's also a look at the nature of creativity. Technique alone did not make the images collected here so distinctive. And while imagination is essential for any photographer trying to succeed in the highly competitive commercial market, just dreaming of an image isn't enough. What the photographers in this book describe so clearly and engagingly in their own words is the strange, alchemical process by which vision and technique come together to create a photo that grabs our attention.

The next time you're staring at a subject and thinking about how you want to shoot it, we hope that the tips and advice found in this book will provide you with some inspiration. But the way you choose to apply these techniques will reflect your own style, your own needs and vision. Fuel all that with a heavy dose of your imagination, and I have no doubt that the photographic image you produce will be distinctly and entirely your own.

—Holly Hughes, Editor-in-Chief, *Photo District News*

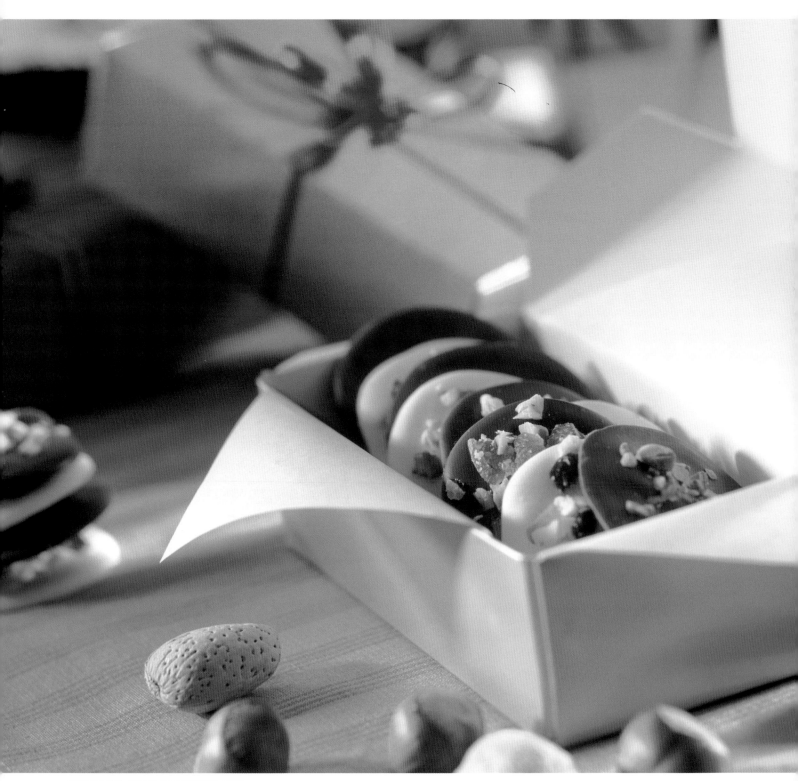

PREFACE

Lighting is about results. It is about the feeling you imbue in a subject, the mood you invoke in a scene, the qualities you bring out through judicious use of the tools at hand. Lighting is the key ingredient that adds flavor and texture, helping you make a visual statement or deliver a client's message.

The photographers who have contributed to this book all have one thing in common: They understand light and lighting. They know how to deal with the demands of the assignment, the challenges posed by a subject. To them lighting is as much a tool as is the camera. But the story does not end there. In fact, it begins elsewhere.

Each assignment begins well before the lighting is even contemplated. It stems from a client or art director and possibly a sketch laying out the requirements of the shot, and continues on to countless decisions made before, during, and after the shoot.

But eventually, it does all come down to the lighting. How we light is an expression of our individual vision. But when a client is involved, how we light may be more a reflection of an art director's vision, not yours—or possibly a meeting of minds. Still, there is a reason you were hired for this job, and we hope the client will understand that the project should be largely left in your capable hands. As you prop the set and position camera and lights, you realize one thing: There are no light decisions, but many right ones.

This book is largely based on my monthly "Technically Speaking" column published in PDN. The column represents a first-person account. Each photographer relates what the client or art director was looking for, the concept behind the picture, and what technically went into the production of that photograph. My first "Technically Speaking" column was published way back in October 1991, originally under the nom de plume Horst J. Rheinholdt. (Where I got that name from I'll never know, but let's not dwell on the past.)

This book brings you a mix of published columns and new work from photographers who have been featured in PDN. We have added several lighting diagrams and an array of component images, where available, in an effort to help you more fully appreciate the dynamics of each shot. But nothing beats set shots—seeing the original set in which the photograph was made. We are fortunate to bring you a number of these as well. They give you a sense of immediacy that no lighting diagram can ever come close to duplicating.

I felt privileged to have worked with all these photographers over the years. They have taught me much. I can't help but be awed by their images, imagination, talent, and expertise, as I'm sure you will be.

The "Technically Speaking" column in PDN, my affiliation with it, and the high standards the column upholds would not have been possible without the tireless efforts and vision of PDN's editors and staff, past and present. I am especially thankful to Holly Hughes for her continued support and guidance, and to Jackie Tobin, along with former PDNers Liz Forst and Jeff Wignall. I am deeply indebted to my "Technically Speaking" editors, who have included Anthony LaSala, Terry Sullivan, and Holly Hughes, and appreciative of the excellent work by the art, design, and production team at the magazine. They have all made me shine in the eyes of my readers.

As for the book itself, that would not have been possible without the urging and support of PDN's Jeff Roberts and Amphoto's Victoria Craven. This volume itself is a reflection of teamwork by everyone at Watson-Guptill/Amphoto, PDN, and the numerous photographers whose images grace these pages.

On a personal note, I'd like to thank several friends for being there when they were needed: Eric and Nava, Jerry and Linda, Josh and Esther, and Jack and Stacy. Enjoy!

—Jack Neubart

CARLOS ALEJANDRO Carlos describes himself as "a commercial photographer concentrating on the communication of the ideas of business." In business for 18 years, he operates Carlos Alejandro Photography (www.caphoto.com) in the Mid-Atlantic region, specifically Delaware and Philly.

TONY ARRASMITH Tony operates Arrasmith & Associates, Inc. (www.tonyarrasmith.com) in partnership with Sarah Miller, and has been in business 18 years. Based in Cincinnati, his studio focuses entirely on large-format digital capture, while providing in-house retouching/proofing. Specializing in shoots involving custom-made sets and humor, he describes his style as "Tim Burton meets Norman Rockwell on steroids."

THIERRY BEARZATTO Thierry has been in business 12 years, operating Bearzatto Studio, Inc. (www.bearzattophoto.com) out of Los Angeles. He specializes in automotive and tabletop advertising, and describes his work as "simple, elegant, stark."

DAVID ALLAN BRANDT Working predominantly in advertising photography in the U.S. and overseas, David is equally at home shooting on location and in his studio. He operates David Allan Brandt Studios, Inc. (www.davidallanbrandt.com) out of Los Angeles, and has been in business for 20 years. He describes his shooting style as "creative and conceptual."

STEVE BRONSTEIN A photographer in New York City since 1979, Steve specializes in a wide range of still-life work involving props, miniature sets, motion, liquids, and computer compositing, often devising uniquely creative ways to introduce a product into a shot. In 1990 Steve and his partner, Howard Berman, opened up their own production company, now known as B-Hive Productions (www.b-hivepro.com). Steve's work has been honored with many awards throughout his career.

JENNIFER CHEUNG Jennifer operates Jennifer Cheung Photography (www.jennifercheungphotography.com) out of Los Angeles. In business for 15 years, her specialties include still life, food, interiors, gardens, and lifestyle for editorial and advertising, both on location and in the studio. Her work is defined by its "clean, simple approach to lighting and styling."

PHOTOGRAPH BY DAN SMITH.

CHRIS COLLINS Chris has operated Chris Collins Studio (www.chriscollinsstudio.com) for 25 years. Based in New York City, he describes himself as follows: "I'm considered a problem solver and all around advertising photographer. Assignments vary from simple product shots to international campaigns involving special effects." Chris defines his shooting style as consisting of "dramatic, appropriate lighting, coupled with strong graphics."

DAN COUTO A photographer for 15 years, Dan operates Dan Couto Photography out of New York City (www.dancouto.com). He notes that his work has a "strong digital involvement, which has," he observes, "led to a keener visual sense and enhanced conceptual skills."

KATRINA DE LEON Katrina (www.photoserve.com) operates De Leon Productions, Inc out of her Fifth Avenue digital photography studio in New York City. For the past 22 years she has specialized in photographing food, fashion accessories, shoes, toys and children's clothing, and accessories.

DON DIXON Based in Toronto, Dixon Film & Photography (www.dixon-film.com) has been in business for 25 years. Don describes his operation as a team of eight specialists "working together to create unique, conceptual images for the advertising industry. We shoot on location as well as in studio, with emphasis on people and cars." He adds: "I like to have a loose and playful atmosphere on set."

NEAL FARRIS In business for 20 years, Neal operates Neal Farris Photo-Design (www.nfphotodesign.com) out of Dallas. "I try to approach each project with a fresh eye," he points out.

DENIS FINNIN Denis Finnin is Director and head photographer, the Photography Studio, American Museum of Natural History (www.amnh.org), in New York City. Among the books he has contributed to are *Pearls: A Natural History, Amber: Window to the Past, Discovering Fossil Fishes,* and *The Nature of Diamonds.*

PHOTOGRAPH BY RODERIDK MICKENS.

JEFFREY GREEN Jeff Green (www.jgreenphoto.com) operates his studio out of Las Vegas, specializing in architecture, people, food, and products, for clients nationwide. He notes, "The freedom inherent in editorial and corporate work lets me exhibit my true style. However, when I am involved in a large advertising production, I will carry out a layout to fit the AD's criteria perfectly."

JILL GREENBERG Jill has been in business for 15 years, specializing in advertising and fashion, with particular emphasis on actors, celebrities, the music biz, especially pop stars, and children. Currently operating out of Los Angeles, Jill Greenberg Studio, Inc. (www.manipulator.com) was formerly based in New York City.

PHOTOGRAPH BY PAUL WALDMAN.

LOIS GREENFIELD Lois (www.loisgreenfield.com) has been a photographer for more than 30 years, working out of New York City. She observes: "My investigation of the expressive potential of movement has expanded my image-making into many areas, from photographing dance companies and sports figures to creating ads that use the metaphoric potential of movement to illustrate their campaigns." Recent books include *Breaking Bounds* and *Airborne.*

CHARLES HOPKINS
Charles has operated Charles Hopkins Photography Inc. (www.charleshopkins.com) out of Hollywood for 12 years. Specializing in automotive photography, he notes that "the proper light suited to the job" defines his shooting style. "We flow from strobes to tungsten to Kino Flo to ring-lights to natural light with equal aplomb."

RICHARD IZUI In business nearly 30 years, Richard operates Izui Photography Inc. (www.izui.com) out of the Chicago area (Evanston, to be precise). He specializes in high-end digital photography on location and in the studio, focusing on automotive, products, and people. He defines his work as "clean, stylized digital manipulation" that enables him to bring vehicles shot in the studio into the great outdoors.

SPENCER JONES Spencer established his New York City studio in 1987 and has worked in commercial, editorial, and stock photography. He specializes in still life (www.glasshouseimages.com).

MOSHE KATVAN Moshe has been in business over 20 years, operating Katvan Studios, Inc. (www.katvan.com) out of New York City. He specializes in still life, and photographs people in collaboration with wife Rivka.

NICK KOUDIS Nick (www.koudis.com) operates out of Los Angeles, focusing on special effects and photo-illustration. His style of digital photography is often quirky, sometimes edgy, but with a humorous twist. He enjoys inventing scenarios wherein his protagonists "act" out roles with a certain undefined depth.

HUGH KRETSCHMER
Hugh (www.sharpeonline.com) has worked as a photographer for 15 years. He has recently relocated to Brooklyn, New York. He defines himself as "a photo-illustrator. My goal is to solve the visual problem presented to me in a simple and unexpected way."

TONY LABRUNO Focusing on automotive photography, primarily in the studio, Tony operates Tony LaBruno Photography (www.tonylabruno.com) out of Los Angeles, and has been in business for 17 years.

MARKKU LAHDESMAKI Markku operates Lightroom Inc. (www.markkuphoto.com), and has been in business for over 20 years. Operating out of Los Angeles, his clients extend around the globe, on assignments involving location and studio work. He defines his work as "storytelling landscapes and conceptual studio photography."

JOCK MCDONALD Jock McDonald operates Jock McDonald Film, Inc. (www.jockmcdonald.com) out of San Francisco and specializes in offbeat portrayals of people, along with more down-to-earth black-and-white portraiture.

JOE PELLEGRINI Joe operates Joe Pellegrini Photography (www.joepellegrini.com) out of Chicago, and has been a commercial photographer for 14 years. He specializes in tabletop, food, and product photography, on both digital and traditional film media.

HOWARD SCHATZ Howard Schatz (www.howardschatz.com) lives and works in New York City with his wife and business partner, Beverly Ornstein. His fine-art work, for which he has received international critical acclaim, has been exhibited in museums and photography galleries worldwide and has been published in numerous magazines, as well as in 14 books. His most recent book is entitled *Botanica* (Fall, 2005). He is especially known for his unique imagery made underwater with dancers and models, in such books as *Waterdance* and *Pool Light*.

GREG SHAPPS Specializing in tabletop and product photography, Greg operates Shapps Photography (www.shappsphotography.com) out of Chicago.

PIERRE TREMBLAY In business 12 years, Pierre (www.pierretremblay.com) operates out of Montreal, Quebec. Specializing in stock and advertising photography, he works with clients around the world. "I like my images to look as natural and real as possible," he declares. "To accomplish this, I'll use whatever means necessary before, during, and after the shoot." In the past few years, on top of his photography work, he's been directing music videos and short films.

PHOTOGRAPH BY KEVIN GOGGIN.

ROB VAN PETTEN Rob has been in business for 32 years. He operates Rob Van Petten Photographer (www.robvanpetten.com) out of New York City. He defines his work as fashionable lifestyle images for advertising and editorial. His style of shooting is perhaps best reflected in a recent portfolio, involving "a colorful collection of fantasy retro/future illustrations. The toys are techno. The action is fun and fashionable."

CHRIS VINCENT In business for 18 years, Chris operates Rezny/Vincent Photography (www.reznyvincent.com) in New York City, in partnership with Aaron Rezny. "I started by concentrating on visual puzzles and eye-catching imagery. This morphed into liquid special effects, and from there my work logically branched out into the beverage arena," Chris observes. He defines his work as "clean, crisp, and uncluttered."

DAVID ZIMMERMAN David operates Zimmerman Studio Inc. (www.davidzimmerman.com) out of New York City, and has been in business for 21 years. He describes his specialty as "high-speed liquid photography for advertising and design clients."

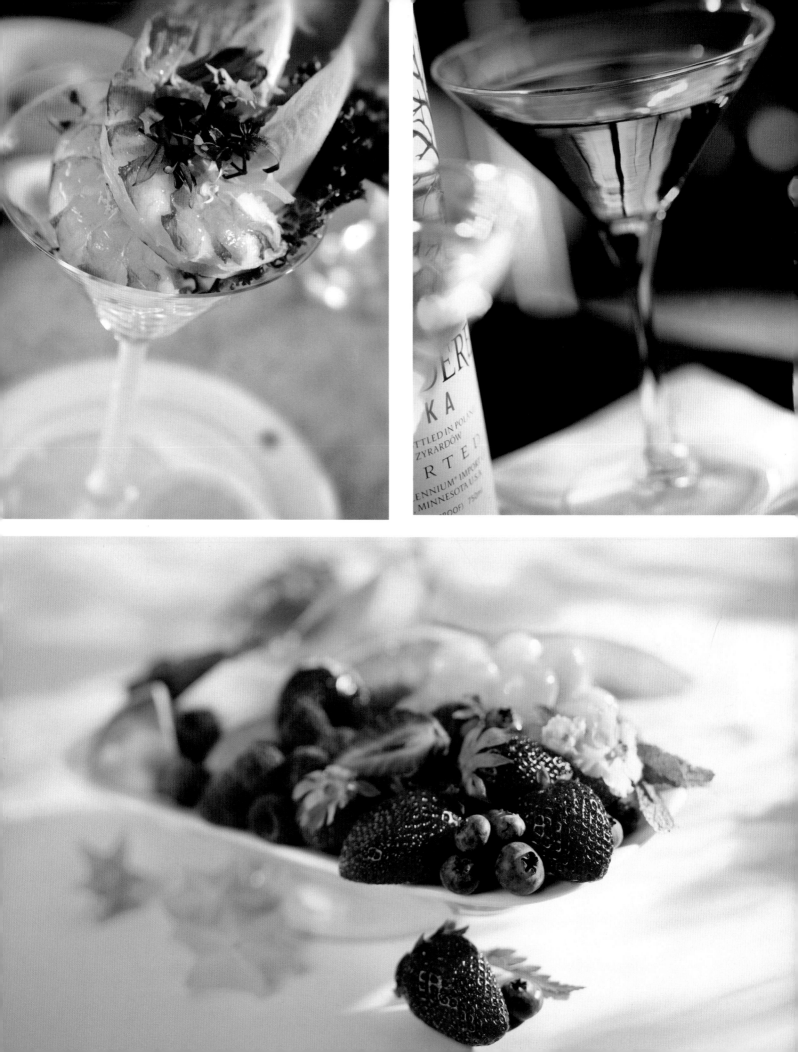

food and beverages

Innovative, often **ingenious** lighting is a key ingredient in dishing up truly appetizing images of a meal or a beverage. These photographers have masterfully **devised ways** to bring out the juicy **texture** of a steak with optical spots, make a martini inviting with an amber gel, and in other ways make **images** sure to whet appetites.

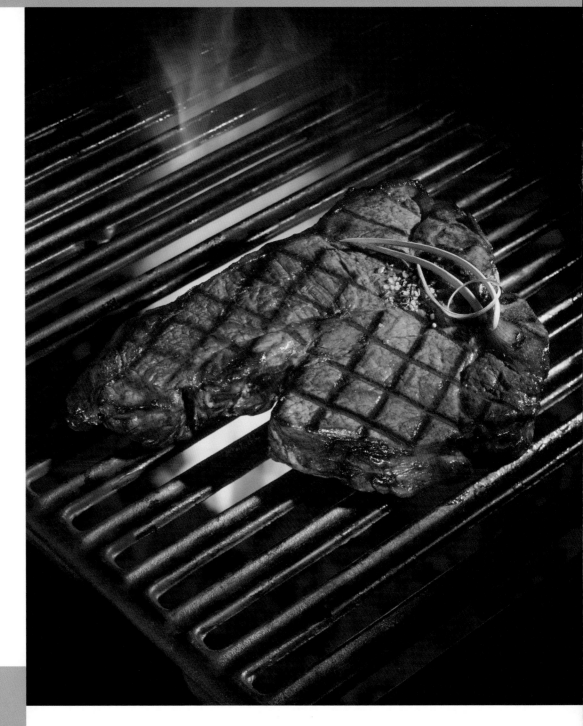

PRO TIP Unlike mirrors, white cards do not impart a hard edge to the light—they just act as fill, providing a flat light. I wanted the texture of the edge of the steak to come out, and the mirrors provided a harder light with the same quality as the original light source.

The challenge was to make the flames look believable and the steak as appetizing as one being prepared on a chef's grill. The lighting played a pivotal role in supporting this fantasy. In fact, you can say it was done with mirrors—at least, in part.

JOB SHEET

USAGE: **Advertising**

CLIENT: **Loblaws Supermarkets, Canada**

AGENCY: **Perennial Inc.**

ART DIRECTOR: **Brent Roth**

FOOD STYLIST: **Linda McKenty, Montreal**

LIGHTING: **Tungsten and strobe**

CAPTURE: **Analog**

PHOTOGRAPH COPYRIGHT ©PIERRE TREMBLAY.

PRO TIP The tungsten lights I worked with here are ETC Source Four spots. These are theatrical lights and the latest-generation optical spots. I use them because they're highly directional, with very good contrast, making colors really pop. These lights are especially good for making all the details and textures in food really stand out. And like other optical spots, they accept gobos, so you can use them to project patterns onto the set.

It was barbecue season once again, and Loblaws, a Canadian supermarket chain, wanted to promote its steaks with point-of-purchase posters in its stores. We were given a rough layout, with plenty of freedom to execute this shot.

This picture is one I've done many times, and each time it becomes more savory. Now, if you were thinking all we had to do was put the steak on the barbie, you'd be mistaken. While it was one image start to finish, there were several layers in this shot, which took six hours to prep and shoot. But before we talk lighting, perhaps I should give you the flavor of the complexity of this set.

This is not a real barbecue grill. That would bring the briquettes too close to camera, generating too much heat and making it impossible to position the camera above set. Also, the size of a regular grill would be restrictive. Our grill consists of two heavy, cast-iron grids held together by four stands with C-clamps and extension arms. The extension arms kept the hot metal a safe distance from the stands. More importantly, they gave us room to move around on the set.

About a foot and a half below the grill plate is a sheet of glass, 3x4 feet in size, and on it are the charcoal briquettes. Two feet below that is a white card, which covers the entire floor. So in essence, the set has three levels, and each needed to be lit separately.

I like to bring my tungsten lights up to about 4200K, with a ½ or ¾ CTB, depending on the age of the bulb. This still keeps the set on the warm side, but not overly so. Otherwise, I find these lights too warm. Our main light was an ETC Source Four optical spot, positioned to the right, at two o'clock, on a C-stand 4 or 5 feet up and 6 feet from set, skimming across the meat to bring out the texture. The light was too hard, so I inserted a gobo and defocused the beam and projected pattern, creating a soft, dappled light. The highlights on the grid come from this light.

The next light actually consisted of several round, parabolic makeup mirrors that kicked in just enough light along the edge of the steak to bring out its thickness. The mirrors were 4 or 5 inches in diameter, on their own stands and a few

A makeshift chef's grill appears simple, yet it is constructed of several layers, each demanding its own lighting.

inches apart. One was closer to camera, kicking in light in the front. Another was toward the back, around ten o'clock. A third, smaller mirror was on the right side.

I also used a large Chimera softbox with a 400 W/S Dyna-Lite head. It was 5 feet above the set, for overall fill, and it softened the overall contrast.

On the briquette level, we had two Dyna-Lite heads and one Bowens monolight—all with medium and small grids, at 800 or 1000 W/S each— a lot of light to pump up the dark tones. They were directed at the charcoal, with thick amber gels. There was one on the left, one at the back, and the third on the right, each on a low stand, about 3 feet off the ground and 2 feet from the set. Pointed right at the briquettes, they gave them the look of flaming coals. The strobes for the briquettes had only medium grids. The briquettes appear to be glowing, but they're not really ablaze.

Two feet below the briquettes, on the floor, I put a white card and lit it with two Dyna-Lites—one from the front and pointing more toward the left, right under the camera, and one from behind, pointing more toward camera right, on the opposite side of the set. Each light had a combination of red

and amber gels, so that, where white patches were visible through the briquettes, now you see red. The power was 800 W/S, split between the two heads (which don't have grids, because I wanted the light to cover the whole area). Both lights have barndoors to prevent them flaring the camera, especially the light positioned behind the set.

I always need to flag the lens from the large softbox, so there is a little black card on an articulated arm by the lens (known to some as a "French flag"). A gobo to the right of the camera prevented flare from the main light.

Because of the layered set, I shot from a carefully worked-out angle so that everything appears to be in alignment. I used a view camera with a relatively long lens—a Sinar p2 and 240mm, exposing on Kodak Ektachrome. Exposure was $f/11$ at $\frac{1}{2}$ sec. The view camera let me employ the front and back standards to control depth of field. And, if it isn't obvious, I needed the longer lens to keep a

FOOD AND BEVERAGES

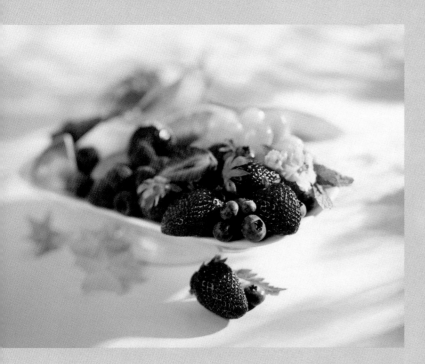

JOB SHEET

USAGE: **Advertising**
CLIENT: **Provigo Supermarkets, Quebec**
AGENCY: **Perennial Inc.**
ART DIRECTOR: **Danyo Therrien**
FOOD STYLIST: **Linda McKenty, Montreal**
LIGHTING: **Tungsten and strobe**
CAPTURE: **Analog**
PHOTOGRAPH COPYRIGHT
©PIERRE TREMBLAY.

The client wanted this picture to simply look fresh, natural, and inviting. We shot this dish with a Sinar p2 (2 feet from the set) with 150mm lens, on Kodak Ektachrome VS for a ¼-sec. exposure at *f*/5.6 ½ (pushed ⅓ stop for contrast). The white backdrop was shaped into a 30-degree sweep at the rear. Two ETC optical spots formed a bank, each with ½ CTB. Each head had a gobo inside, with the beam defocused to project a softly contoured pattern onto the set, creating a dappled look. These lights are 5 feet up, 4 or 5 feet away. To soften contrast, we added a 400 W/S Dyna-Lite inside a large Chimera softbox 5 feet above the set, and goboed. To give the dessert a certain freshness and appeal, the art director wanted the shadows to be on the cool side, so we clipped blue gels onto the baffle surface of the softbox. This combination of ½ CTB (covering the entire flash head) and Rosco aqua blue (a strip down the middle) gave us the hint of blue needed. To complete our lighting, we used two small parabolic mirrors. We added a card, with the white side facing the set for fill, the black side toward camera as a gobo.

good working distance from the heat. In truth, the main reason I shot with the 240 was that all the stands kept me from getting closer than 3½ to 4 feet from the set. I shot from a small ladder, with the camera at 6 feet.

The food stylist took care of searing the crisscross pattern onto the hero steak so it looks as if it were actually prepared on a grill, while we used a stand-in to compose and light the shot. We must have had two dozen steaks to work with. Some foods you can eat after the shoot. Steaks and other meats have to be tossed. *C'est la vie.*

PRO TIP The first time I tried this I didn't water down the briquettes, which were lying on a large sheet of glass. After one briquette ignited, the glass simply shattered from the heat. Luckily, I had finished shooting. I now use wire-mesh glass, and every time after we shoot, we water down the briquettes to make sure nothing is lit. You can't see the wire grid in the frosted glass because it's covered with coals. Finally, we always keep the studio well ventilated—and have a fire extinguisher nearby.

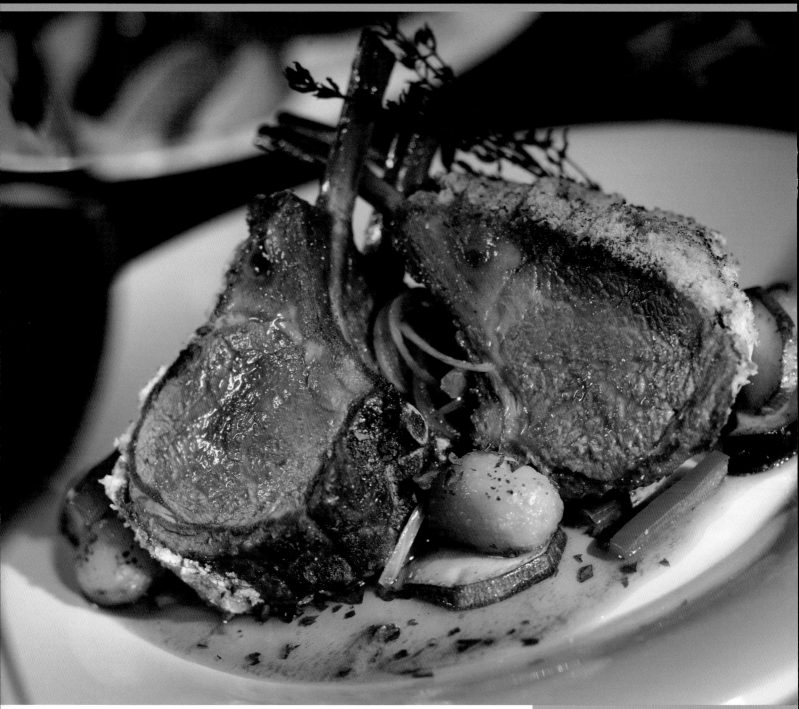

I t wasn't easy to show a lamb chop in the best light: The patio used as a set was shaded, and the sun was going down. In fact, it was already pretty dark outside. Tungsten lights and some amber gels proved to be just the right ingredients for an appetizing shot.

PRO TIP Tungsten generates a lot of heat, and this is especially problematic if the shot takes awhile. My solution to that is to use low-wattage lamps. I don't turn them on until I'm ready to do a Polaroid or to go to film. With strobe, I turn on the modeling lights only briefly—to get focus and to preview the set, and then I turn them back off again.

JOB SHEET

USAGE: **Editorial**

CLIENT: *Las Vegas Life* **magazine**

FOOD STYLIST: **Trace Hayes**

LIGHTING: **Tungsten**

CAPTURE: **Analog**

SECONDARY USAGE: **Advertising (licensed by Lutèce)**

PHOTOGRAPH COPYRIGHT ©JEFFREY GREEN.

PRO TIP Why tungsten? When I want to do these real moody, contrasty shots, tungsten gives me a lot more control. I can really focus the lights with pinpoint accuracy and see exactly what it's doing—without having to burn an excessive number of Polaroids. This way I can see the exact effect through the lens and zero in on the lighting.

The dish, as well as the ambiance, sets the stage, inviting you to luxuriate in the fine dining experience. In this shot, we had to let you infer the surroundings from the table setting for one simple reason: We had to shoot this picture on the patio right off the main dining room, and that meant building the entire set outdoors.

We started by moving a table from the dining area outside and covering it with a really dark fabric to serve as a tablecloth. We used a plate I brought from my studio, and, for a realistic-looking setting, added a glass of red wine to break the frame in the left foreground and a salad in the background. The chef cooked the dish and my food stylist added some finishing touches, including a glaze to give the meat a glossy sheen and keep it fresh-looking under the lights.

I had to work fairly quickly. The restaurant opens at five; I got there at two and had to be out of there before the dinner crowd began arriving. I shot with a 4x5 Arca-Swiss F-line, with a 150mm lens and Fuji 64T, positioning the camera a foot to a foot and a half from the set, at a height of 3 or 4 feet. I tilted the lens forward just a little bit on the front stan-dard, to bring all the meat into focus for this $f/11$ exposure at $\frac{1}{2}$ sec.

Our lighting consisted primarily of 100-watt MiniMoles, with all the lights barndoored fairly tightly, less than half open. I positioned one light to the right of the plate and another on the left side, but a little higher and aimed straight down onto the front of the meat to give it a tantalizing, glistening look. The third light was farther back and aimed on the salad from about the same height as the light on the left, coming in on the set from overhead and to the right of the dish. This head was diffused, and directed downward so it shed just barely enough light on the vegetables to bring out some of their features. All these lights had a very light amber gel, to add a little warmth, and all were within a couple of feet of the set. I also used a white fill card just to the left of the lamb chop plate. You can see the light from this card on the back of the plate. In contrast, I left the wine glass dark to maintain the feel of a dimly lit restaurant. I wanted the lighting to draw your eye right to the dish.

This recipe seems to have been a success: Though this was an editorial assignment, the restaurant bought the shot for advertising.

Hot food means working fast. If the dish had to be made steamy, special pellets could be hidden in the food to create smoke.

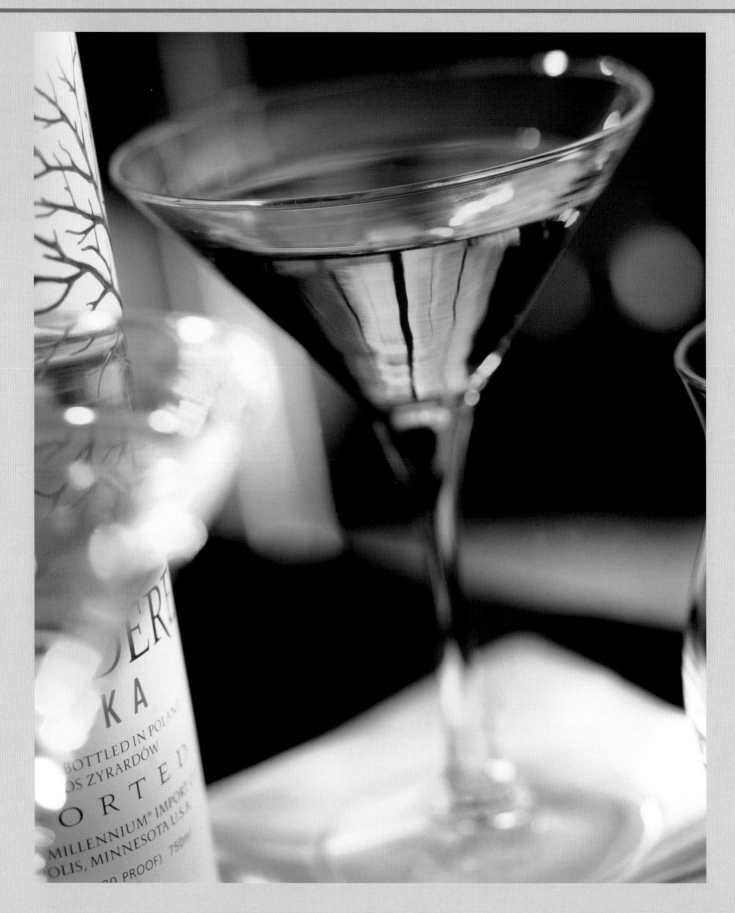

JOB SHEET

USAGE: **Collateral**
CLIENT: **Bellagio Las Vegas**
SET DESIGNER/FOOD STYLIST: **Tony Abou-Ganim**
LIGHTING: **Tungsten**
CAPTURE: **Analog**
PHOTOGRAPH COPYRIGHT ©JEFFREY GREEN.

The Bellagio was looking for some pretty drink images to be used in a poolside drink menu and in brochures. We set up in one of the hotel lounges, selecting six popular drinks that would photograph well, this apple martini among them. In this shot, the client wanted only a hint of the vodka bottle, but otherwise left it to me to design the picture with this sense of an inviting yet casual air. For this shot, I used a 4x5 Arca-Swiss F, with the 210mm Rodenstock lens set to *f*/5.6 and ¼ sec., exposing on Fuji 64T (pushed slightly), for this tungsten-light shot, with the camera no more than 2 feet from the set. The first light, a MiniMole with barndoors, was positioned to the right of camera, aimed down into the drink, from a foot above set level. This light had a very light amber gel to subtly warm it up and make the drink even more inviting. The same is true of the light to the left, behind the bottle (at set height), backlighting this glass. For the glass in the foreground we added one head to keep it from going dark, placing this light at the left-front corner of the set, at a downward angle. The final light is another spot, from the right back, coming in as a fill to bring out the label on the bottle, while also hitting the stem of the glass and the vase on the right.

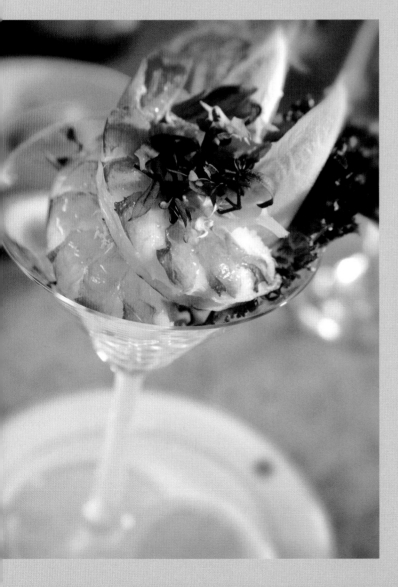

JOB SHEET

USAGE: **Editorial**
CLIENT: *Las Vegas Life* **magazine**
FOOD STYLIST: **Wolfgang Donweiser**
LIGHTING: **Strobe**
CAPTURE: **Digital**
PHOTOGRAPH COPYRIGHT ©JEFFREY GREEN.

The photograph had to capture that tantalizing freshness of these shrimp through the angle, composition, and lighting. We shot this dish at the Veranda Café in the Four Seasons, Las Vegas. When setting up our lights, we substituted a glass filled with lettuce for the hero dish. With the actual dish on set, we immediately started shooting, using a Canon EOS 1Ds, with 24-70mm Canon 2.8L lens positioned 8 to 10 inches from the shrimp. We began with a White Lightning Ultra, with 20-degree grid, to the right, fairly high, shooting down at about a 45-degree angle. We aimed another light (barndoored, with subtle diffusion), low, across the background elements. Then I had another head on the left, a little bit behind the shrimp, coming in on the set from a relatively high angle—positioned as you would a hairlight in a portrait. To soften this light, I removed the front diffusion baffle from a softbox and draped it over the head. Finally, I added a small pop-out silver reflector on the left of the shrimp cocktail, to bounce some of that first light back in. Exposure was *f*/5.6 at ⅟₆₀, with WB set to "flash" for that slightly warm feel to the picture.

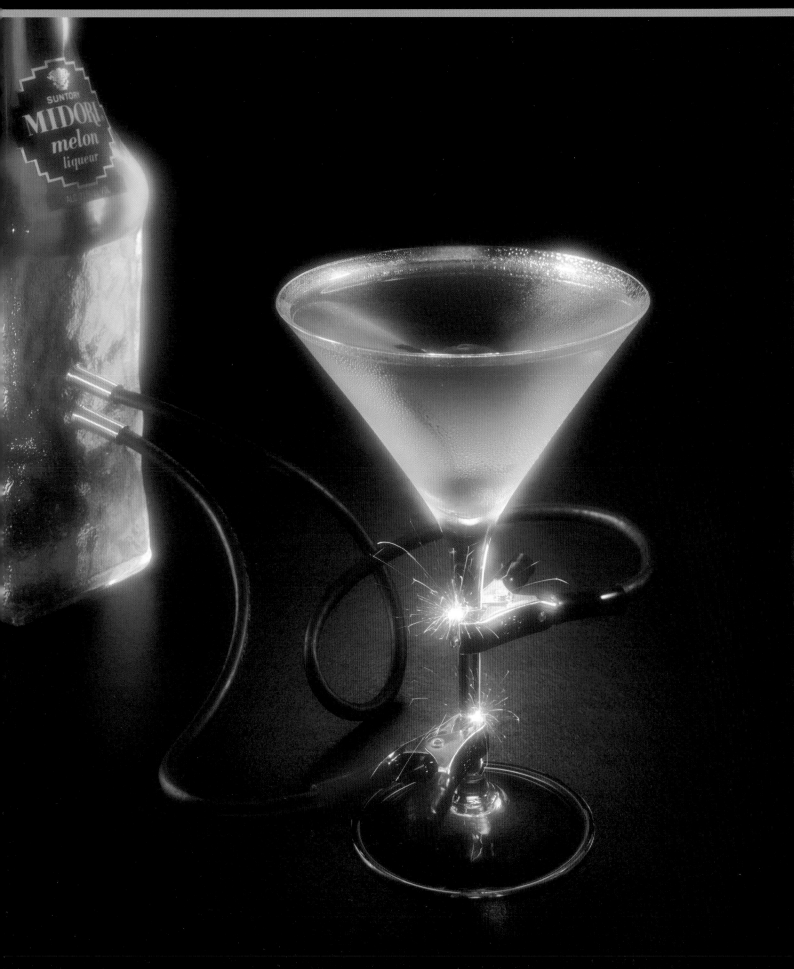

JOB SHEET

USAGE: **Advertising**

CLIENT: **Midori**

ART DIRECTOR: **Wayne Schombs**

MODEL-MAKER/MIDORI "FLASHLIGHT": **Bob Zaccharian**
 (the Prop Shop, Brooklyn, NY)

FOOD STYLIST: **Delores Custer**

DIGITAL ARTIST: **Dan Smith**

FIRST ASSISTANTS: **Tom Flynn and Mike Crane**

LIGHTING: **Strobe and light painting (plus sparklers/jumpercable shot)**

CAPTURE: **Analog**

PHOTOGRAPHS COPYRIGHT ©CHRIS COLLINS.

PRO TIP In the advertising work we do, the agency almost always provides layouts. But the agency's sketches aren't carved in stone. They provide a starting point. We brainstorm the concept with the art director until we arrive at a workable solution.

The task at hand wasn't to capture lightning in a bottle for the client—but in a martini glass, at least in one of the shots. The others would prove no less spellbinding. That, and all the components of this complex shoot, required an inventive lighting setup, judicious use of light painting, and one or two magician's tricks.

"Electrifying" was the word the art director used to describe the look he wanted. And you could feel the electricity in the air as we set about shooting this Midori campaign. We decided on several images, with the drink aglow in each. I shot with a Toyo 8x10 and 120mm lens, on Kodak EPP, over the course of two days.

The first—and main—shot involved jumper cables, made for us by a prop artist. We glued these cables to a bottle at one end, while clamping them to the martini glass at the other. Where the clamps touch the glass, we added sparklers. Once these are lit, all you see are glittering particles of incandescence. This image was double-exposed. We put a very intense blue gel on the camera to kill some

orange in the sparks, making them look more like electrical sparks.

The photograph was done entirely in-camera. We shot the sparklers at $\frac{1}{125}$ and $f/5.6$. I chose the two best frames for sparks above and below, then mounted those transparencies on a lightbox, on a separate set.

Next, I exposed my main shot of the bottle and glass, removed the film from that 8x10 camera, and moved it into another 8x10 on the sparkler set. To align everything perfectly, I used an acetate tracing on the ground glass to outline positioning of the drink shot.

A Hosemaster No. 5 Frost diffusion filter in front of the camera made the Midori bottle and the mar-

This image and those on page 22 had to appear to be electrically charged. We used multiple sets, creating most of the effects in-camera, some of them involving light painting and a special filter.

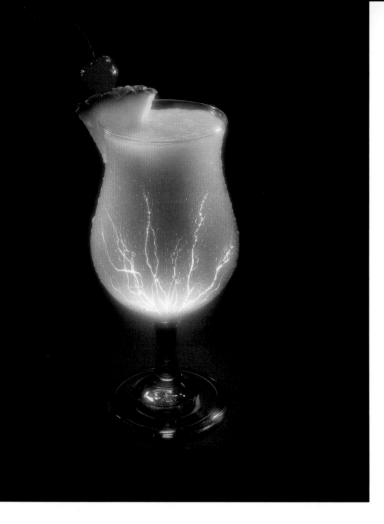

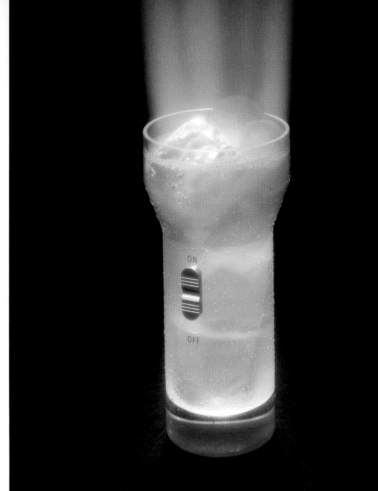

Lightning streaks created in Photoshop (left) and a light shining through a hole in the bottom of a glass (right) created an electrically charged effect.

tini glow. The glass and bottle image was a multiple exposure; we wanted the green glow, but didn't want the effect over the entire picture. Exposure by strobe was $f/45$ at $\frac{1}{60}$ sec.

Now for the lighting. I used a Speedotron head with standard reflector inside a 1-foot bank for the bottle. This is positioned low, on the left. I also used a 1-foot bank directly above the martini glass, on very low power. The rimlight on the stem comes from a head on the right. The backdrop was a nicely textured, black semigloss–painted surface. To give

us that purple glow on the backdrop, we placed a head behind the set, gelled with a combination of double layers of magenta and CTB. This light had a grid and diffusion.

I did some light painting, too. After making my base exposure with strobes, I lit up the martini glass with the Hosemaster, the light coming mostly from above. Additional light painting accented the bowl of the martini glass and the cherry. With the Hosemaster, I painted along the right side of the bottle, coming in from behind it to avoid hot spots. A little light is also painted onto the Midori label. The light-painting exposure was $f/45$, for 10 sec.

The Midori lightning shot (above, left) involved several steps. First we photographed the main set, our food stylist preparing the drink with its fruity trimmings. The lightning streaks were created in Photoshop. We made a Kodalith of this lightning

PRO TIP To give the drink that cool, refreshing feel, we had to add condensation to the glass. I don't like spritzers in such situations, because the effect looks heavy-handed. I prefer something more subtle, and the way I achieved that here was by using a steamer on the martini glass.

and then photographed the Kodalith, double-exposing that onto the main shot.

Then we used a neat little trick. Instead of just photographing the lightning streaks as we did with the sparklers, we took a glass sheet covered with water droplets and put it in front of the Kodalith with the lightning streaks. If you look closely, you can see the droplets are on the outside and the lightning is on the inside—so it looks as if the lightning is inside the glass. Without that step, we couldn't have created that illusion. The glow at the base of the lightning comes from the Hosemaster light hitting the bottom of the drink, with a diffusion filter in front of the camera. We lit the backdrop and glass in a similar fashion as described earlier.

The Midori flashlight shot (opposite, right) began with a constructed model, the food stylist again preparing the beverage. We put acrylic ice cubes in the glass, then put the glass on a black-painted, textured surface, like the one in the lightning shot. This time, however, we cut a hole underneath the glass so that we could shine a light (a Speedotron head) upward.

After completing the main flashlight shot, we took the film out of the first 8x10 camera, put it in another 8x10 aimed at the light rays, and double-exposed it. We created the light rays using layers of gels and ND filters overlaid onto a light bank on the second set. The gels went behind strips of construction paper. On the bank itself we masked off everything except for the layers of gels in the middle. Then we threw these "light rays" out of focus to give them a soft edge typical of true light rays. Although I didn't use the Hosemaster on this shot, I did use the diffusion filter in front of the lens for this part of the exposure.

personal vision

"What I have tried to illustrate in this photograph is mankind's reckless attempts to coerce nature."

JOB SHEET

USAGE: **Editorial**

CLIENT: *Family Circle* **magazine**

CREATIVE DIRECTOR: **Diane Lamphron**

FOOD STYLIST: **Fred Thompson**

PROP STYLIST: **Candace Clark**

FIRST ASSISTANT: **Carlos Alayo**

LIGHTING: **Strobe**

CAPTURE: **Analog**

PHOTOGRAPH COPYRIGHT ©KATRINA DE LEON.

PRO TIP Whether the shot will end up in advertising or editorial, use real food whenever possible. Editorial shoots do give you some leeway to enhance the food with fake elements, although recent trends have leaned toward total realism.

To its many devoted followers, tiramisù is the perfect Italian dessert—its taste, sublime; its texture, delicate, if not ethereal. To capture that sumptuous light quality on film, the lighting made use of several softening elements, including Plexiglas and a bounce light.

Timing was the key with this tiramisù dish: One minute it's there in all its glory, the next it's metamorphosed into a goopy mess under the lights, no matter how cool these lights or the studio. So our 4x5 Cambo, with 210mm lens, was at the ready. Based on earlier testing, we had a CC025M filter on the lens to bring the 4x5 film to a neutral color. We didn't want the colors to be unusually vibrant. We wanted the shot to have more of a vintage feel, so the colors in the photo are evocative of the 1930s. Our choice of props helped reinforce the muted quality we were looking for.

But having everything ready to go was no guarantee that we would capture this scrumptious Italian dessert on film before everything melted.

We still had to move fast, although we did allow the cinnamon to melt into the tiramisù, to give the dish a bit more texture. To stop the clock after that point—or at least slow it down enough to keep the dish intact—we shut off all modeling lights on our Norman strobes for the duration of the shot.

This story involved eight shots for eight separate recipe cards. We did the first four on the first day, the second four the next. While we didn't have layouts, we did have a size for picture placement—4x5 vertical—so we worked to that.

You can't really do a mock-up of this dessert. You just wait to appreciate its beauty as the food stylist places it on set. All the same, we needed to work with something during prep, and that some-

With dishes that don't hold up well under lights, it's extremely important to be ready to shoot the moment the food is placed on set, and then to shoot quickly. Also, to convey the flavor of dishes such as this tiramisù, one benefits from using a restrained approach, imbuing the colors with a more muted feel.

thing, though hardly tiramisù, served us well enough. We used the spoon from the shot, as well as a glass bowl with nothing in it except a paper towel crumpled into a ball (with a strawberry on top), just to have some shape to work with.

The prop stylist had provided tableware for me to select. I made my choices with an eye toward a muted, vintage look. The vase on the right and a stack of small bowls in the background on the left give the set some additional color and shape. The backdrop is a simple tablecloth. I intentionally added a curve to the napkin, adding softness that would balance against all the hard shapes on set. In terms of composition, the napkin played off the ripples in the glass and plate.

The first light was a Norman head fitted with a medium-size reflector behind a 4x4-foot sheet of ⅛-inch Plexiglas. The light was positioned 8 inches to the left (behind the bowls in the back). To soften the light even further, I had a layer of diffusion material placed over it. The Plexi was 1½ feet from the set, with the head 2½ feet behind that, providing a nice, even light—in essence, becoming a softbox.

The next light was a Norman Tri-Lite optical spot, which created some specular highlights. It was 4 feet away from the set, to the right and toward the back, and 3 feet above. I like the Tri-Lite because I can put templates in it that, among other things, create window patterns to break up the light and add a little drama to the set. In this instance, the Tri-Lite was defocused, so there's no sharp delineation of the projected pattern. This particular light is pretty old—the aging Fresnel lens has become discolored over the years—and I use a ¼ CTO on it to get a quality of light slightly warmer than neutral.

Finally, there was a very, very soft bounce light (from a Norman head fitted with a standard reflector) coming off the white ceiling. The head was positioned near the camera. I have 12-foot ceilings in my studio, and this light was at 8 feet, pointing straight up, for overall fill.

To keep the bright red tonality of the strawberry on top from competing with the creamy texture of the dessert, I let this strawberry go dark in front through expeditious control of the lighting. I used an exposure of $f/8$, for shallow depth of field.

JOB SHEET

USAGE: **Editorial**
CLIENT: *Family Circle* **magazine**
CREATIVE DIRECTOR: **Diane Lamphron**
FOOD STYLIST: **Fred Thompson**
PROP STYLIST: **Luba Kierkosz**
LIGHTING: **Strobe**
CAPTURE: **Analog**
PHOTOGRAPH COPYRIGHT ©KATRINA DE LEON.

The article focused on country inn breakfasts for the holidays. I worked with a Cambo, 210mm lens, and EPP (f/16 ⅔ at ¹⁄₅₀₀, pushed one-quarter), using Normans, with ⅛ and ¼ CTOs on the lights for warmth. I shot tight for a more intimate feel. To begin, I bounced a medium dish (at 1200 W/S) into a 40x50-inch foamcore. I added a large bank (at 200 W/S) near camera, for fill. I also added a 30x40-inch white fill card at the front left corner. For some specular highlights and dappled lighting, I used an optical spot with a cookie cutter, adding a gobo to prevent flare from the foamcore light.

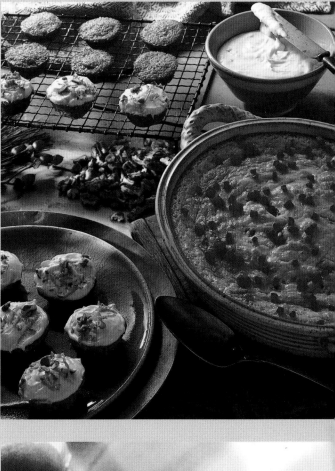

JOB SHEET

USAGE: **Editorial**
CLIENT: *Victoria* **magazine**
ART DIRECTOR: **Kim Freeman**
FOOD STYLIST: **Rosco Betsill**
PROP STYLIST: **Kim Freeman**
LIGHTING: **Natural light and strobe**
CAPTURE: **Analog**
PHOTOGRAPH COPYRIGHT ©KATRINA DE LEON.

To illustrate a story on fresh ways to use raspberries, we chose a non-alcoholic raspberry cordial as our subject. We captured this image on a Nikon F4, with 105 Micro lens (with a Nikon Soft FX3 to diffuse the highlights), on Kodak EPN, for an f/8 exposure. A 6-foot-tall bay window provided a nice, even late-morning light for the set, which stood 4 feet from the casement. We'd covered the window with a ¾ CTO warming gel to make the lighting even more inviting. However, to imbue the shot with a fresh, sunny feeling, we had to add a light outside—a bare bulb, running off a Norman 2000 W/S pack, with the light far enough away so that it appeared truly specular and sunlike as it shone through the window. We also had a medium Chimera bank on very low power, for fill, positioned to the left of camera and slightly overhead, 3 feet from the set. I added a narrow white strip down the back of the cordial bottle and the bottle to the left to catch the light and give the liquid more punch (we left the other bottles and glasses alone). Because the berry drink was fairly murky, you couldn't see the card. Finally, we added black cards around the lens, against flare.

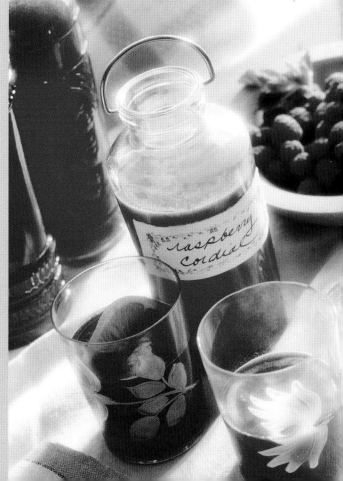

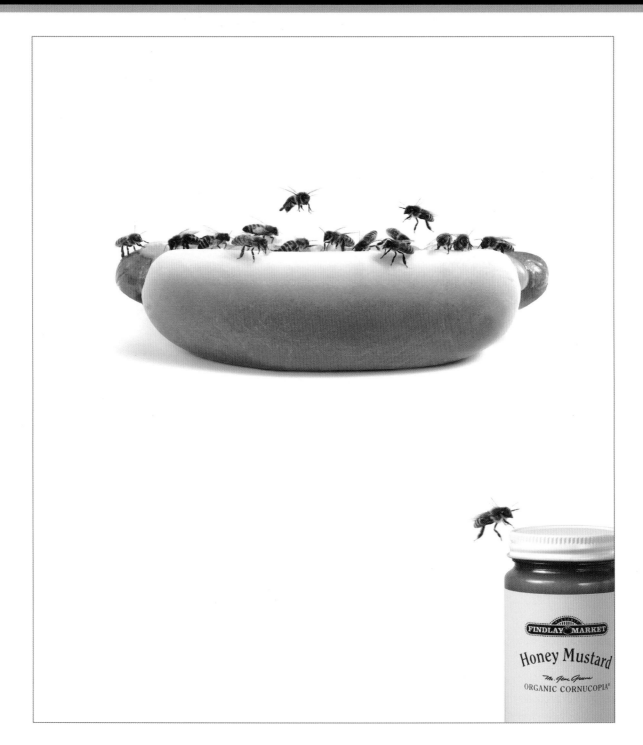

The client wanted to show bees ecstatically swarming a mustard-slathered hot dog. So how do you get all these bees to do your bidding? That was the challenge in store. Considering the knotty logistical problems, lighting was the easiest part of the job. Still, there were subtleties and considerations in the way the lighting was finessed that make this shot believable.

JOB SHEET

USAGE: **Advertising**

CLIENT: **Organic Cornucopia**

AGENCY: **HSR Business to Business**

CREATIVE DIRECTORS: **Laura Black and John Pattison**

FOOD STYLIST: **Linda Lawson**

FIRST ASSISTANT: **Sarah Miller**

LIGHTING: **Strobe**

CAPTURE: **Digital**

PHOTOGRAPHS COPYRIGHT ©TONY ARRASMITH.

PRO TIP The silver board is Thermo-Ply insulating fiberboard. We buy it in 4x8-foot sheets and cut it to size, so we can use the sheets on set as silver reflectors. We also take it with us on location. It has a diffuse mirror quality, so you don't get an overly hard light off it.

When I heard the concept behind this point-of-purchase campaign for honey mustard, I chuckled. Then I had to ask myself: How do we go about shooting this? How do we get bees into this shot and do it in a way that keeps it real, not to mention painless?

At that point, I got on the phone with a local beekeeper. With the key information I needed in hand, I got back in touch with the agency to let them know we could do what they had in mind. The art director provided a rough sketch for starters. The rest was up to us.

When I paid him a visit, the beekeeper gave me a jar full of worker bees. That was the easy part. Aside from the bees, we needed a glass container to house them, to give us the needed control to shoot the picture. The truly difficult part was yet to come.

First, how were we supposed to get the bees from point A—the original jar—to point B, the Plexiglas housing? How were we going to light the shot? And, most imponderable of all, would the

bees actually be attracted to mustard, even honey mustard? That last question was the first one I had put to the beekeeper. He assured me it could work. Still . . . bees together with hot dogs and mustard? Any chance we could make that ants?

It took a lot of brainstorming to turn our rudimentary plan into a viable solution, but once we had one, everything fell into place. The next step involved setting up my Hasselblad ELX with Imacon Express 96 back and 120mm lens.

First we had to photograph the frankfurter. A fake hot dog and bun would not have had the right texture or reflective quality, so our food stylist prepared the dish. We set up our lights, which had to remain in place for the entire shoot—for consistency. The backdrop for the frank is white seamless, with the camera 3 feet from the wiener and 18 inches above it.

We began the shoot with a Briese retrofitted to a Profoto 2400 W/S powerpack as our main light. This was fitted with a large, umbrellalike

To contain the bees, a hole was cut in a Plexiglas case big enough for the lid of a mason jar. The bee-filled jar was moved to the lid. Then the netting that sealed the insects inside was pulled away, so the bees could migrate into the case. The final step was to screw the jar onto the lid.

dish. We bounced this light into a V-shaped silver card on the left of the set. We also surrounded the set on two sides with black cards, to prevent stray reflections in the glass.

After shooting the hot dog, I locked everything down. We replaced the wiener with rolled-up yellow-and-white rayon cleaning cloth (secured with tape at one end), which we coated with sugar water—following the advice of the beekeeper. Obviously, we couldn't use a steamy hot dog, and allowing the wiener to cool—well, you've seen hot dogs when they chill, and they're not a pretty sight!

As expected, the bees migrated straight to our sugary lure, remaining enticed by our concoction long enough for us to shoot 20 different "poses." You may notice a dab of mustard on some of the insects. We did add a little mustard to our sugary mixture to help us with continuity in post production. By the way, we didn't refrigerate the bees to make them less peppy. We wanted to keep them normally active.

We picked the best exposures, with the bees flying, taking off, landing, or just milling about. We then digitally masked out the synthetic lure and other extraneous elements to create the "bee component" for the final art—the marriage of hot dog and swarm for our final composite. We also retouched the bun in our original shot to remove surface imperfections.

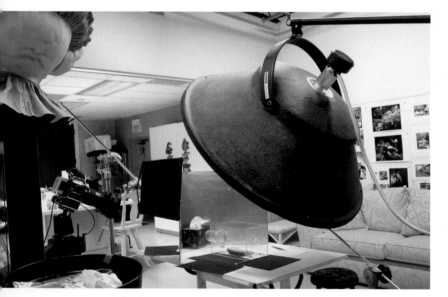

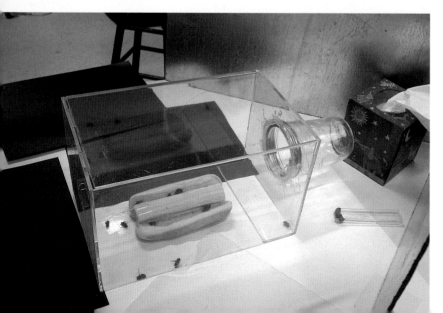

The lighting for this shot was fairly straightforward. The trick was devising the set and getting the bees to cooperate. While the lighting was simple enough, with one main light, it was the added cards that made the difference.

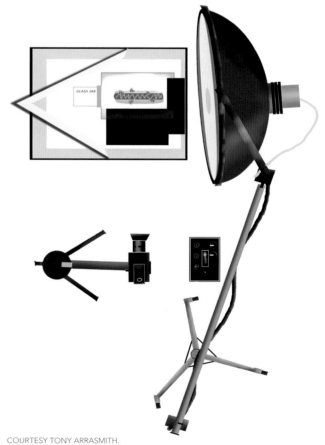

COURTESY TONY ARRASMITH.

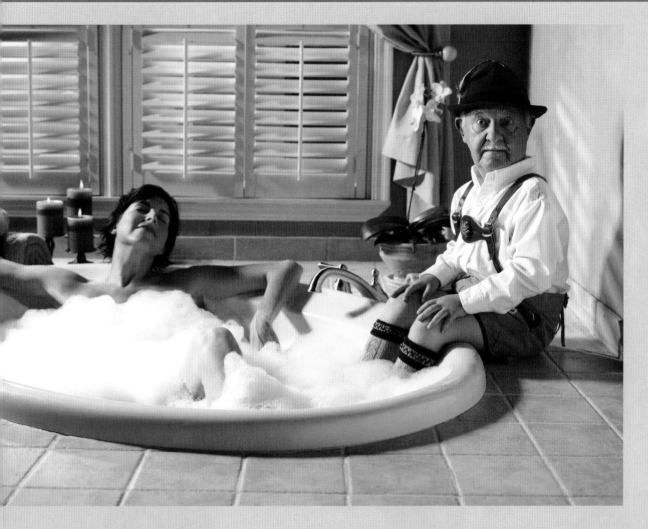

JOB SHEET

USAGE: **Advertising**

CLIENT: **Schmitt Sohne**

AGENCY: **The Creative Department, Cincinnati**

ART DIRECTOR: **Drew Hill**

CREATIVE DIRECTOR: **Dave Fagin**

HAIR & MAKEUP: **Jodi Byrne
(Illusions in Make-up & Art)**

FIRST ASSISTANT: **Mark Wieczorek**

LIGHTING: **Strobe**

CAPTURE: **Digital**

PHOTOGRAPH COPYRIGHT
©TONY ARRASMITH.

The concept behind this amusing campaign simply proclaimed, "Take a little German with everything you do," with the product, a German wine, implied in the shot. In order to make the shot more politically correct, we'd decided to composite an older man's head onto a young boy's body,

giving us our "little man." We designed and built the 12-foot-wide by 7-foot-deep set, taking perspective into account. I used a Hasselblad ELX, with Imacon Express 96 digital back and 120mm lens (f/5.6 at $\frac{1}{60}$, ISO 50). The first head up established the lighting direction and was a Profoto Pan dish with white interior, at camera left and at a 45-degree angle toward the model in the tub. A Profoto 45-degree reflector with ¼ CTO (for a late evening feel) and barndoors came in from camera left, aimed through the blinds to create the wall pattern. A grid spot was next, aimed at the boy (as he took his turn sitting on the tub), from 6 feet up and feathered slightly to hit a white fill card right behind him, to his left. Also behind him is another light, on a Pro-6 Freeze powerpack, from high enough, reaching past his shoulder and the white card, and aimed at the female model's face only, to reduce contrast. When we replaced the little boy with the elderly gentleman, we did everything the same, except that we put a silver disc in front of his chest, to fill in the hat, and a 2x4-foot fill card for the face, at a 60-degree angle positioned directly in front.

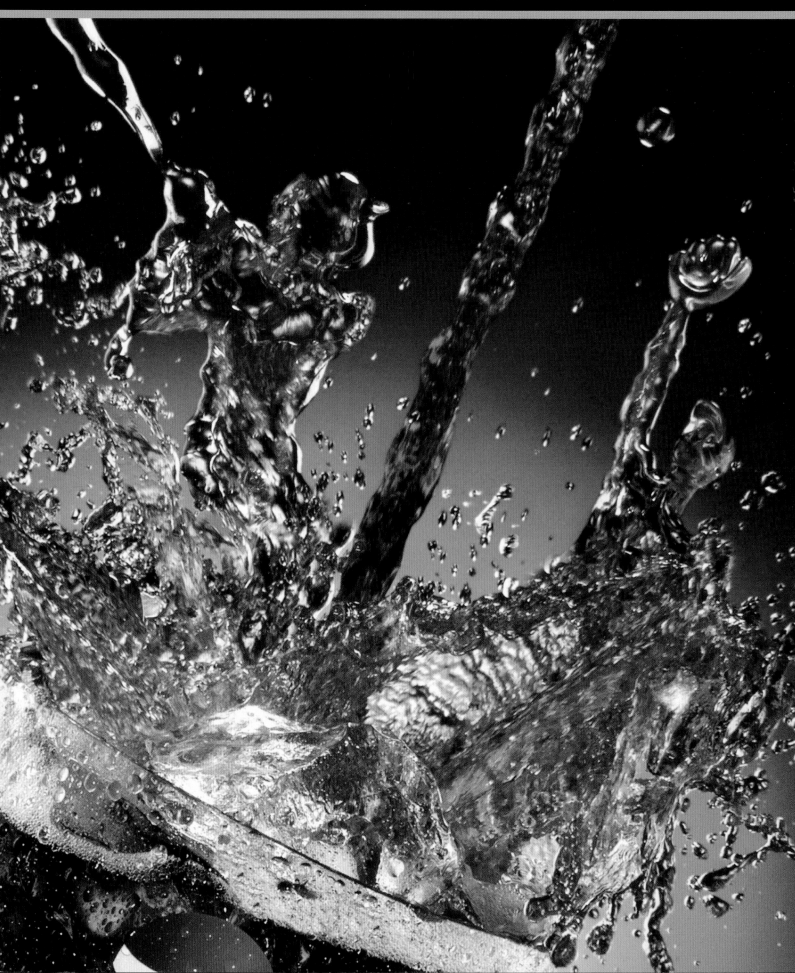

JOB SHEET

USAGE: **Advertising**

CLIENT: **Pepsi**

AGENCY: **BBDO**

CREATIVE DIRECTOR: **Nick Striga**

MODEL-MAKER: **Clockwork Apple**

LIGHTING: **Strobe**

CAPTURE: **Analog**

PHOTOGRAPH COPYRIGHT ©DAVID ZIMMERMAN.

PRO TIP All the props were built to twice their normal size: the glass, the acrylic ice cubes, the logo, and the resin figures. We did this so that we could carve maximum detail into the models.

Popular pastimes lay at the heart of this shot. But more than that, the client wanted the picture to be dynamic. The solution was to create two shots, each with a bit of splash. The figures, seemingly made from the beverage, had to look real, right down to the color. And yes, the lighting played no small role, ensuring that the peak energy was captured in each shot, with just the right touch of movement.

To illustrate that "Nothing Else Is a Pepsi," the creative director wanted the soft drink linked to popular recreational themes—with figures involved in those activities magically emerging from a splash of the beverage. The themes focused mainly on sports, but included a musical theme as well. The agency gave us rough layouts. We had to make all the elements blend so convincingly that distinguishing between real and fabricated elements would be no easy task.

We shot seven magazine ads, with at least two—and up to six or seven—figures in each. We built two sets: one for a "pour," the other for an "explosion." The pour shot (like the one here) showed a stream of Pepsi being poured into the glass, with some spattering. Explosion shots showed the liquid energetically splashing out in all directions.

We had to control the liquid's movement and color, as well as the tonality of the models. These were made of resin, for better color accuracy and translucency. We had come up with a resin shade that worked with our film—Velvia—but it still wasn't a perfect match for the beverage. The figures were amber, while Pepsi has more reds and browns to it, even going to black at some points while in the glass, and lighter and thinner when poured or splashed. So it was important to match these colors as much as possible with lighting and filtration, while compensating for the resin's tendency to look more red when shot on this film. To equalize density in the pour shots we increased the light intensity behind the glass, while using less light behind the pour itself. To bring the liquid in the tumbler to the necessary tonal level, we put a green gel on the back of the glass.

Resin figures seamlessly blended with an actual liquid pour, with the help of a specially constructed glass set. A combination of high-speed and conventional strobe lighting completed the picture.

We knew that splashing liquid does many things—for example, producing very thin sheets with little ripples. We mimicked that effect in the resin of some of our models. To go with the liquid feel, we gave the models' arms a fluid, drippy look. The elbow of one baseball character was made to look as if it were actually dripping. Parts of the models were held together by wire running through the figures. While the client retouched out the wire visible in the baseball figures, we were able to conceal wires that served to anchor the figures with the help of foam and ice cubes, as well as the liquid itself.

The glass itself was a specially fashioned acrylic container twice the size of a real glass. We'd constructed a movable base inside the container so we could "float" the ice cubes at varying levels within the glass, which sat on a small platform secured to a C-stand. For the Pepsi logo, we had a print shop copy the original artwork Pepsi sent us onto crack-and-peel transfer stickers, which we applied to the glass.

Each glass had a tube running through its center, from top to bottom. The resin figures were attached to the tube. For explosion shots, we mounted a ring of plastic—a "splash guard"—at the top of the tube. We attached a hose to the bottom of the tube and sent Pepsi up through it with a hand pump. The liquid shot up and out in all directions when it hit the plastic splash guard at the top.

The pour shot you see here was different. Dispensing with the splash guard, we built an acrylic "catch basin" to receive the pour and direct liquid in different directions (which we could modify in order to reshape the flow). We manually timed the exposures. I poured the Pepsi, holding it in a tube above the set, much like you hold water in a straw, releasing it for each exposure. This let me control the rate of flow.

We had 30-gallon tanks on the floor to collect the spills. Although some liquid found its way out, my 4x5 Toyo with 240mm lens was safe behind glass for this $f/45$ exposure. We tested on Polaroid, and lots of it, before going to final film.

Our lighting was primarily Ascor Sun Guns, supplemented by two Norman strobes on each set. We placed one Ascor on the left and one on the right—each with a small reflector and behind milk-white Plexiglas, to light the product and the glass. We aimed a Norman focusing spot at the logo, avoiding any spill on the surrounding glass.

We also put a Norman overhead, to give the edges of the liquid a sense of motion. The slower flash duration from this strobe made the drops appear slightly elongated. The Norman had a reflector on it, but no diffusion, because we wanted a specular highlight. We also placed a blue-gelled Ascor behind Rosco Tough Spun and aimed it directly into the set to provide separation and give us that graduated blue backdrop.

We shot one ad every two days, on each of our sets. The model-maker would bring us the figures in the morning, we'd test them all day, and refine the shot and shoot final film the following day.

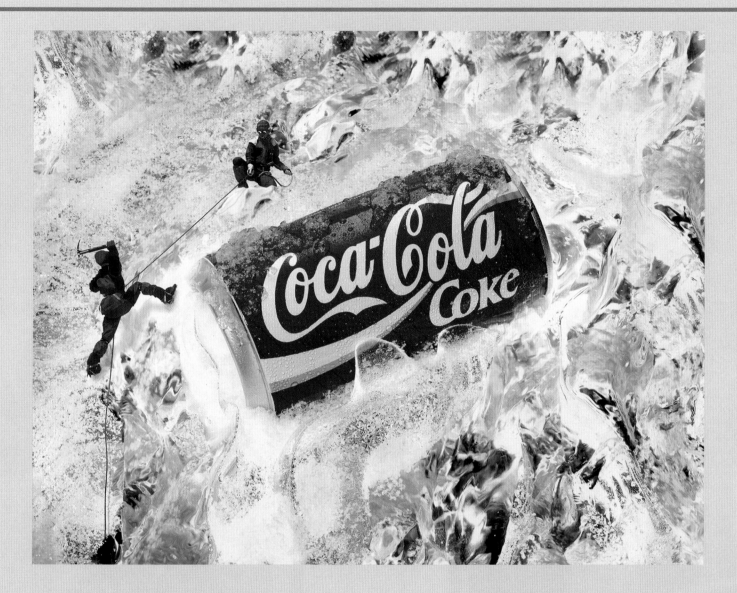

JOB SHEET

USAGE: **Advertising**

CLIENT: **Coca-Cola (Japan)**

AGENCY: **McCann-Erickson**

MODEL-MAKER: **Clockwork Apple**

LIGHTING: **Strobe**

CAPTURE: **Analog**

PHOTOGRAPH COPYRIGHT
 ©DAVID ZIMMERMAN.

Each picture for this campaign (aimed at the Asia-Pacific market) involved a different outdoor sporting environment, with athletes in varying activities and the product as hero. We shot this on a Toyo 4x5, with 180mm lens and Fuji Velvia, using Norman lighting to give us a daylight quality. We shot the people in the studio, individually propped up to get the correct angle, using strobe as main light and fill. They were then silhouetted, and shadows were added digitally. The bottom rope element was also photographed separately and composited into the shot. The can, ice (acrylic and custom-made), and snow were one image—we dripped artificial frost and snow onto certain areas. We had a bare bulb in the upper left-hand side of the tank lighting the ice and can, for specularity. Given the importance of the color and the deep tonality of the product, we used a fair amount of fill in front, adding an overhead banklight to give us a gradated edge on the can, so it looked round and metallic. There was also a light underneath hitting a sheet of aluminum, adding specular highlights coming through the ice, together with a sense of contrast. The client did the digital composite on this shot.

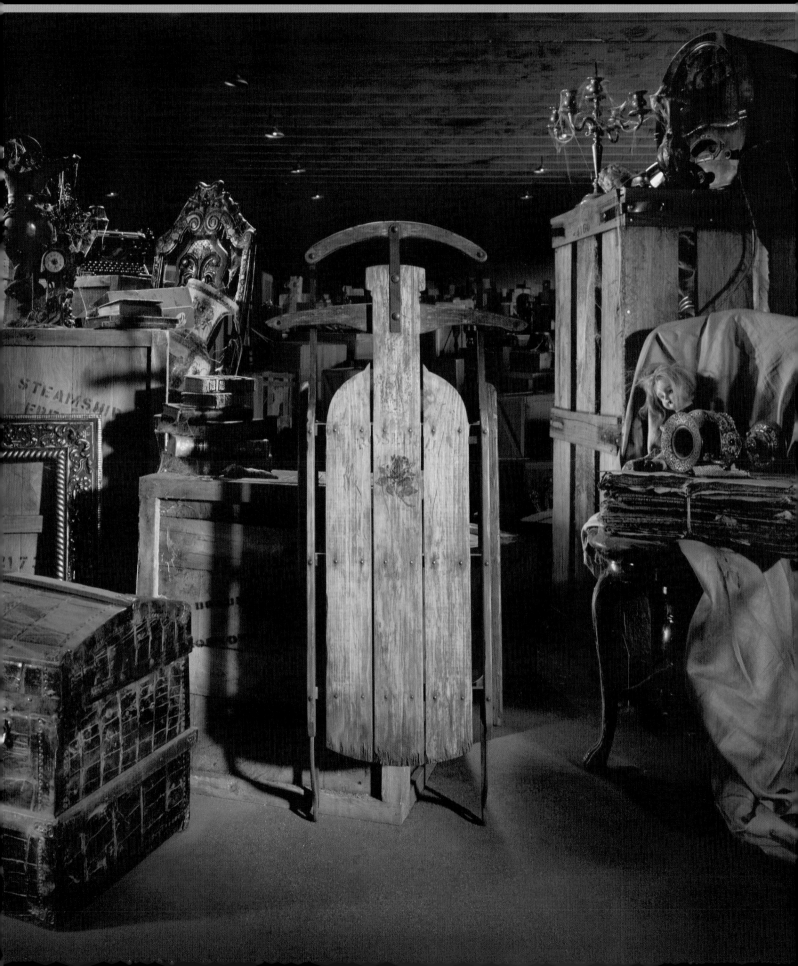

JOB SHEET

USAGE: **Advertising**

CLIENT: **Absolut**

AGENCY: **TBWA\Chiat\Day**

ART DIRECTORS: **Dan Braun and Bart Slomkowsky**

MODEL-MAKER: **McConnell & Borow**

PROP STYLIST: **Christine Mottau**

LIGHTING: **Strobe**

CAPTURE: **Analog**

PHOTOGRAPHS COPYRIGHT ©STEVE BRONSTEIN.

PRO TIP I was careful to light the two sets consistently. This was key to creating the impression of a single image, front to back.

A trademark of this studio is the ability to shape an ad around a popular icon, brilliantly rendered so as to faithfully represent the product. This one pays homage to the classic film *Citizen Kane* and involves two sets of different proportions, seamlessly merged into one shot. It took exquisite control of the lighting to carry off this illusion.

My involvement with this long-running Absolut campaign goes back awhile. Often, we've worked the design of the bottle into the visual, making it fit naturally into a landscape. In one instance, it was part of a Transylvanian mountaintop castle; in another, a boardwalk over the dunes in the Hamptons; in yet another, a hotel in Miami. Sometimes, we've integrated the Absolut shape into a physical prop, such as the valves on a New Orleans jazz trumpet in one ad, and gum sticking to a shoe in another.

Absolut Rosebud pays homage to the famous Orson Welles film *Citizen Kane*, and specifically to the final scene, in which the main character's beloved childhood sled, named Rosebud, is revealed. We did, however, take significant liberties with the look and style of the sled from the movie, to accommodate the Absolut shape, as well as with the surroundings we used.

Our Rosebud is actually two photographs—one foreground, one background. The foreground consists of the sled and all the other full-scale props around it. We constructed some of the props (the crates, for example). Others are rented antiques. We decorated the sled itself to look very old, and we made the floor—a section of Masonite—look like cement. This, our main set, was 10 feet wide by 10 feet deep, with the sled about 3 feet tall and other objects as tall as 5 or 6 feet. To lend an aged, neglected look, we dressed the set with theatrical cobwebs and dust.

This shot actually consists of two sets, the foreground full-size, the background a miniature built with meticulous attention to scale and arranged in forced perspective. Precise detail meant everything to the shot's success, down to what only appear to be ceiling fixtures in the miniature.

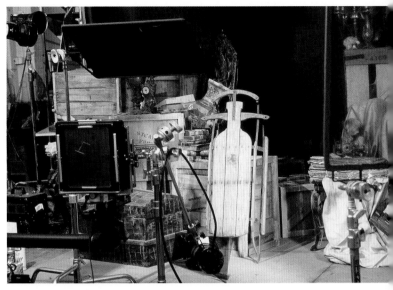

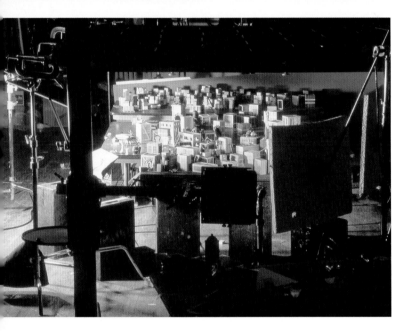

These production stills capture the complex nature of the shot, showing the key light, the foreground set with the full-size sled, the miniature set that comprised the background, and the ceiling for the miniature set. One frame shows how small the miniature props actually were in relation to a human hand. Yet in the final shot, every element appears totally credible.

The boxes and crates you see in the distance are part of the miniature set we used for the background. The ceiling is part of the miniature as well. We arranged the boxes and crates in forced perspective—to create a sense of seemingly endless depth, as if the warehouse went on forever. (We were inspired by the final scene in *Raiders of the Lost Ark*, where the Ark of the Covenant is placed in a huge government warehouse.) The biggest boxes in the second set were about 4 to 6 inches tall—about an inch to a foot in scale—and became progressively smaller with increasing distance from the camera.

We shot the main, full-scale visual on an 8x10 Arca-Swiss, with a 300mm lens and Fuji Velvia exposed at $f/22$ to $f/32$. For the miniature, we switched to a 4x5 camera and 90mm lens, combining the two images in post.

Our key light for the main set was a Desisti Fresnel strobe scrimmed off with double nets, positioned on the right about 6 feet high. I had to pop the strobe about eight times to build up an adequate f-stop. Many of the details were edge-lit or highlighted by Speedotron grids. A pencil tube suspended above the set provided a general hard backlight.

We lit the miniature, background set to maintain a feel consistent with the main set. Here, two Speedotron heads came in on the set from the right and scrimmed off the background, while a reflective silver card provided fill on the left side. I took special care to make camera angle and height the same on both sets. The fixtures that look like incandescent lights on the ceiling of the miniature set were actually lit by fiber optics—a subtle touch that gave the set added authenticity.

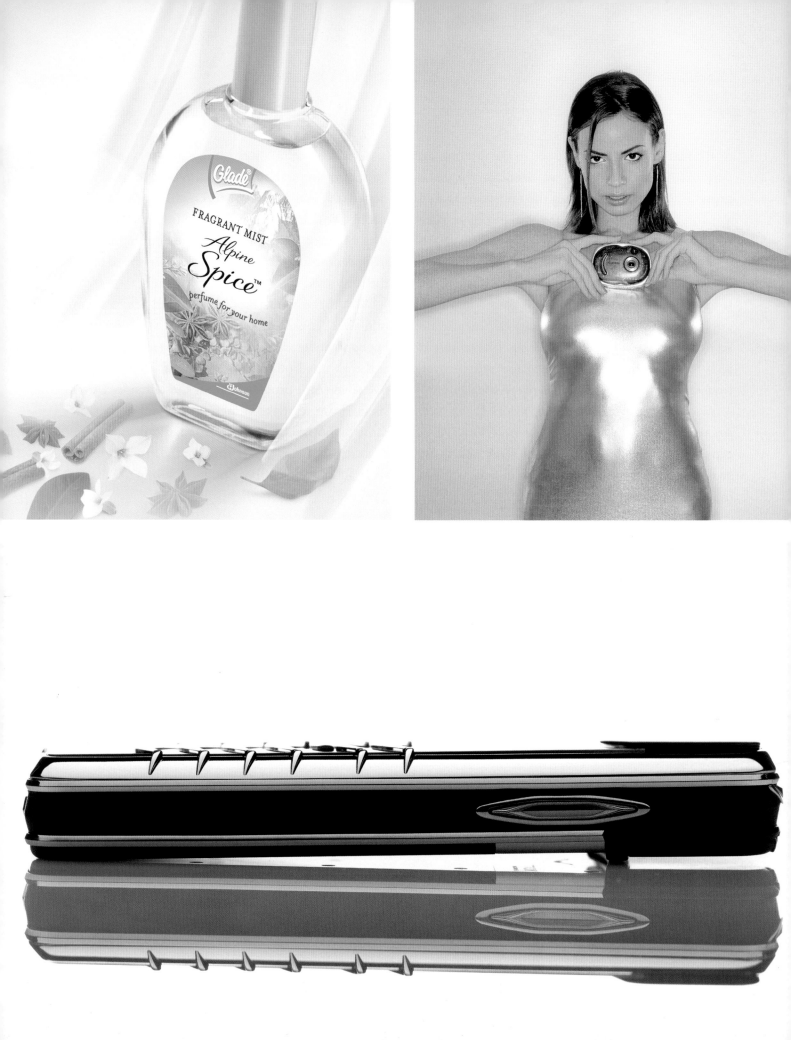

around the house

The challenge of shooting **household products** is to depict these items in a manner that delivers a message succinctly, yet effectively. **Lighting drives** these messages home.

Spencer Jones takes what could be an ordinary picture and raises it to the level of art. At the same time, he has made the chair more inviting, while supporting the high-tech design with a fabricated backdrop and lighting that makes the shot even more intriguing.

PRO TIP The mirrored flooring material we employed is a rear-surfaced reflective material, so we didn't have to contend with the double image normally encountered with typical mirrors—a decided advantage to this material.

I welcome any opportunity to shoot a job where I can express a strong sense of design in a photograph, especially something of a seemingly abstract nature. And this project for a direct mail campaign was just that. I submitted the concept to the client before continuing with the next leg of this assignment.

Coming up with an idea is one thing. We still needed to build a backdrop that would allow the chair to practically disappear against it, while still maintaining the chair's identity. My set designer and I brainstormed to figure out how we would achieve this effect. The solution proved simpler than we'd imagined. We began by purchasing a fairly large number of 8½x11-inch sheets of silver board, then rolled these sheets up into tubes and glued them down in columns. That took care of the backdrop. For flooring material, we used a 4x8-foot plastic mirror sheet, which reflects back the chair legs, along with the bottom row of tubes. In post, we digitally retouched out the visible seam (where backdrop meets floor), for a cleaner flow. This set was raised 2 feet off the ground, with apple crates and a 4x8-foot sheet of plywood supporting it all. To give us the necessary perspective, we employed a Sinar view camera with 210mm lens, shooting on Fuji RTP 64T tungsten. Camera distance to set was 12 feet.

Three feet separated the chair from the backdrop. Lighting all this silver was the principal challenge, especially trying to keep tonal integrity in both the foreground and background. The first and main light was an Arri 2K, with the barndoors on flood. I placed this light on camera front right, 12 feet up and 9 feet away, aiming it at the front of the chair (the side facing to the right). That gave us some nice highlights, but left the rear of the chair fairly dark. To correct this, I added two 1Ks, also on flood—and piggybacked, positioning them behind a 4x4-foot sheet of Rosco Tough Spun so that the light hitting the back of the chair would be enough to bring out tonal detail, without burning anything out. The diffusion screen was 6 feet from the set, with the lights another 2 feet back.

At the same time I realized I still needed to put some light on the background. The solution was to suspend a 650-watt head directly above the chair on a boom, 12 feet up, with barndoors configured to allow some spill on the chair but away from camera. That still left the legs of the chair facing camera underlit. To remedy that, I added a 650 as a kicker, positioning this light about 3 or 4 feet up and 9 feet from the chair.

The mirrored floor added a positive reflection that, together with the specially constructed wall, reinforced the abstract nature of this shot, giving the chair a futuristic look.

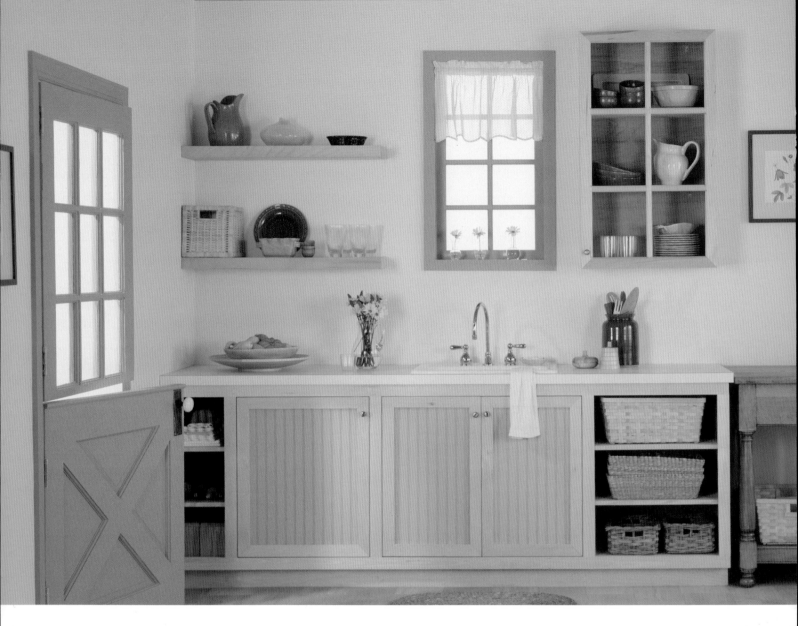

There was a need for speed here, as sets were being photographed while others were under construction or being lit. The only way to succeed in the time allotted was to work with a basic lighting scheme as a template. Still, it took a keen eye to see when that template faltered and to respond accordingly with lighting that lent each space just the right lived-in flavor.

JOB SHEET

USAGE: **Advertising and collateral**

CLIENT: **Behr**

ART DIRECTOR/SET STYLIST: **Michele Adams**

CO-SHOOTER: **Steven Nilsson**

FIRST ASSISTANTS: **Sue Leland and Hai Jun Park**

LIGHTING: **Strobe**

CAPTURE: **Analog**

PHOTOGRAPHS COPYRIGHT ©JENNIFER CHEUNG AND STEVEN NILSSON.

PRO TIP The client often wanted the ceiling painted, which meant lighting that surface as well. Otherwise, we would have bounced light off the ceiling. Using flats allowed us to avoid any hint of a tint that would have resulted from overhead surfaces. We also did some testing with the film in the on-site lab. But we all went into this project accepting that film is not paint; the client understandably made final color corrections in post.

Behr had previously used stock images of interiors, digitally changing the paint colors. However, those images were dated. Now the company was embarking on a paint rebranding campaign and refurbishing its paint centers in the Home Depot outlets, and felt it was time to refurbish images showing company products. The idea was to show multiple paint combinations in a variety of home interior settings—a huge project that involved 63 sets and 250 shots.

We were working to a tight deadline, shooting numerous views of the different settings, both wide and tight shots to cover the various uses. As is often the case on such projects, I teamed up with Steven Nilsson, shooting two sets a day, pre-lighting two more sets, and having an additional two to four sets built as we were shooting. We brought two photo assistants with us to work on this two-month-long project, shooting at a studio in North Carolina.

Behr had already chosen the paint color combinations for each room set. Sometimes the colors were translated into the props. Getting those props, however, was sometimes a problem. The on-site facilities made a big difference. We could buy chairs at thrift shops, and our upholsterers

would refinish them. We could pull a tear sheet of a type of bed or shelving, for example, and the carpenters would build it.

We brought most of our own lighting, namely Dyna-Lite and Norman. We also used the studio's Speedotron packs (in various shots) and had additional, rented gear shipped to us from Samy's in Los Angeles. We primarily shot 4x5, with a combination of 210 (for the two-room shots), 150, and 120mm lenses. (Shots focusing on details often involved 2¼.) The camera, loaded with Kodak E100G, stood at the edge of the set.

Maintaining a consistent feel throughout the campaign was important. The windows were white as part of the branding look, with soft light bouncing into the set as fill. Hard light coming through a window or door added dimension as it raked the wall or floor. For fill we used 8x8-foot V-flats, which doubled as gobos (white inside, black outside), positioned at the edge of each set. Occasionally a plant was placed outside the set.

Often, two sets were right next to each other, so lighting each was a challenge—avoiding spill onto the second set, with very restricted space between

This was one of 63 sets. Given the volume of work on this project, it was necessary to develop a basic lighting scheme as a template so the work could proceed more quickly and efficiently.

Lighting was adapted to each new situation. The guiding principle throughout was to keep the illumination looking as natural as possible. The position of windows and doors often dictated how the shot would be finessed.

the set and a wall. Sometimes we would light one set, then spin the camera around to a second set right off frame, and flip the lights on for that shot.

We used Norman 2000 packs on the kitchen set, which measured 10x12x9 feet. We set up two heads to the right of the set, one near the back, another at the front edge, 75 and 60 inches high, respectively, each bouncing into the corner of our V-flats, each at 400 W/S. In the left front corner, we had an 800 W/S head at 75 inches, also bounced into a V-flat. Each head was fitted with a reflector and diffusion screen, to fill the set with a soft light. Toward the middle of the set on the right we had a 600 W/S diffused head aimed into a white seam-

less behind the door, at an angle to the set, so that it reflected inward—for that clean, airy look outside the house. We added one more diffused head back there, a little lower and tighter in to the set, again aimed at the seamless. But this light does more, sneaking through the crack in the door to cast that shaft of light nearby.

Behind the set we had two more 600 W/S lights at different heights, aimed into white seamless that hung outside the window, behind the plant. The lower light was angled to add definition to the vases on the windowsill.

For the home office set, which measured 10x8x9 feet, we employed Dyna-Lites, beginning with two 250 W/S units, both diffused, with V-flats along the right (similar to the kitchen shot but a bit tighter in to each other). We also had a medium Chimera at camera left, for the center of the room.

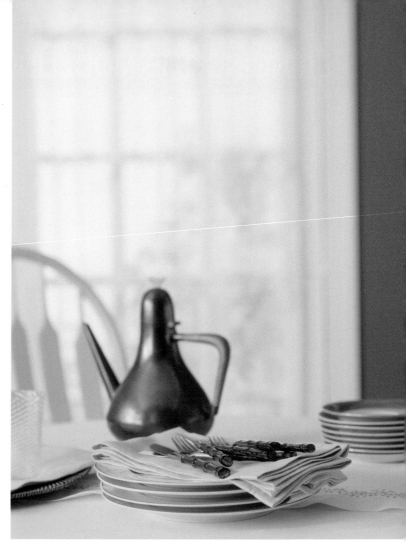

Shots focusing on details such as these settings were often made on 2¼ . Such details had more of a still-life look and feel.

To ensure that we saw white outside, we again bounced two diffused heads into seamless outside the set, flagged on the right. The room still looked a little flat, so we brought in two more lights, both with diffused heads, at 500 W/S, to give the inside of the window added dimension. One light cast a shadow of the plant on the wall nearby, making a world of difference in this shot.

M oshe Katvan knows how to make the ordinary anything but. Here he takes a cosmetic product and imbues it with a dreamy quality. It was not simply a matter of working magic with the lighting, as the view camera had a key role, producing an image that plays with our senses.

Avon wanted a different look for the launch of their Anew cosmetics line, and decided my approach could provide it. The art director supplied a layout and gave me plenty of freedom to create the image my own way. The only direction I got was to do something with a light tonality, against which it would be easy to read the type. This shot was for a double-page catalog spread.

My backdrop began with a 6- to 7-inch-diameter chunk of cut glass from an antique bottle. Using clear tape, I covered the front surface of the glass with several light blue gels, randomly placed around the surface, each ¼ inch to 2 or 3 inches in size. To add texture, I suspended a piece of tracing paper between the glass and the jars from a crossbar and weighted it down with A-clamps. This technique

PRO TIP The basic idea behind this technique is to merge the product with the backdrop, so that one appears to be a natural extension of the other. At the same time, you want to retain the product's integrity—its color, texture, and feel—so people will recognize it.

involves shooting an image inside its own silhouette. Because this would be a two-part exposure, I first covered the backdrop with black velvet to photograph the jars themselves. This kept stray light from hitting the background. When shooting the background, I removed the velvet.

I prepped the set a day in advance, spending between 4 and 5 hours, with an equal amount of time for the actual shoot. For the product in the open jar, we wanted some dimension, and that meant creating a creamy whirl. The only way to achieve this effect was with mayonnaise. With a round wooden dowel, we whipped the mayo until it reached the desired consistency, then pulled the stick out to get the swirl at the top. That gave us the right color and texture, very closely resembling the actual product.

The bottles rested on a raised glass shelf, about 4 feet from the backdrop, with the first light—our main light—directly above them. This light, fitted with a wide dish, had Mylar over it for a softer touch. The second light came from below, to give us a small highlight between the glass and the bottles. The same type of dish was on this light, but this head was powered down to avoid washing out the image. We suspended 8x10-inch silver reflectors

from custom-made lightstands, which we positioned in front of the set and on either side. These added highlights on the right of the bottle, while filling out the left side of the jar, so it separated from the background. We inserted another reflector into the set, to give the middle jar a little edge. This reflector is all the way in the back toward the left edge of the tracing paper, behind the glass shelf.

Like the other lights, our background light was a Speedotron. Here, however, I didn't use the strobe, opting for the bare quartz modeling light and projecting it through the glass and tissue paper. This produced a grainy background. Because I was shooting daylight-balanced film, I taped a color-correction gel to the bare side of the cut glass, which was suspended in front of the light.

For the next stage, we shifted focus (using the front and back standards) away from the product and onto the background, giving us a soft, out-of-focus foreground. We now simply lit the background, so the product was in silhouette. We shot this entirely on one sheet of Kodak EPP, with an 8x10 Toyo and 360mm Schneider lens. Our exposure for the product was $f/45$ at 60 seconds. The background exposure was $f/16$ at 20 seconds.

Two exposures on one sheet of film, for foreground and background, contributed to the picture's soft, dreamy quality.

JOB SHEET

USAGE: **Advertising**

CLIENT: **SC Johnson**

AGENCY: **141 Worldwide**

ART DIRECTOR: **Rob Mulsoff**

FIRST ASSISTANT: **Randy Prow**

LIGHTING: **Strobe**

CAPTURE: **Digital**

PHOTOGRAPHS COPYRIGHT ©SHAPPS PHOTOGRAPHY.

PRO TIP Because we used a spray bottle, I had to remove the central tubing, which could prove a distraction. The level of liquid had to be adjusted to an optimum, ideal height. I also had to remove the back label—achieved with a razor blade and hot water. Because it was a glass bottle, we didn't have to be overly careful about scratches, which would be hidden by the front label anyway.

This set may not have been complex, but it was demanding nonetheless. The props had to recognizably support the product; the color scheme had to be unswerving. Lighting was the thread that held it all together, ensuring that this composite image worked seamlessly.

Normally, I shoot a job and composite the final image myself. Here, I was asked to shoot all the pieces separately and deliver them as individual files. Why? So the client could move the pieces around and finesse the image, then lay down type where it would work best in an advertising insert. I was given a comp as a general guide to the finished piece. We shot digitally (on a Nikon D1X, with 85mm PC lens), which facilitated the entire process.

The client supplied the bottle, complete with label. We shot that as is. However, the client later stripped in a clean label, without halftone patterns. We photographed each category of similar elements as a group, so the client could pick and choose specific leaves, flowers, and spices that best suited the picture from the different clusters. Everything was sitting on white Formica.

The client wanted the look of green light shining through the curtain, to sustain a consistent color scheme. For the foreground color, I had to mark exactly where the bottle was on set, then replace it with a clear bottle bearing no labels—and filled with a solution of green food coloring strong enough to project onto the foreground. We positioned a Speedotron head inside an Altman optical spot (a converted theatrical light) directly behind the bottle. This gave us a very sharply defined, hard light that established green streaks in front of the bottle.

To light the individual plants and cinnamon, I had a Speedotron head fitted with an 11-inch reflector. I placed diffusion material over it and positioned this light 2 feet away, to the left, at a 45-degree angle coming down from the side and slightly in front. There's also a fill card on the opposite side of the

To help support the central theme of the product, props had to be gathered from a shop around the corner and online as well. And that was the easiest part of this job.

lights. In addition, I used a 16x20-inch Plume soft-box 3 feet overhead, also for fill. (I should point out that the client silhouetted the elements to remove the shadows and created the gauzy effect as well.)

The curtain was also a separate shot. To make the curtain look as if it was blowing in the wind around the bottle, we used monofilament to pull the white sheer fabric in different directions to create the folds. We lit the curtain by putting a sheet of white foamcore behind it, with two umbrellas, one on either side in copystand fashion. Then, coming down from above, we had a large Plume softbox with green gel inside to tint the shadows with this color. The curtain you see is actually a composite of several shots of this element.

The soft X pattern in the upper left represents a window frame that the client later made transparent and shadowlike. We shot it out of focus to make it fuzzy, in keeping with the client's needs. The window frame was positioned several feet from the studio's white wall, which was uniformly lit, creating a silhouette pattern. The green in the upper left was taken from the green in front of the bottle and digitally added as a complementary, unifying element.

We used several sources to light the bottle.

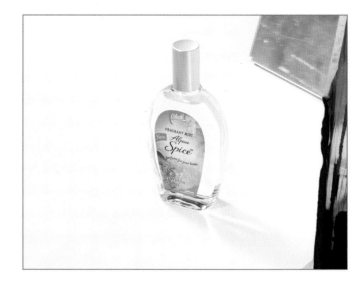

Overall illumination came from a homemade box light, 12 inches tall and 8 inches wide. I use this when lighting small objects, especially highly reflective items such as bottles and cans. It has a Speedotron head behind it, running off a 2400 W/S pack, with a milk-white translucent Plexiglas diffusion baffle—and it can sit flat on a tabletop surface. This light was positioned vertically in front of and to the right of the bottle. Another light came from the back left corner and above, creating that dark edge along the left side of the bottle, giving it dimension.

The shot of the bottle required a couple of mirrors. One was a 4x6-inch mirror leaning against a brick on the surface, at the back right corner, reflecting light back into the bottle and giving us that little highlight on the back right edge. The second mirror illuminated the label itself (this helped the client when it came time to strip in the custom label, by providing a sense of relative brightness). This mirror, coming from the right front, also helped create the vertical highlight down the cap.

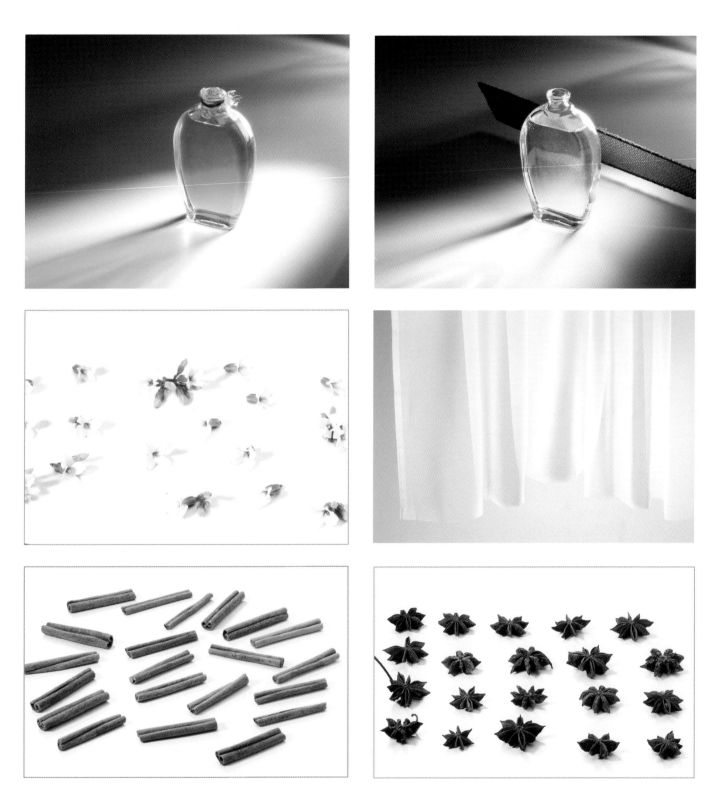

The hero bottle and a green-tinted substitute liquid were not the only ingredients. The curtain shot you see here is only one of several that went into a final composite for this backdrop. The client also selected from the cinnamon sticks and plant parts we shot to give the final composite its alpine flavor.

W hen colorful lights reflect in a shiny countertop, the effect makes you want to take a second look at what, on the surface, is simply a built-in refuse bin.

JOB SHEET

USAGE: **Collateral**

CLIENT: **Franke Sinks**

LIGHTING: **Tungsten**

CAPTURE: **Analog**

PHOTOGRAPH COPYRIGHT ©JOE PELLEGRINI.

The client wanted a flow of color throughout the product catalog, with multicolored backgrounds forming a common thread throughout so that one page would be blue, another green and blue, the next green, and so on. For consistency, we kept the angles pretty much the same across the back, where the surface ends, so the images would flow from one page to the next.

You're looking at a kitchen countertop bin that could be used for trash or recycling, providing a convenient receptacle when clearing the counter. We chose to fill it with bottles and cans of a color that matched the set. One of the other things the client had asked for was a mottled pattern along each surface, to help emphasize the color scheme. We shot this on a Sinar 4x5, with 240mm lens. Film was Kodak 64 tungsten. We had to do four shots a day for two weeks straight to make our deadline for the catalog. For this shot, a set builder cut out a hole in white DuPont Corian for us. The backdrop is gray seamless. The set is 6 feet wide by 6 feet long.

The speckled pattern of color on the back wall comes from two 1K Fresnel tungsten heads in the background—Rosco green on one, blue on the other—each hitting crinkled foil. The darker spots are areas not getting any of the intermingling reflections. These cards are under the set, facing the background. The two 1Ks are at full flood, with barndoors to prevent spill. In addition, we had a 750-watt head overhead, above the center of the set, with diffusion, serving as fill. We didn't want the white countertop to wash out all those colors with too bright a light source, hence the diffusion. This light gave me that soft gradation across the lid.

The diffuser is Rosco Rolux stretched inside a frame and positioned parallel to the surface, 3½ feet above the set and covering it entirely. The light is an additional 3 feet above the diffuser, and practically aimed straight down through it, to get that soft light. All the other lights were right up alongside the edge of the set. I also used a 750 closest to camera. It hit another one of these crinkled silver cards— this one gelled blue, giving us some of the blue light in the countertop. This light has a large snoot, to keep it off other areas. One more 750 hit the bottle on the right side. That one had a snoot, no gels, and came in from the far right of camera, at the lower right-hand corner of the set. We also added a blue-gelled 250-watt light on the right-hand side—that one hit another crinkled silver card and gave me the blue where the sardine can is on the countertop.

Finally, we had a 250 head hitting inside the refuse bin, just to kick some light around in there. This light came off a boom arm and was right up against the top of the frame holding the Rosco Rolux diffusion material.

The use of colorful lighting gave an otherwise mundane kitchen accessory real consumer appeal.

The use of colorful lighting (in the shot discussed in the preceding pages) gave an otherwise mundane kitchen accessory real consumer appeal.

COURTESY JOE PELLEGRINI.

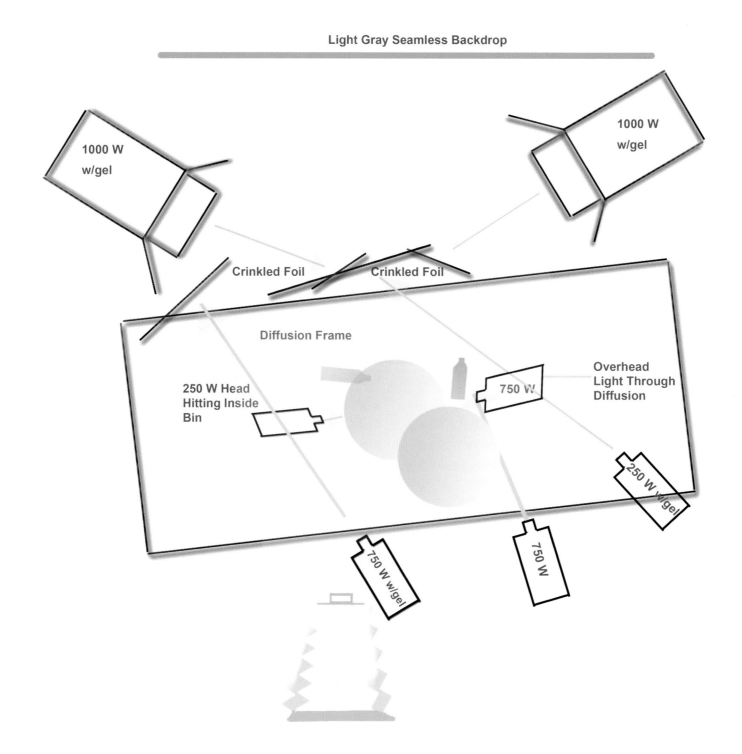

Light Gray Seamless Backdrop

1000 W w/gel

1000 W w/gel

Crinkled Foil

Crinkled Foil

Diffusion Frame

250 W Head Hitting Inside Bin

750 W

Overhead Light Through Diffusion

250 W w/gel

750 W w/gel

750 W

JOB SHEET

USAGE: **Collateral**
CLIENT: **Franke Sinks**
CREATIVE DIRECTOR: **Chrys Mochel (Intermark)**
DESIGNER: **Kim Larson (Larson-Marvine)**
LIGHTING: **Tungsten**
CAPTURE: **Analog**
PHOTOGRAPH COPYRIGHT ©JOE PELLEGRINI.

The client provided the faucet—the featured item, along with the countertop and sink. We designed the glass backdrop to give the shot a really clean look, in sync with the feel of pure water, a key selling point for this faucet and the water purification system it employs. I had two assistants on this shot, which was made with a Sinar 4x5 and 240mm lens, on EPY 64T. I added a CC05R for color correction with this film, for an ƒ/16 ⅓ exposure at 1 second. We began with a 1K Baby Mole Fresnel bounced into a white seamless sweep that stood behind the backdrop. I positioned this head low to the ground, from the right, several feet from the sweep, at a 45-degree angle—and pointed toward the middle for a gradated effect, as if from a nearby window. I aimed another Baby (all Baby Moles had barndoors) at a glancing angle into the glass blocks themselves, for those specular highlights. I added yet another Baby, to flood a 4x4-foot diffusion frame that we constructed, for that highlight along the left side of the fixture. Next I positioned a 3x4-foot diffusion frame (on the sink surface to the right of the fixture) in front of a 650-watt Tweenie with barndoors—for the highlight on the nozzle and along the front edge of the faucet. I then added two 200-watt MiniMoles, each with a small snoot, from the right. One is pointed at the faucet, just to kick up the sheen a little bit; the other at the dark countertop. I poked a hole in the first diffusion frame to make room for a MiniMole fitted with a small snoot so it would hit the glass and give it some distinctive highlights, spilling over onto the tablets. Unwanted reflections in the sink bowl were a problem. To remedy that I lined the front of the bowl with brushed silver to kick back light from the diffusion screen on the left. That gave us our nice, clean wash of white along the back.

JOB SHEET

USAGE: **Advertising**

CLIENT: **Samsung**

AGENCY: **Centerpoint Design, NYC**

CREATIVE DIRECTOR: **Jean Shin**

ART DIRECTOR: **Shanley Jue**

WARDROBE STYLIST: **Kellen Whiteman**

HAIR AND MAKEUP: **Amanda Redgrave**

DIGITAL ARTIST: **Kevin Goggin**

LIGHTING: **Strobe**

CAPTURE: **Analog**

PHOTOGRAPHS COPYRIGHT ©ROB VAN PETTEN.

PRO TIP The reason for my back-to-back lighting setup? It allowed me to control a concentrated spot on the model's face—heating up the facial features and making the shadows a bit stronger, with added contrast. Moreover, if you have the two heads plugged into separate channels on your pack, you can ratio the two and really finesse the light quality.

This advertorial used multiple shots to tell a story, imaginatively and with futuristic overtones. The story maintains a playful atmosphere, and, since one frame forms a jumping off point for another shot, the lighting had to be cool and consistent throughout.

As the concept came together for this Samsung consumer advertorial, I realized that we didn't need an elaborate space; on top of which, the time crunch didn't really allow us the luxury of location scouting. After examining all our options, I mentioned to the art director that my studio would be perfectly suitable. He agreed, adding that we wouldn't be using any furnishings in this shoot. The pictures had to reflect the high-tech, almost "cyber" quality of the items. The lack of furniture was designed to mirror the simplicity of living in a new age of electronics.

In keeping with the futuristic aspects of the shot, I directed my stylist to find outfits with a metallic sheen, especially for the female model. This would also work to bounce back a lot of light, adding to the cyber look. We had two assistants on

this job, which was shot in one day. The art director remained on set for the duration, approving Polaroids as we progressed.

I used a Hasselblad ELX with an 80mm lens for the first shot under discussion (the one with the TV, which was actually the third in the series). My film was Fuji 64T—we exposed five rolls for each of the four shots. I chose this emulsion for its bluer blues with daylight-balanced lighting. That said, I had to selectively employ deep blue filters to accent various aspects of each picture. Exposure was $f/8$ at $\frac{1}{125}$.

My key light consisted of two lights positioned back-to-back and attached to a boom. I aimed one, a 125 W/S Dyna-Lite, into a 36-inch, white-surface umbrella, which bounced light back onto the young woman. Attached to the same bracket but immediately behind the first light, so that this head

Strobe lighting on tungsten film, combined with a selective use of blue gels, enhanced the metallic blue feel in this cyber-age tale.

is aimed directly at her, is another 125 W/S head, with a 10-inch reflector and barndoors. This light was diffused so as not to overpower the umbrella. These lights stood to my right, 52 inches from the model, at a height of 6 feet, and fairly tight in to the camera, to produce a somewhat even wash of light from the umbrella. Both lights ran off the same powerpack, while each of the other lights ran off separate packs.

A 4x8-foot foamcore reflector on the floor to the left side of the set, angled slightly inward toward the woman, produced highlights on her clothing while adding fill to her face and right arm. The edge of the board stood just shy of the male model, so it didn't affect him. The next light created the hot area on the backdrop. I positioned a 250 W/S head with a snoot and a heavy magenta gel behind the TV, aiming it squarely at the studio's white brick wall. This gave us separation, while providing subtle color contrast. The TV was 8 feet from the wall, with the background light midway.

I added a 125 W/S light with barndoors and a deep blue gel at a height of 6 feet. This light came off the corner of the TV from the back of the set and to the right, hitting the right side of the woman and upper torso of the recumbent man. This also added contouring along the side of the female model's right arm, adding depth. Equally important, I used this light to simulate the glow from the monitor on the man. The monitor was a non-working prop. We added the on-screen image in Photoshop.

The screen shot came from the second picture in this series. I simply extracted a cropped section with the male model's head photographed against a glass block wall. Lighting for the full-frame image (shown above) began with the girl. I used my combination key light (umbrella plus diffused head, as described earlier) so that it came in fairly on axis from the left. On the opposite side, I added another 125 W/S dif-

The story continues with this shot, except that a portion of it was also used for the TV screen image in the previous picture.

fused head with blue gel. For the man, we had one 125 W/S blue-gelled head positioned far right. A 250 W/S head, bounced off a rear wall behind the glass blocks, provided fill.

For the cover shot in the series (the young woman alone), we aimed for an edgy, super-cyber look, to set the stage for our cyber tale. Here, I fitted my Hasselblad with a 150mm Schneider T★ lens. It provides better perspective than an 80 when you're working with one person. More importantly, I wanted to use a Flash Clinic ringflash that had been custom-fitted to this lens years ago. This Ascor QC-8 ringlight was about 8 inches in diameter and set at 800 W/S, giving me an $f/11$ exposure. By tipping the model's head down and keeping the modeling lamp on, we avoided red-eye from the ringlight on axis with her face.

The ringlighting gave us the circular catch-lights in the dress, along with a subtle halo-like shadow surrounding the camera she's holding. Flash-to-model distance was 6 feet, and she was 2 feet from a sheet-metal backdrop, which reinforced the futuristic theme. The vertical glow on the metal came from this same light. We further directed two 125 W/S edge lights at her, at about a 35-degree angle from behind, level with her face, 5 feet away on either side. We fitted these with 10-inch reflectors, diffusion, barndoors—and again, for that blue accent along her arms and sides of her dress, heavy blue gels.

Her hair was wet and very black. The ringflash failed to bring that out, which meant I needed a fairly hard light to emphasize the hair texture. So I added a boom light (also at 125 W/S and similarly accessorized), suspending it 3 feet above her head and practically against the wall behind her.

A ringflash highlighted the metallic quality in both the dress and the backdrop for the cover shot in our futuristic fable.

personal vision

"Promotion is moving away from the print book and toward the website. Direct mail is very important. Most important is a personal relationship. Find a way to get to talk to the people you want to work for. Send them a really nice print and then ask them to give you five minutes of their time. And that's really where I make inroads, I think, through personal contact, and showing a personal interest."

W hen a high-tech cell phone was introduced to a choice clientele, the photograph had to reflect the polish and sophistication that went into designing and fine-tuning the instrument. The lighting had to be subtle, bringing out the phone's stylish curves and fine lines.

"Just enjoy yourself and try to make it look beautiful" was what I was told when handed this assignment. That would not be difficult, as graceful lines and a slender profile lend this subject an almost flutelike appearance. Vertu Americas, a subsidiary of Nokia, had launched a worldwide campaign to promote this new, exclusive cellular phone. Designed for a very discriminating clientele, this device was made of platinum and incorporated the highest-grade components available. I was given a

prototype of this gleaming, 5-inch-long phone for the shoot.

This was the first shot in a two-week project. While I had creative carte blanche, the client did want the shot to be simple and elegant, while emphasizing certain angles and features. The client also wanted lots of open space, not for type, but to let the phone "speak" for itself. We shot this phone in every possible way—horizontal and vertical; with different lighting; varying focus; and against

JOB SHEET

USAGE: **Advertising**

CLIENT: **Vertu Americas/Nokia**

CREATIVE DIRECTORS: **Sheldon Phillips and Tara Carson**

FIRST ASSISTANT: **Anthony Chiapetta**

LIGHTING: **Strobe**

CAPTURE: **Analog**

PHOTOGRAPH COPYRIGHT ©THIERRY BEARZATTO.

different backdrops: first white, then black. A clean white background was vital to this rendition. So was controlling the value of the reflections. The trickiest part in shooting a reflective item against white is managing to hold every detail. We used numerous flags to achieve that.

Our backdrop began with a 4x8-foot sheet of milk-white Plexiglas. A 9-foot-wide white seamless sweeps out from behind and underneath. The table-top was 4 feet high. My Sinar p with a 150mm Schneider, loaded with 4x5 Fuji Provia, was no more than 2 feet from the subject, just high enough to peek over onto the set. My Speedotron heads each ran off individual 2400 W/S packs, except for one head that ran off a 1200 W/S power supply. I began with three backlights, aimed through individual silks and fitted with 11-inch reflectors. Two were positioned left and right, with one centered higher. All bounced into the sweep at the back, producing a wash of pure white. These lights were filtered with ¼ CTB to bring them to 5100K, thereby countering the film's color balance and the warming effect of the silk.

I had a white card above and just in front of the phone, at an angle, with a 3-degree grid spot bouncing off it, at 1200 W/S. This light came in from the right at a fair distance (platinum picks up everything) and feathered off the right side of the card, to produce that white gradating value along the front of the phone. The card was 2 feet long by 1½ feet wide—large enough to cover the phone, especially the curved ends.

When we shot the first Polaroid, the reflection on the Plexi from the phone wasn't bright enough. So I added a 10-degree grid to make it brighter, bouncing it off the center of the sweep at the base, where it starts to curve upward. The flags were among the first things on set, to deal with all the reflections in the platinum. A narrow black flag about 2 feet behind the phone and just above it pulled light off the back of the keys. It also goboed light away from the lens, with other cards around the lens further preventing flare. Two vertical black flags supported that horizontal flag, each angled slightly in toward the phone, again pulling light away.

Giving this ultra-chic platinum cell phone the melodious tones of a flute required subtle placement of lights, bounce cards, and flags.

How do you take a product that is very staid in appearance and make it exciting? Lighting would play a pivotal role in giving this product as much punch and specularity as possible, thereby instilling the shot with a fresh, vibrant look.

For this national ad campaign, the client wanted to show the product cradled in a fluid environment, with a hint of action in the liquid. Beyond that, we could do what we wanted. I'd calculated that shooting down at the product in a tank of water would give us the most interesting shot.

This is a single capture on a Leaf 22 back attached to a Contax 645, with 120mm macro lens. Camera-to-set distance was 3 feet. We wanted

PRO TIP Controlling water flow was key to the success of the shot. An assistant manually controlled a hand-operated aluminum piston pump, which let us vary force and pressure to see what worked best. The same assistant worked the pump throughout the shoot because hand-pumping is a matter of feel: You get into a rhythm.

JOB SHEET

USAGE: **Advertising**

CLIENT: **Neutrogena**

AGENCY: **Carlson & Partners**

ART DIRECTOR: **Yeweng Wong**

FIRST ASSISTANT: **Tony Gale**

LIGHTING: **Strobe**

CAPTURE: **Digital**

PHOTOGRAPH COPYRIGHT ©DAVID ZIMMERMAN.

PRO TIP With any liquid set like this, we typically start testing with a sheet of transparent Plexiglas covering the camera, because we don't know exactly how far the water will reach or when it will splash outward. Once we see that water isn't getting to the camera, we remove the Plexiglas for the final shots.

PRO TIP We built the set here in the studio, after spending the better part of a day on the design, based on the layout and practical considerations, and doing preliminary testing. We devoted another day to tank construction and rigging, along with building the surrounding set.

water coming from beneath the product, so we drilled a hole in a transparent Plexiglas tank that we set up and ran transparent tubes though the bottom to get water shooting up. This resulted in the liquid hitting the back of the bottle and exploding off it. The tank is about 2x2 feet, supported a few feet above the ground.

The product itself is a solid acrylic model that was built by the agency's model builder. To obscure rigging and tubes under the tank, we painted the back of the product white so that it simply reflected its own amber color. A translucent deflector, to control water flow, stuck out from the side of the product. You don't see it, because the water disguises everything surrounding the product. The product is on a flexible wire so that we could change its angle, or remove it entirely to clean or replace it.

The background underneath the tank is solid white, for a reason: The art director wanted splashes of amber surrounding the product, so we cut one-inch-wide strips of amber gels and laid them out on the white background in a manner that would give it a more realistic feel. Where necessary, we removed strips to maintain the integrity of the watery reflections. Water does a great job at disguising and diffusing detail, so you don't see the strips, just a stippled background pattern. And water will give you white, gray, and black tonalities if it's rippling, as here.

The main light was an Ascor barebulb strobe, for as much sunlight-like specularity as possible. Flash duration is about $\frac{1}{4500}$ sec. I have 8000 watt-seconds coming out of this head, which is capable of outputting 40,000 W/S in a single pop. This light is above and to the left of the set, 4 feet away. To fill shadows we used another Ascor head, but with a 12-inch reflector and diffused with Rosco Tough Spun. This light hit the set from the upper right, at a 45-degree angle downward, from a couple of feet away.

The background lights were a pair of diffused 12-inch Ascor heads positioned behind the set and low, bouncing off milk-white Plexiglas back up toward the set. A piece of aluminum sheeting in the front served as fill, to give us a little highlight at the bottom of the product. Black foil around the outside of the tank reflected the black tones back into the shot. We used only bottled water, for its clarity. We used gallons of water, changing it when any dust or tone noticeably built up in the liquid.

The simple, clean look of this shot belies the complexity of the set and lighting that went into it.

JOB SHEET

USAGE: **Collateral**

CLIENT: **Alza Pharmaceuticals**

AGENCY: **Girgenti Hughes, NY**

ART DIRECTOR: **Steve Frederick**

DIGITAL ARTIST: **Michael Weiss (Michael Weiss Photography, Mt. Kisco)**

FIRST ASSISTANT: **Ward Yoshimoto**

LIGHTING: **Strobe**

CAPTURE: **Analog**

PHOTOGRAPHS COPYRIGHT ©CHRIS VINCENT.

We rarely see ads in which the product does not appear in the featured shot. In lieu of showing this product, Chris Vincent illustrated the problem the client's medication would address through the use of fast lights and a sharp eye.

The roiling waves in a crystal sphere represent the agitated state that the client's new incontinence medication would alleviate. The shot, based on a design provided by the art director, would be featured in sales brochures for this pharmaceutical product.

This digital composite has two key components: the water and the crystal ball. Setup and shooting took two days in the studio, with a total of four assistants, two for each phase. I used a 14-inch-diameter clear glass vase, knowing a 6-inch crystal sphere would replace this first container in the final image. The vase was open at the top, to allow the inflow of water, and held in place with epoxy on a base that we added. Creating the wave motion within this vase would be the tough part. We used a valve to control the flow of water through tubing held above the opening of the vase. The height of the tube and amount of water determined the degree of agitation as the water streamed down into the container. When released, the water tripped an electric eye from a Dale Beam, with a $\frac{1}{300}$-second delay—just enough time so that we would catch the splash at its apex. This shot determined the shape of the water motion, so the image could be believably composited inside the crystal ball. The apparatus we devised had the ability to rock the container, to give us a swishing movement in the base of the image—for our main body of water. We shot this separately, with identical lighting as used with the splash. This step was needed because the client felt that too much agitated movement would have an unsettling effect, proving counterproductive to the message they wanted to convey.

The sloshing water and crystal sphere were photographed separately, then composited. The toughest part of the job was controlling the flow of water to get just the right wave motion.

We set up a Toyo 4x5 with 210mm Schneider lens, aimed squarely at the subject, at a distance of 4 feet. The film was Ektachrome 6117 (64 daylight). The lens was set to $f/45$, with the shutter on T ("Time"). In all, we would expose 150 sheets on the water and 100 sheets on the crystal ball.

Capturing the movement with stop-action precision required high-speed strobes, so we rented Broncolor Pulso A2 packs for this phase of the shoot. Each light ran off its own pack.

We shot the water with white light coming from behind, to create good contrast and give us dark edges and bright highlights in the middle. The background light was the first light up, on a C-stand, at full power, 4 feet up, and dead center behind the vase. We positioned a 3x6-foot diffusion screen 3 feet in front of the head and 6 feet from the set to produce the hot spot on the center of the screen and create the desired contrast. The second light added specular highlights to the water and came in from the left and behind, at about a 45-degree angle, 8 feet up and 9 feet from the set. This head was at half-power, with a grid.

When you get a really snappy image of the water from the background light, you want to hold it, but you may need to adjust the contrast of the overall shot by bleeding a front head into it and reducing the black in the liquid. That's what we did with the third head, at one-quarter power, 5 feet from the set, 6 feet up, and coming in from the right front corner.

We shot about 10 variations of the crystal ball, with different backgrounds and on a separate set. Here, we switched to Speedotrons, again with each light on its own pack. A pinpoint amount of tacky wax held the small sphere steady on the level portion of a 4x8-foot brushed stainless steel Formica sweep. The camera was 6 feet away.

To render the backdrop blue, we gelled our background light with a Rosco 80 (deep blue). Coming in from a frontal angle to the right of the sweep, this head hit the top of the sweep and reflected into the top of the globe. The second light was fairly close to the top of the sweep, creating a white highlight in the top right corner behind the crystal ball. We added a grid to prevent spill.

Another light prevented falloff on the left-hand side. I added a 4x8-foot diffusion screen, with two blue-gelled heads on low power behind it, for uniform fill, thereby ensuring that the whole surface went blue. The heads were 8 feet from the set, with the screen positioned midway, slightly above axis, and extending behind the subject. We used a compendium bellows lens shade to prevent flare, adding flags where necessary. The shadows and highlights in the lower left are from the blue backlight. In digital retouching, we added highlights and shadows to the sphere, to give it a sense of roundness and volume, and most importantly, to make it more substantive and give it more presence.

Each piece of film represents one additional stage leading toward the final composite.

fashion and jewelry

In our **fashion statement**, every nuance, every layer, every sparkle is exactly where it should be, all brought to the fore with diligent attention to the **lighting** and the **subject**.

You might say that taking this route was a tough call, unless you knew the brand name on these resilient jeans. The film-noir lighting supported the dramatic intent of the shot.

Comps give the photographer a visual sense of what the art director is looking for. Sometimes the photographer, not the art director, provides the sketches; other times it's a collaborative effort. In this instance, the art director brought three scenarios to the table, one of which is shown below. That set the tone for the shot.

COURTESY DAVID ALLAN BRANDT.

I t's "a tough world out there," Tough Jeans. That was the headline. The shot was violent, disturbing, even shocking—designed to grab you. Set lighting aimed for a brooding sense of menace . . . everywhere but on the product, which had its own lighting plan.

JOB SHEET

USAGE: **Advertising**

CLIENT: **Tough Jeans**

AGENCY: **Live/China (Hong Kong)**

ART DIRECTOR: **Tim Ying**

CREATIVE DIRECTOR: **Kinson Chan**

FIRST ASSISTANT: **Peter Breza**

LIGHTING: **Strobe**

CAPTURE: **Analog**

PHOTOGRAPH COPYRIGHT ©DAVID ALLAN BRANDT.

PRO TIP Casting is always a big part of any shoot. I'm always looking for somebody who's going to give you what you want. I was pretty detailed in describing to the models we were looking at what we were trying to do, going to the extent of showing them the layouts. We had to apply the same sensibilities as we would if we were casting for a film, even though these were not actors. By the time this model came to the shoot, he knew what to expect. By the time he got in front of the camera, after hours of makeup, he was in character.

The art director brought us three scenarios. Each involved a different weapon—to show how tough these jeans were. The concept was influenced, to a degree, by the Quentin Tarantino film *Kill Bill*.

Each shot showed the same model, wearing different jeans, for national magazine ads and outdoor displays, targeted for the Asian and European markets. This scene involved a young man wearing a tattered, rain-drenched poncho, which we imagine got torn up in a fight, while the jeans survived the night with no more than a wrinkle, if even that.

Depicting this situation called for more than a makeup person. While a wardrobe stylist brought in the poncho, a Hollywood special-effects artist came in to apply makeup and "scars." The weapons came from a local specialty shop in L.A. We took a lot of painstaking care in making the jeans look as if they fit into the shot but still looked like the product.

The backdrop is my studio wall, painted gray with streaks to suggest heavy rain or just urban grime. The model stood 10 feet from the backdrop, with the camera 7 or 8 feet from him. For dramatic effect, we shot upward, on a Hasselblad 503CW fitted with 80mm lens. Film was Fujicolor NPZ 800. I prefer negative film, particularly a high-speed emulsion, for the grain. I delivered prints to the client.

Our lighting emphasized physique, not the face, so we let the model's features go in shadow, adding more menace. The first light was the key lighting for the body, defining contours. This was a medium Chimera coming from almost directly overhead, off a boom 3 feet above his head. To give us just a hint of the facial features, we had one head on a C-stand, 6 feet high, coming from in front of the model, with a fine grid. This light was dimmed down and gelled blue for effect.

The garment looked partly stonewashed, with light areas on it, but was still too dark with only the key light. So we added two more lights, aimed at the legs, to give us detail. Each head had a grid, and came in on the jeans from above and to the right of camera, focusing on different areas. In positioning these lights, we had to be careful to maintain the integrity of the main light from overhead, so it wouldn't look as if we had multiple light sources.

Finally, we used two medium Chimera banks sharing one Norman 2000 W/S pack dialed down very low, one from each side, hitting the backdrop. All the other lights ran off their own 2000 W/S packs.

On the face of it, the job seems simple enough—until you stop to consider that each facet of this uncut diamond, among the largest stones of its kind, poses a stumbling block, and each has to be captured with clarity and detail. Lighting was tricky, yet simple enough in the right hands.

PRO TIP A major difficulty in shooting the diamond was coping with dust on set—and on the diamond (static electricity from the gem makes it a dust magnet). You don't see the dust until you magnify the photographs. We used an air compressor to get the set completely dust-free, and an ionizing brush to clean dust off the rock itself.

JOB SHEET

USAGE: **Advertising and collateral**
CLIENT: **Bruce Museum of Arts and Science (Greenwich, CT)**
ART DIRECTOR: **Carolyn Rose Rebbert, Curator of Science**
LIGHTING: **Tungsten and light painting**
CAPTURE: **Digital**
PHOTOGRAPH COPYRIGHT ©DENIS FINNIN.

PRO TIP We used a white Plexiglas surface for its reflectivity to make the bottom half of the photograph more interesting. Falloff gave us the gradation, with the studio totally dark behind the gem.

The science curator at the Bruce Museum in Greenwich, Connecticut, was planning a show on gems and minerals. We'd worked together before, so she contacted me to shoot promotional pictures, which were also used in the catalog and on the invitation to the exhibit opening. This is the Arkansas Diamond, one of the world's largest natural uncut, unadulterated diamonds—maybe a half-inch high. A key to the assignment was to show all of the rock's facets.

The curator came to our studio for the shoot. We shot digital so she could approve pictures on set and return with the images on CD. Our camera was a Mamiya RZ67, with a Phase One Studio Kit scanning back. To get really tight we added two extension rings to the normal lens. ISO equivalent was 400, because the shot required considerable light.

To make the rock stand upright, I attached a thin wire tipped with tacky wax to the center of the stone from behind. We precisely centered the optical axis in front of the diamond, enabling us to see all its facets—and keep you from seeing the wire behind. (Look carefully, and you'll detect a bit of clouding from the wax showing through. The "chocolate center" is the natural color of the uncut stone.)

The difficulties revolved around the diamond's high reflectivity, and the fact that it would not stand on its own. The scientists were especially concerned that we bring out the surface imperfections, which look like craters.

We began our lighting with one Photogenic 125-watt MiniSpot coming straight down from 1½ to 2 feet overhead, creating the circle of white light around the base on the Plexiglas. A diffusion screen underneath that head softens the light and reduces the glare in the surface of the stone.

At camera left, a fiber-optic wand comes down at about a 45-degree angle, to bring out the curve in the stone (which is highlighted), plus the two facets on the side facing camera. You can see the shadow from that light to the right. One reason we kept the shadow was to throw off symmetry in the lighting, adding tension to the photograph. This also brings out some facets more than others, lending the image greater three-dimensionality. As a bonus, the fiber-optic beam refracts inside the diamond and comes out in different areas.

The lower region of the stone was too dark with just the top light. So we added two silver cards—one on each side at the front, at a 45-degree angle, aimed at the diamond's base. The two highlights on the downward-facing facets come from that.

The dark edge was blending into the background on the right. To remedy this, I added one more light at camera right, fairly far back, creating a spectral highlight on the top right-hand side of the diamond, giving it added presence.

JOB SHEET

USAGE: **Advertising**

CLIENT: **Capezio**

AGENCY: **HardHats**

ART DIRECTOR: **Suzan Ting**

CREATIVE DIRECTOR: **Evelyne Gaidot**

HAIR & MAKEUP: **Susan Schectar**

FIRST ASSISTANT: **Jack Deaso**

LIGHTING: **Strobe**

CAPTURE: **Analog**

PHOTOGRAPHS COPYRIGHT ©LOIS GREENFIELD.

PRO TIP When photographing this kind of movement, I pick an area on the cyclorama floor where the lighting is optimal, and I prefocus there, making sure the dancers don't stray too far from that spot. That also means we don't have to light a wide space.

Lois Greenfield has the unique ability to combine fashion with the art of the dance, paying tribute to both. The subject of this shoot was the shoes, and any degree of blur was out of the question. So a well-practiced eye and hand, combined with lightning-fast strobes, came to the fore to capture these moments. And, contrary to all appearances, nothing was left up in the air.

The client was Capezio, a dance apparel and footwear company, and the agency explained the look they wanted by pulling out my book *Airborne* (1998, Chronicle Books). They pointed to several photographs that conveyed the kind of feeling, look, and energy they wanted in this campaign. The shots would be used in consumer ads, billboards, and elsewhere.

The agency specified the shots should be black and white, explaining that the ads would juxtapose two images, a close-up portrait of one of our models against an action shot of dancers in motion. In the shot you see here, we're not calling attention to the shoes. The point is about being the dancer wearing the shoes, what the shoes allow you to do. That notwithstanding, we knew it was critically important to capture the feet tack-sharp—without any blurring—and our lighting would play a pivotal role in achieving that.

Our talent came from several sources, all but one based in New York City: Parson's Dance Company; the Hubbard Street Dance (Chicago), which happened to be in town then; AntiGravity; and the Lyons Group. I judged the dancers and models based on their ability to move in dance form, along with their expressiveness and athleticism (all, of course, subject to agency and client approval).

Action-stopping lighting and tight control of the situation helped in capturing dancers dramatically suspended in midair, with a dramatic flair.

I especially wanted intense-looking people, and to bring out their intensity I chose the Broncolor Satellite Soft light. This reflector lends a dramatic, defined character to these shots, giving the faces a chiseled look, and it works equally well for one or two people.

I shot this with a Hasselblad 500C/M, fitted with a 120mm lens. Exposure was $f/5.6\frac{1}{2}$ to $f/8$, at $\frac{1}{250}$, on Kodak Plus-X. We shot 95 rolls, 120-format, over three-and-a-half days, covering the entire campaign with many different ads.

We alluded to different dance styles through the dancers' movements, verifying with Capezio's Marketing Director, Kim Robinson, that the foot

PRO TIP For shots involving jumps, we cushioned the floor of our cyclorama with gym mats. The cyc was originally custom-built to be dancer-friendly, with its wooden floor dampened to absorb shock and soften the impact of landing. Knowing it would take a considerable beating, we had the floor surfaced in epoxy to reduce maintenance.

positions were appropriate for the dance style. I directed the dancers' movements, guiding them toward specific positions and postures that they should assume while in the air. By the way, everyone's jumping—that's the theme, except the tap and break-dancers.

As I've said, avoiding blur in key body parts was crucial. In the past, using different lighting, we found that trying to stop very quick action up in the air, even at $\frac{1}{250}$ or $\frac{1}{500}$ sec., still produced some blur. With the Broncolor system employed on this job, we set the flash duration to $\frac{1}{2000}$ sec., so the actual instant of exposure is far smaller than the shutter speed. That's what made the critical difference in getting sharp feet and hands.

A Broncolor bitube head with Satellite Soft reflector attached was the key light, running off two Broncolor Grafit A2 packs for a total of 3200 W/S. This light was positioned at a 45-degree angle from the front, camera left, at a height of 8½ feet, and 8 feet from the subject. We had to be flexible with this light, moving it to a slightly more frontal position in scenes with more than one person, to avoid one dancer casting a shadow on the other. The relative position of camera to subject was 20 feet; subject to back wall, 15 feet. Two white V-flats formed a three-sided enclosure (back and sides) around this light, to catch some of the spill and kick it back onto the set.

Each of the remaining lights was on a separate 1600 W/S powerpack, beginning with a 44-inch white Photek umbrella, serving as a kicker light.

Solo performances were also captured as components that the client would later composite into the shot, in the foreground.

Powered down, this light came in from the left side, practically on axis, at a height of 5 feet.

Our cyclorama measured 16 feet high, by 22 feet wide, by 27 feet deep. We lit the white cyc at very low power, positioning one diffused head on the left so that the wall gradated in shades of gray. That background had to be a midtone so that subject tonalities would stand out against it for a black-and-white shot. This light was goboed off to prevent spill onto the backs of the dancers. We also added two 4x8-foot black V-flats on the right side of the set, to draw off some of the light from our subjects.

personal vision

"In this photograph I take a completely opposite approach to the way I usually photograph my dancers. Rather then showing their streamlined bodies in dynamic movement, I decided to confine them in fabric that would not only immobilize them but obscure their bodies, and turn them into a graphic design."

PHOTOGRAPH COPYRIGHT ©LOIS GREENFIELD.

Fabrics gracefully caressing and flowing from the form of the model in a gravity-defying liquid environment are all rendered so delicately, so fluidly. They make us question what we're actually seeing. All this would not happen without years of experience and a very deft approach to lighting.

The art director had seen my book *Water Dance*, which showcased my work with dancers underwater, and wanted a similar look for a national magazine ad campaign for the client's new ISO hair-care product line. The client specifically wanted to convey the impression that these products are a health-conscious alternative to competitive products.

We set up the pool with a black cloth backdrop, draping it over the pool edge, weighing it down, and stretching it over PVC tubing to keep it flat. Throughout the shoot, I handheld the camera, a Nikonos with a

PRO TIP We chose four models for this job. I had to be in the pool for at least 8 to 10 hours. But we couldn't keep a model in the water that long. We alternated models about every half hour to keep them refreshed. The models did not use any breathing apparatus or goggles, and came up for air often. That's when I gave them directions. Underwater, a weight belt helped me hold my position, while the model was free to move.

JOB SHEET

JOB SHEET
USAGE: **Advertising**
CLIENT: **Helene Curtis**
AGENCY: **Cramer-Krasselt**
ART DIRECTOR: **John Marin**
LIGHTING: **Strobe**
CAPTURE: **Analog**
PHOTOGRAPH COPYRIGHT ©SCHATZ/ORNSTEIN.

PRO TIP After gelling the lights, here's a trick I use to control color while shooting underwater: I vary the camera distance to the subject to enhance or reduce the color saturation. The closer I am, the more the color is saturated; the farther away, the more muted the tones.

20–35mm zoom lens, occasionally shifting position for a different angle.

For safety, we couldn't have our lighting in the same room with the water, and this facility provided a way around that. Behind one end of the deck is a huge glass window (to the left); behind that, a large empty room, where I could set up my lights.

We positioned four strobe heads, totaling 10,000 W/S of flash power, off four individual packs. The heads were right up against the glass, in a row, about a foot apart. On its way to the water, light bounced into the room, off the walls, then into a horizontal 20x20-foot silkscreen diffuser secured to the walls by hooks—parallel to the surface of the pool and 5 feet overhead. We triggered the strobes by radio remote, using a special waterproof wire hookup. All those watt-seconds were needed because I lose perhaps 80 percent of the light as it hits the water.

To determine exposure, I put a light meter in a waterproof bag, then measured the flash underwater. I also shot a test roll, and during the shoot, I made clip-tests for skin-tone expo-sure—especially since I was alternating models regularly. The clip-tests are also important because sunlight filters into the pool at varying intensities during the day and may affect the exposure if it gets really strong. This level of light let us shoot at $\frac{1}{125}$ sec. at $f/8$. On such jobs, we shoot 30, 40, 50 rolls of Ektachrome daylight film per day.

I worked with two assistants on this shoot, one of whom acted as troubleshooter. He checked that the strobes were firing correctly and notified me, when I came up for air, if a problem had occurred. We devised a system, with an assistant outside the water tracking exposures and flash pops, to make sure everything was in sync.

The red-haired look on the model you see here actually comes from the specially designed lighting gels we use to get proper skin tones. I covered the glass in front of the strobes with Lee tomato-red gels.

Between the pristine, clear water, which we meticulously maintain, and the quantity and quality of our light, we were able to deliver the rich tones and soft textures the client had expected of us.

The art director wanted rich colors, with the model enveloped in the soft light reminiscent of a cloudy day, and images that express a sense of flowing hair and a certain sensuality. The only clothing involved is chiffon, held in place by the model.

This high-key exposure required a two-pronged approach, with lighting and digital editing geared to preserving the pearly white opalescence of the jewelry.

PRO TIP I have a rule in our studio: We replace the foamcore every two years, because, as it ages, the color it throws out changes, and you can only compensate for that so much. When we began seriously working with digital, we threw everything out and bought all new foamcore. We use foamcore in half-inch-sheet thickness.

Pearls may appear to be an easy subject to photograph, but their bright tonality and luster can wreak havoc for the unsuspecting. Lighting is the first step on the road to success.

Jewelry shots like this one involve two levels of involvement. The fashion photographers get the items first, establishing a mood or theme with their pictures of the models wearing these accessories in their live shoots. Then we get the jewelry, and what we do has to reflect those shots in a still life. So, the difficulty is having to follow someone else's lead. At the same time, you want to imbue the shot with your own artistic sensibilities to create a still life with its own vitality.

JOB SHEET

USAGE: **Collateral**
CLIENT: **Neiman Marcus**
AGENCY: **NM Direct**
ART DIRECTOR: **Janet Longstreth**
SET STYLING: **Jay Evers and Janet Longstreth**
FIRST ASSISTANT: **Hunter Ward**
LIGHTING: **Strobe**
CAPTURE: **Digital**
PHOTOGRAPH COPYRIGHT ©NEAL FARRIS.

PRO TIP I find that baffles on softboxes affect color balance much more than do flashtubes. I switch out these baffles every three or four years. Also, I'm not big on using coated flashtubes, either, because the difference between coated and uncoated is not always observable.

We weren't given a layout, but did receive a page size—6x8 inches. The picture had to fit that space and leave room for copy. We did 17 shots in two days; this picture took two hours. I used a Hasselblad H1 with 80mm lens and Imacon Express 132C digital back, in single-shot mode.

The element common to both the fashion shoot and our tabletop set are the white plastic chairs, which the client had flown in from the earlier shoot in New York. The entire set is made up of these chairs, stacked one atop another. The chairs were slippery, so to make them remain in position we secured them with various clamps attached to stands. We also had to deal with a slippery necklace draped over the side of one chair. We took care of that easily enough by delicately applying tacky wax along the underside of the necklace.

The bottom chair stood on a 4x4-foot plywood surface elevated to a convenient shooting level. We shot at a 45-degree angle, from 6 feet away. Angle and distance, combined with the lens focal length, let me hold depth of field for all the items. A 4x4 white panel drop behind the set created a wall, which you don't see owing to tight cropping in post.

My main light was a Plume 100 softbox on the back left, at 45 degrees, almost butted up against the set, perhaps 2 feet away. I also had a large Plume 140 above the set, serving as fill for the jewelry. On either side of the camera is a 4x8-foot foamcore L-flat, creating a four-walled "room." I bounced one head into the corner of each L-flat to help wrap the shadows better, giving everything a nice, soft edge. Each head is fitted with a 10-inch reflector, running off two Norman powerpacks. There is just enough room between these two L-flats for the camera lens to peek through.

For this high-key exposure, we took an incident meter reading triggered by a radio remote. With digital, I do my final exposure assessment in the computer using a histogram. Since we were shooting in studio, we could tether camera to computer and get instant previews in a size we could easily work with.

Normal exposure in a high-key shot like this would have cost us tonal detail in the pearls, whose opalescence creates bright, white highlights. If these wash out, you get lackluster gems. In such situations we bracket the shot, as with film, then rebuild the image using darker and lighter exposures to save highlight details that might otherwise be lost. Specifically, we overlay a darker exposure over the final one to keep detail in the pearls. In Imacon software, we saved the two images as layers, then created a layer mask—completing the process by simply painting in the portions that needed more detail. In the end, our pearls looked as luminous as nature—and the client—had intended them to be.

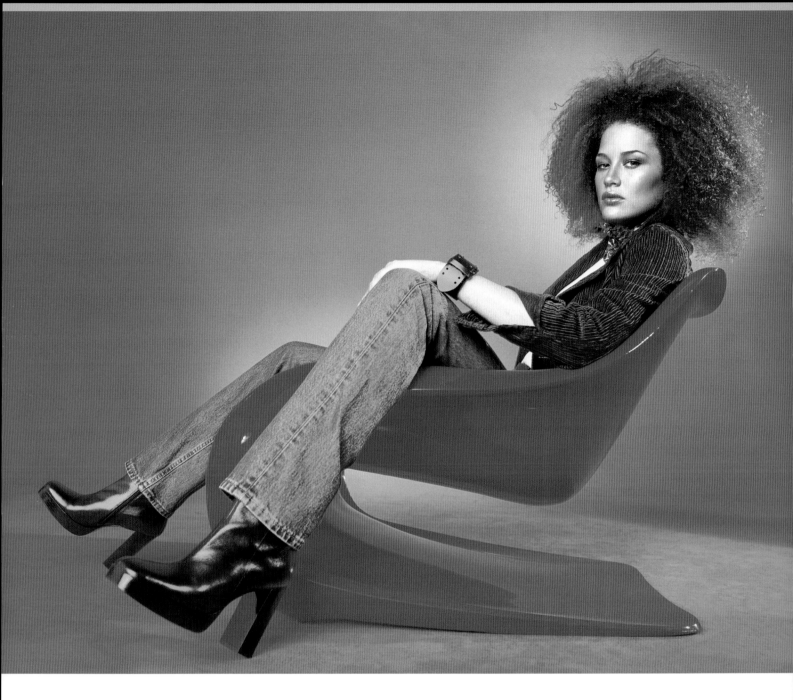

Some fashion shots are tempered with muted colors. Others, especially those intended for a youthful audience, are vibrant, maybe even wildly colorful, reflecting a zest for life. With the help of the lighting (and some digital retouching) to lend additional flair to this shot, the normally staid blue color in the jeans pops out in contrast to the energetic reds that surround it, making a vivid statement by its quiet elegance.

JOB SHEET

USAGE: **Advertising**

CLIENT: **Levi Strauss & Co. (Levi's)**

AGENCY: **Zimmermann Crowe Design, San Francisco**

CREATIVE DIRECTOR: **Neil Zimmermann**

HAIR & MAKEUP: **Troi Olivierre**

PROP STYLIST: **Dee Pool**

DIGITAL ARTIST: **Kevin Kornemann**

LIGHTING: **Strobe**

CAPTURE: **Analog**

PHOTOGRAPH COPYRIGHT ©JILL GREENBERG.

For a national campaign promoting their Original Red Tab line of clothing, Levi's wanted to produce a variety of youth-oriented point-of-purchase displays. The assignment would involve numerous shots, with a number of different models. It would span eight days, focusing on two or three models a day. The agency's creative director provided the initial guidelines, but was otherwise receptive to my ideas—and my color schemes. We made all the shots in my studio; we took some against seamless, while we shot others, this picture in particular, against a cyc.

We already had the clothing, provided by the client, and the accessories. We needed one more thing: a red chair, which my prop stylist rented—at $1,000 for the day. The set was largely in place from the shot produced earlier in the day, and it didn't take long to tailor it to our needs. We began by painting our two-walled eggshell cove red.

I shot on a Pentax 6x7 with 45mm lens. This focal length allows me to get in really close to the model. Exposure was $f/6\frac{1}{2}$ at $\frac{1}{30}$ sec., shooting Agfa Optima 100 color negative film—I like the color saturation this film provides and the way that it treats skin tones. We rate the film at EI 50—I like to overexpose my negative film. We shot four rolls of 120 film of this pose alone, basing initial exposures on flashmeter readings and Polaroids. Once the shoot was completed, we scanned the processed negatives on a drum scanner.

Using a supersaturated red cyc and gelling lights made it necessary to pump a lot of light into the shot. For that reason, we had to rent additional powerpacks. All our lighting is Speedotron, and on average, we had one head to a pack. Photo-optical peanut slaves synched the lights together.

We began by setting up a large Elinchrom Octa lightbank, without diffusion, as the key light. This large, umbrella-style bank had a silver surface to produce a more specular light over a wide area. The light was very low, almost touching the floor, coming up to about eye level with the model, and 5 or 6 feet from her. The model herself was 8 to 10 feet from the cyc wall. I was sitting, sometimes lying, on

Colorful lighting gave this shot just enough flair to give Levi's the marketing edge they were looking for.

the ground right in front of her, shooting handheld. Because I was positioned in front of the main light, some of that light was blocked. So I placed a small head with a 12-inch reflector on a floor stand to the right, for fill.

Beyond that, there are two green-gelled lights hitting the model from the right. One is on her hair, the other aimed toward her boot—each on a floor stand, with each head inside a 12-inch reflector. The light on the model's face is coming mainly from the key light. We also had one magenta and one cyan light on the left, in 12-inch reflectors—both on the jeans. One was on the floor and the other a little higher. The cyan light was more from the front, with the magenta light more to the side. The cyan gel, we'd found, picks up the blue of the jeans, giving the material much better color saturation.

I prefer my backgrounds to have some modulation, some modeling. It makes it more interesting. With that in mind, we created hot spots on the cyc for a halo effect, by throwing two magenta-gelled lights on the backdrop. There was one head coming in from either side of the set, hard as we could get it without grids. To saturate the background with a wash of intense red color, we added two red-gelled lights on either side. These were actually among the first lights to go up. As with the halo lights, each head was inside a 12-inch reflector.

We didn't restrict the lights, so that some of the colors were allowed to mix—such as the green gel mixing with the magenta, turning it a sort of yellowish orange, to add a little more variation and interest to the shot. There is also a local red color cast falling on the model. That's coming from red light reflected off the cyc. Cyan highlights in the boots are coming from the cyan light, which is also hitting the watchband. Along the sleeve you can see evidence of the green light. And the magenta gel is bleeding through from the background to her hair on the left side.

Despite all the color, more was needed—and added in digital postproduction, in Photoshop. For example, I made the jeans even more saturated and enhanced some of the contrast. I also had to do some retouching on the model's face and underneath her chin. And finally, I had to retouch out the light stands that my wide-angle lens captured on film.

PRO TIP A painted cyc provides better saturation than paper or anything else, in my experience. Even then, we would still throw more color on it, to saturate the red even further.

JOB SHEET
USAGE: **Editorial**
CLIENT: *Paper* **magazine**
STYLIST: **Heidi Bivens,** *Paper* **magazine**
HAIR: **Herve, for Frederic Fekkai**
MAKEUP: **Robin Schoen, for Bradley Curry**
LIGHTING: **Strobe**
CAPTURE: **Analog**
PHOTOGRAPH COPYRIGHT
©JILL GREENBERG.

"Leave nothing to chance" might have been the title for an editorial feature on camouflage fashion, with this shot illustrating how foliage and color help model and clothing blend in to the picture. Or is that the other way around?

Camouflage fashion was the theme, encompassing nine outfits and six models. This shot features a full-length dress with a train, made of camouflage fabric. I shot against a green seamless backdrop, with a Pentax 6x7 and 45mm lens, on Agfa Optima 100. Exposure was ƒ/16 at 1/30. The model stood 6 to 8 feet from the backdrop, while I positioned myself between her and the light, shooting from a low vantage point. An Elinchrom Octa lightbank sans diffusion screen served as the main light. We added a light on a floorstand from the right, as fill. To add a color accent to her skin, we positioned one magenta head on a boom. Four more lights went up, aimed at the model,

two on each side of the set—those on the right were gelled red; on the left, green, supporting the overall color scheme. Beyond that, I threw two hot spots on the green seamless with the help of 12-inch reflectors without grids, each positioned in close proximity to the backdrop, to give it a more vibrant quality. These lights are positioned on either side of the set, about 4 feet and 7 feet up, respectively. We lit the foliage (which was clamped in place) with four different lights, left to right: purple, cyan, green, and red, coming around in an arc shape. The foliage is the same branch, with digital variations. We used additional retouching to enhance the colors and skin tones.

sci-fi

Letting your imagination soar in photography opens up a world of possibilities. Be it a manned lunar landing or the average Martian family, each scenario requires skillful use of lighting tools to create that sense of immediacy and authenticity

I n this photograph, Steve Bronstein merges two well-known images, one which brings to mind a momentous event in American space exploration, the landing on the moon, and an icon of the advertising world, the camel representing the brand of the same name. Typical of this studio, the shot involved multiple layers and expert technique, both in-camera and in post. At each stage, the lighting played a pivotal role, helping to maintain the illusion.

PRO TIP Looking at the shadows, you'll note that we emulated the same lighting from set to set. We wanted to evoke a strong principal light source—the sun—obviously coming from the same direction.

PRO TIP I do a lot in-camera, choosing not to rely too much on Photoshop. I'm careful to shoot things in a way that they can go together cleanly.

This shot is inspired by the famous Apollo moon landing picture of an astronaut, with Earth reflected in his helmet visor. Instead of Earth, however, the reflection we see here is of a rocky outcropping—in the shape of a camel.

Of the several sets we used for this shot, the hardest to create was the looming rock formation. We had to make the rocks look as if they had assumed a camel shape naturally. What's more, the shape had to evoke the client's "approved" camel icon, even though it appears only as a reflection in the astronaut's helmet.

I used the same projection technique here that I used for "Creating a City of Lights" (see page 138), with one major modification. There we were dealing with a largely level topographic representation. Here we see the rock formation reflected in the helmet—which is a curved, spherical surface—and that means the reflection had to appear distorted. If I used my basic projection technique to guide the model-maker in shaping the camel, the shape would still have to be "spherized" digitally to make it look like a reflection. That process, in turn, would alter the shape too much, so it would

no longer resemble the client's camel icon.

I could also do the projection onto a sphere, but that would be clumsy to execute and difficult to light properly. I needed a way to distort the projected image so that after it was digitally spherized, it would assume the necessary shape. Photoshop gave me the tools I needed.

Taking the shape of the client's camel icon, I applied a "negative spherize" effect in Photoshop and used the resulting distorted shape to make my projection. To the eye, the distorted shape looks totally incorrect. Working with the model-maker and my assistants, we created the basic shape out of clay to match this projection, tweaking the camel until it closely matched the "squeezed" negatively spherized tracing. To check my work, I did a low-res scan of a 4x5 Polaroid of the clay camel. I then applied the exact opposite—a "positive spherize" effect, which rendered my shape accurately in the visor.

Now we were ready to light the set, beginning with a hard tungsten light to represent the sun. For the original relief of the camel, we had one 2K from the left corner, a few feet away, raking the set at a fairly low angle, maybe 30 degrees, with 1¼ CTB

Multiple sets came together to convincingly create this scene—of man once again visiting the moon, only to be greeted by an unexpected icon.

(for neutral color balance with tungsten, then shifted slightly toward blue). For a realistic feel, the model-maker dressed the clay "lunar surface" with a fine powder and rocks, using Vatican art stone.

I exposed the camel shape separately from the rest of the moon surface. Though these various set elements were lit similarly, this gave us more flexibility in post—if we had to adjust the size of the camel rocks relative to the terrain. We left a gap in our other terrain set to make room for the camel. Ultimately, we would combine our shots—the camel shape and the moonscape—before applying the digital spherize effect, since the background would require a similar treatment as well.

I also needed to photograph the terrain that appears on either side of the astronaut's helmet. These were two sets made from carved foam and again dressed with Vatican art stone. I photographed these with slight diffusion to suggest that they are off in the distance, and I lit them with the same tungsten lights, with 1¼ CTB, that I'd used for the main moonscape.

We shot the spacesuit as a separate element, for more control. To add realism, I lit the suit to get a hard reflection (the sun) on the visor, using a pencil tube in a Speedotron head. This raw strobe tube gives off a hard light. To control spill, I lined the inside of the reflector with blackwrap. We used black velour cloth where needed to keep reflections from the set off the helmet.

To the right of the set we used an additional head aimed through a diffusion screen to create a soft gradation in the helmet. When I make the first exposure for the specular light, I block off the rest of the set with black flock fabric, so it doesn't see the diffusion. And then when I use the second light, the main light goes off, giving me the soft glow. We made all our strobe exposures with a ¼ CTB gel, which added a slight blueness to the scene.

In post, we combined our images. First we added the camel shape to the moon terrain and spherized it. We then digitally overlaid this combined element onto the helmet reflections. After that, we added the two background terrain pieces, on either side of the helmet, and then digitally composited the stars into the shot. We also included an image of a lunar vehicle, from stock NASA footage, to give a sense of scale to the lunar terrain.

PRO TIP We do initial scans on a desktop flatbed scanner so that we can rough out the layout. For the final composite, we use drum scans.

Several sets combined to form this highly creative composite image. One set, carefully lit to simulate sunlight on the moon, featured the astronaut. The main set re-created the shape of the camel icon, beginning with a ground glass tracing.

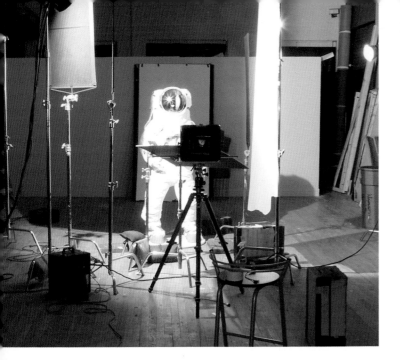

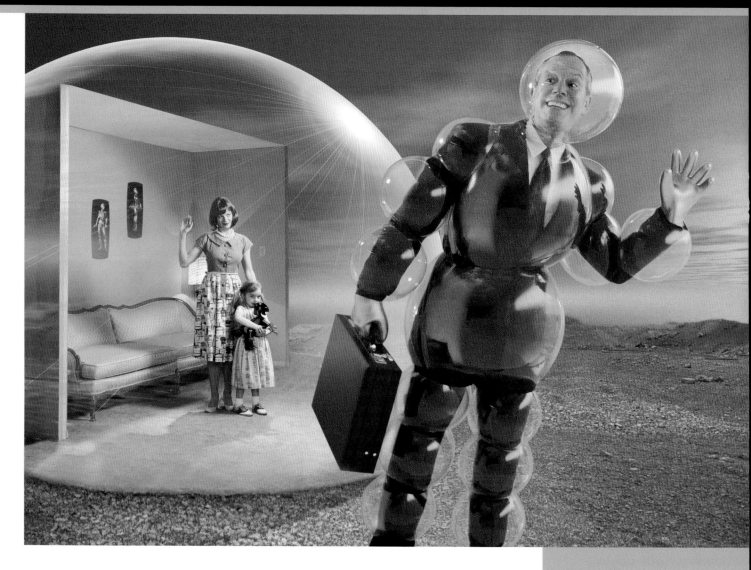

Nick Koudis takes us to the red planet Mars, speculating on the typical day for a Martian family. But the assignment, as light as it appears in temperament, is serious when it comes to the lighting. The challenges, in fact, give one pause to reflect—in more ways than one.

"Will we live on Mars?" This tantalizing question was the theme of a feature article in *Time*, for a special issue titled "Visions of Space & Science." My task, the picture editor explained, was to illustrate a businessman, in some sort of funky suit, going off to work on Mars and waving goodbye to his wife and daughter, who were inside a home encased in a dome. I sketched out my ideas for this one-and-a-half-page spread, and we went from there.

PRO TIP Putting a man's head inside a bubble presented an immediate challenge: He would need air to breathe. Our solution was to pump air through the back. That also resolved another problem—keeping the bubble from misting up.

JOB SHEET

USAGE: **Editorial**
CLIENT: *Time* **magazine**
PICTURE EDITOR: **Jay Colton**
SET STYLIST: **Bette Demeri**
HAIR & MAKEUP: **Maria von Torfeld**

PRODUCER: **Steven Vote**
FIRST ASSISTANT: **Aimee Genell**
LIGHTING: **Strobe**
CAPTURE: **Analog**
PHOTOGRAPH COPYRIGHT ©NICK KOUDIS.

I crafted an outfit out of plastic spheres for my white-collar Martian to wear over his office attire—the "business suit" of the future. Because they would reflect everything and anything in the studio, the plastic spheres our Martian businessman was wearing proved the trickiest elements to light. At the same time, it was crucial that we light him so his regular business attire could be seen through the plastic.

It took the better part of the day dressing, lighting, and photographing our dad. We devoted the evening to photographing the family scene inside the bubble. For each shot, we used a Fuji GX680 III with 125mm lens. The film was Kodak EPP. We based exposures on Polaroids. For our lighting, I needed something broad to emulate the sky that would eventually form part of the background. You might say our lighting for this quirky view of the future was off the wall, at least where the dad was concerned. To light him, we fashioned a bank out of six White Lightning strobes—a combination of 1800 and 3200 W/S units—all at eye level, and all fitted with standard reflectors and barndoors. We bounced the strobes off a white studio wall to the right of the set, with the lights coming from the far left, 20 feet from the wall, and at a 30-degree angle to it. We gelled each of the 3200 W/S heads yellow; the others, red. Our subject was at about a 45-degree angle to the wall and 10 feet from it, with the camera facing him more or less squarely, 15 feet away.

You can see some bands of yellow reflected in the plastic bubbles themselves. While we positioned a flat between the model and the lights to prevent spill onto him, we did allow one yellow light to pass through, just to add these highlights. The 8x12-foot flat, which was 10 feet to his left, also added a solid surface reflection. I shot from behind a blind, 15 feet from the subject, to prevent the plastic bubbles from catching my reflection. Despite that precaution, I couldn't completely hide from these reflective surfaces, and I had to retouch myself out of the picture later. I also had to digitally bring out some details in his clothing—such as one of the buttons on his jacket—that otherwise would have been lost under his plastic coat. We used one more light with a red gel, coming in from the left and behind the subject, hitting his arm and briefcase. This light was an 1800 W/S unit at half-power, 4 feet up.

We lit the family setting with a Balcar beauty dish on a 3200 W/S head, just over to the right, gelled with ¼ CTO. This dish was 6 feet up and 10 feet from the mother and child. We had a ¼ red-gelled dish on a boom 4 feet overhead, providing a backlight. A third flash, right above camera at very low power, helped to pop the subjects' eyes. We got some ambient light from the lamp at the back, but its effect on the overall set was negligible. So, while it may be wishful thinking, this shot does shed some light—if a fanciful one, on a possible future for us on Mars.

This shot consists of several elements. The set inside the family's home is a diorama in the photographer's studio, and the desertlike background and digitally enhanced sky are stock shots. The big bubble is computer-generated in KPT (a Photoshop Plug-in).

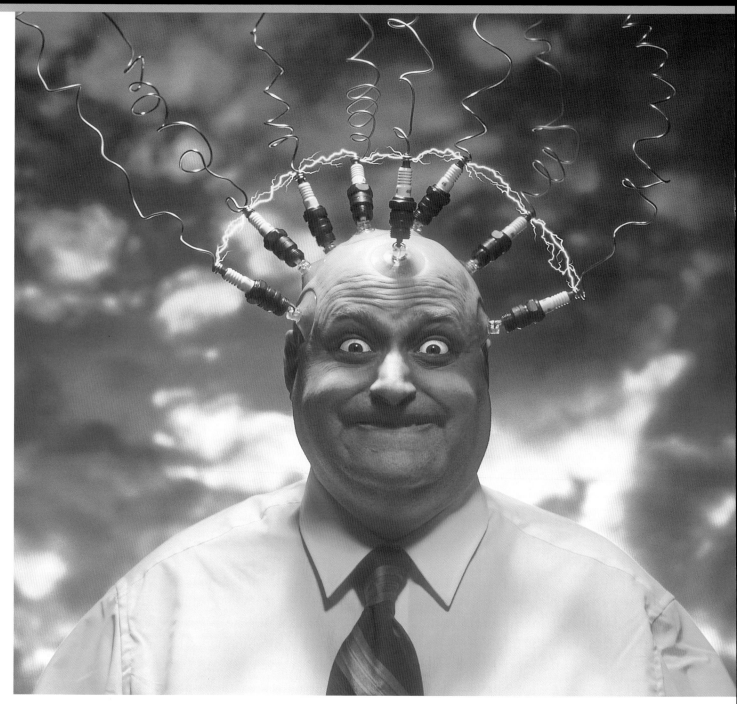

S ome photos are just more energetically charged than others. This tongue-in-cheek promotional piece, illustrating the idea of getting your creative juices flowing, is one. Where there's lightning, of course, there's light as well—so the lighting had to crackle with energy suggestive of the real thing. Strobes and gels evoking electricity provided a high-voltage shot.

JOB SHEET

USAGE: **Advertising**

CLIENT: **Networks 3**

AGENCY: **Miller/Kadnoff**

ART DIRECTOR: **Karleen Kirchner**

DIGITAL ARTIST: **John Lund**

FIRST ASSISTANT: **Skip Barton**

LIGHTING: **Strobe**

CAPTURE: **Analog**

PHOTOGRAPH COPYRIGHT ©JOCK MCDONALD.

PRO TIP The theme, "Jumpstart your creativity," applied here in more ways than one. The agency asked me to come up with three ideas and sketch them out, telling me just to make them wacky. So I put on the proverbial thinking cap, which jumpstarted my creativity, and came up with three sketches, including one for this shot. And the agency approved them.

I produced this "electrifying" shot for a software company, which used it in direct mail and on posters. The client asked for my ideas for three separate shots, each one offbeat, and this was one of them—to illustrate the theme, "Jumpstart your creativity."

I had worked with the model before, on similar-minded shots. In this case, I attached the spark plugs with suction cups, and I ran wires out of each one. The electrical discharges, of course, came later. I shot with a Hasselblad and a 120mm lens, at $\frac{1}{125}$ sec. and $f/11.5$, on Kodak EPP.

The backdrop is a 12x12-foot photograph of clouds, mounted onto the back wall of my studio. I set up four Broncolor P2 lights in copystand fashion, two per side, at a 45-degree angle to the wall, with dense magenta gels. Each pair of lights was stacked, one above the other, with one light at a height of 8 feet, the other at 4 feet—to produce a uniform wash of light, with no reflections on the backdrop. Each pair of lights, left and right, shared one Flashman 2 pack. To provide top fill, I added a 2x4-foot bank suspended over the model's head, with the densest blue Lee filter available. This bank served to light him from the edge of one shoulder to the other. Right behind me, I had another strobe head on a stand. It was pointed right into his face, with a blue filter and a layer of Rosco Tough Spun diffusion. This produced the pinhole catchlights in his eyes. The power setting is way down.

A gobo, set horizontally between the camera and the overhead light, protected against flare. Just outside of frame I had 4x8-foot black cards on either side of the model, to prevent spill hitting him from the background lights. Finally, I positioned two more 4x8 black cards, one on each side of the model, to absorb some of the light coming off the sides of his face and shoulders.

The electric bolts comprised the final element; they were hand-drawn from scratch in Photoshop. And since real lightning bolts generate a fair amount of light, the toplighting I had directed at the model made all the more sense.

A combination of gelled strobes and digital editing produced this electrifying experience.

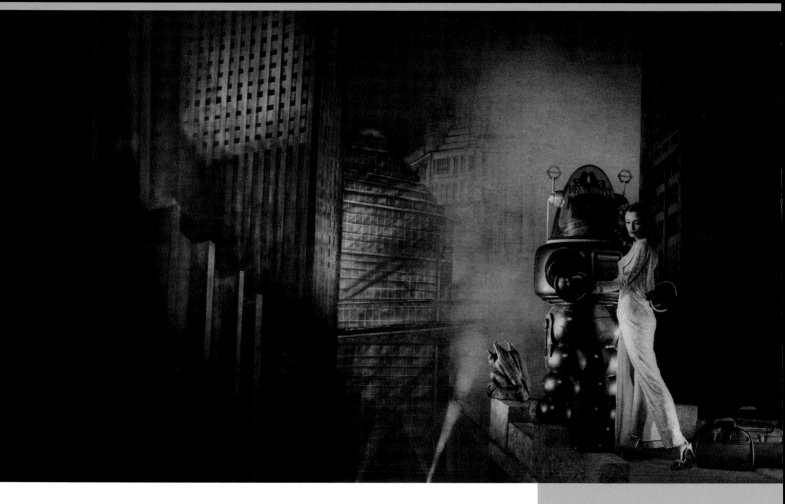

For this assignment, David Allan Brandt takes us into a future as visualized by the great filmmaker Fritz Lang. And then he goes one step beyond, placing two heroic characters on the set, to carry the story from frame to frame, along with the luggage, which carries the story as well. And note how Brandt's experienced hand staged the lighting, so that it carried the fantasy he created.

This shoot centered around a new luggage line labeled "Dune," embodied in a robot—a romantic character who is both futuristic and, in some respects, steeped in tradition. A female model played his quixotic interest. Since the luggage was futuristic in design, the client wanted a sci-fi feel to the shot, but with the robot in a city-set reminiscent of movies dating back to a bygone era—specifically, Fritz Lang's *Metropolis*. There were four shots in the campaign—three for consumer magazine ads and

PRO TIP I want to create a mood or capture a defining moment in my photographs. The lighting is definitely a part of it. I have an idea of the feel of the light I want to get, but there's no set order in putting up the lights. It's previsualized, so it doesn't really make any difference which one I start with.

JOB SHEET

USAGE: **Advertising**

CLIENT: **Mandarina Duck Luggage Company**

AGENCY: **Live Communications (Hong Kong)**

CREATIVE DIRECTOR: **Kinson Chan**

WARDROBE STYLIST: **Andrew Binder**

ROBOT CONSTRUCTION: **PropArt**

FIRST ASSISTANT: **Peter Breza**

LIGHTING: **Strobe**

CAPTURE: **Analog**

PHOTOGRAPHS COPYRIGHT ©DAVID ALLAN BRANDT.

PRO TIP We couldn't use existing prop robots because of exorbitant licensing fees, so we had one built at a local prop house. Actually, this was a robot suit, which allowed the male model wearing it to change position freely during the shoot.

one wide shot for billboards, for the Asia-Pacific market. We shot this campaign in two days, following two weeks of preparation.

The creative director and I worked on the set design from the basic comps. First we had to have the robot built. He wanted the robot to be constructed of a rubbery material that was similar to the material used for the luggage, but in the classic movie design. The client wasn't overly interested in focusing all your attention on the luggage, but did want a real handbag inside the dome that housed the robot's brain, so we had to make that big enough. The rest of the luggage would be placed next to the star players.

This massive set mandated that we rent a soundstage. In fact, we used two separate sets. This city shot made up one scene; a second set took us to the surface of the moon. Set design began with painting the backdrop. I had three separate background sections painted so we could layer the set—adding depth through a combination of lighting and haze (from a rented smoke machine). The

background extended 30 feet, edge to edge, with the left and right side panels each 6 to 8 feet in front of the center panel, overlapping it slightly. From camera position to backdrop, the set stretched about 40 feet.

We built the roof supporting our key players so that it overlapped both the center and right-hand background panels beyond it. To construct the rooftop, we rented some stage flats to use as the support framework. Then we laid on the roofing paper. For the side of the building itself we used very thin wood—about ⅛-inch thick, in 4x8-foot sheets—so thin that we were able to staple it in place. That made it cheaper and easier to construct and tear down later. We added molding, using cinder blocks to make the ledge, which we painted to look like one seamless structure. The prop stylist found the gargoyle—a key addition because it defined this as a rooftop and added to the nostalgic, theatrical feeling. The roof structure was 8x10 feet, with the rooftop a few feet above ground level.

We started setting up our lights—all Normans—

A plethora of lights, a three-section backdrop, and a fabricated rooftop set the stage for our lead characters—and all for a billboard luggage ad.

The client was more interested in the image, rather than showing the product itself. It was not important to highlight the luggage in this or the other shots. Instead, the client chose to emphasize the attitude of the models and the storyline.

once most of the set was in place, beginning with the backdrop. This was supposed to be a night scene, with spotlighting. Still, we had to diligently light the background so it was visible enough to give the set the needed depth and make the scene believable. So our first step was to hide two lights with standard reflectors behind each of the side panels to light the far-center section. These lights were at the same distance, angle, and output.

One light from the right came in on the right-hand background panel, with flags on either side to keep it from throwing a shadow on the background section behind it. Another lamphead behind the rooftop came in on that same backdrop section from the left. A flag to the left of this head

controlled spill. We positioned the smoke machine to the far right and in the back. We took a slightly different approach for the left background panel and lit that section with two lights positioned next to each other from the left side of the set, with a flag on each side to control spill. We then added three Norman Tri-Lites, placing them low to the ground and using them as theatrical searchlights shining up from "street level." You couldn't see the shafts of light until the smoke came in on them.

Then we went to work lighting the rooftop. We began with stand-ins for the robot and model, since we didn't have them when we were setting up. They came in the next day. We positioned separate grids for robot and model at the far left side of the set, then added one grid for each to the right of the rooftop. We also used an extra grid for the model, placed not as far left, and a few feet closer to camera.

We threw two grid spots on the gargoyle. One was on the floor, coming in from the left-hand side and from slightly behind the figure, while a second was banked along the row of grid spots hitting the robot and model from the right. To that bank of lights we added another grid—in a forward position and coming in on the luggage at an angle. A grid light on the floor, near the front edge of the roof, came in on the left side of the building structure.

I'd used Plus-X in my Hasselblad, which left one more step: printing. I always work with the same printer, and together we solve problems and experiment on effects. We cropped the square image down to make it a horizontal, but because this was supposed to fit a billboard, we had to stretch it. Our solution was to copy a small section of the image, then double-print it at far left. Finally, through a combination of paper, bleaching, and toning, we produced this color tone.

The smoke machine was the most trying element in this shot. The smoke would be just right for one or two frames, and then it would drift too far into the set, and we'd have to wait for it to clear.

The same robot and model were placed on a set simulating a lunar landscape. This set (30 feet wide x 20 feet deep) had a rented painted backdrop. Gray-painted muslin covered the floor, and a scree-like material (obtained from a hardware store) added to the rock-strewn effect on the surface. The muslin was close enough to the backdrop to form one continuous sweep. Rented rocks added depth, while seemingly extending out from the background. Two lights hit the painted backdrop, with another two on the foreground, left and right.

The comp for the lunar shot provided a starting point.

COURTESY DAVID ALLAN BRANDT.

personal vision

"I always try to take advantage of any opportunity to do personal work. Even on jobs, I'll always try to shoot additional variations of what interests me as long as there is time to do so. I figure I have everything there, so why not make the most of it? And many times the client will go with my version."

PHOTOGRAPH COPYRIGHT ©DAVID ALLAN BRANDT.

The robot has just gotten a pink slip. We can't be certain of his future, but we can commiserate with him on his situation. And judging by the lighting Markku used to paint this picture, it is not a pretty one.

The forlorn robot sits there, as if in a drunken stupor after getting off work on his last day. Feeling like nothing more than a tin can, he embodies yes-

terday's machinery, put out of work by a manufacturing technology designed to automate procedures entirely without user involvement. What made him

JOB SHEET

USAGE: **Advertising**

CLIENT: **Jot Automation**

AGENCY: **PHS/TBWA**

ART DIRECTOR: **Erkki Mikola**

LIGHTING: **Strobe and tungsten**

CAPTURE: **Analog**

PHOTOGRAPH COPYRIGHT ©MARKKU LAHDESMAKI.

PRO TIP I begin with one main light, and if that alone works, I'm happy. Of course, sets being what they are, that's rarely the case—if you plan to do the shot justice.

obsolete were technologies represented by the client's products, unseen yet effective nonetheless. The difficulty here was telling that story, specifically trying to convey the mood.

Our robot was custom-built in England and used as part of an ongoing campaign. The table, bench, and back wall were also fabricated, whereas we got the sink, lockers, and red chair from a prop house. While we worked to a layout, we had some flexibility in designing the shot.

We used a Sinar 4x5 camera, with 150mm lens and Fuji RDP. A rented smoke machine lent the 20x20-foot set an industrial locker-room feel. We placed the old-style sink just within frame in the foreground to add depth to the shot and make the room look more spacious. And we positioned the red chair to suggest that it had just been vacated by someone who had spoken to the robot.

When setting up our lights, the first thing we did was to turn off all the ambient studio lights and block out the windows. All the lighting here was Elinchrom—with one noteworthy exception. Our first light—the main light—was an Elinchrom coming in from the right off an overhead boom. This head was gridded and aimed down at the robot. It also hit the red chair. We dialed down the 3000 W/S pack to reduce contrast.

A softbox came in from the right, high enough above the sink to strike it at a glancing angle and feather out along the rim of the basin. We positioned this light fairly close to the camera, which was at the edge of the set. A ½ CTO on this light made it a little warmer than the light on the robot. We dialed down this pack as well. We lit the back wall, from a lower angle, with a gridded head positioned to the right. Unlike the other lights, this one was tungsten—an Arri 2K optical spot. We used a ½ CTB on it to bring down the warmth.

The floor appears highlighted in spots because of a dappled layer of dust (with more reflective areas shining through)—typical of a poorly maintained industrial space, and in keeping with the overall tenor of the shot. One incidental benefit of using the smoke machine was that the generated smoke layer was denser in some areas, creating obstacles to the light path. This resulted in an uneven light scraping the backdrop, giving the room a lived-in feel. Even the white studio walls to the left and behind the camera played a role, throwing light back onto the set and providing subtle fill that reduced contrast.

The lighting had to convey the downtrodden mood of the robot within an industrial setting, where a commitment to progress had led to his undoing.

JOB SHEET

USAGE: **Advertising**

CLIENT: **Listerine**

AGENCY: **J. Walter Thompson (Toronto)**

ART DIRECTOR: **Andy Brokenshire**

HAIR: **Tony Chaar**

MAKEUP: **Rachel Hayward (Kirk Talent) and Kelly Meredith (Judy Agency)**

FIRST ASSISTANT: **Arash Moallemi**

LIGHTING: **Strobe and HMI**

CAPTURE: **Analog**

PHOTOGRAPHS COPYRIGHT ©DAN COUTO.

PRO TIP The agency approached me for this job because they were aware of my comic-book style, a style that lends itself to this type of photo-narrative story execution. And they wanted something that very much looked like a still from a movie—in essence, a movie poster, with a cinematic feel to it.

We've seen this story played out numerous times—notably in the *Alien* sci-fi movie series. But in this instance, our heroine is fighting back a monster with potentially devastating power. Bringing all the pieces together for this scene was an awesome task. The lighting was no less demanding. It had to support the drama, reinforce the intrigue, highlight the danger our heroine faced in this unusual twist on the battle of good against evil.

Listerine had a new hero in the battle against bad breath, PocketPaks. The plan was to introduce their protagonist in a TV ad and on movie posters, which would hang in theaters alongside posters for actual films. As he gave me the layout, the art director said he wanted the poster to look like a real movie poster, which made a generous allowance for type.

For a portion of this shot I used elements of the stage setting for the TV commercial. The rest was left up to me and my crew. I shot on a Mamiya RZ, with 65mm lens for forced perspective, on 120 Fujichrome, pushed to ISO 400. We used 20 rolls of film just on our heroine.

The model and her attire came from the TV commercial, as did the creature's hand and much of the backdrop. The jaws came from a previous shoot done in my studio. The entire creature from the commercial wouldn't fit in a still shot, so we had to improvise. The scene unfolds with the critter going on the offensive (breathwise), only to be rebuffed by the woman firing packets of the product into the gaping jaws. Her weapon—a PocketPak dispenser—leaves a trail of "shells."

Creating this composite image took a week: one full day for the talent shot; half a day for the PocketPaks; a day for the background; half a day for

Fighting the good fight required an elaborate series of shots focusing on the action heroine, who found herself facing this alien, and worse yet, the creature's really bad breath.

the creature's mouth; another half day for the hand; and three days of digital retouching.

We started by photographing the woman against a blue screen, using the cove in my studio, with the camera 5 feet away from her. We knew we'd be digitally extracting her using KnockOut (now Corel KnockOut), which works best against this background color. The intent was to place her against a digitally constructed scene, originating with a collection of stills of individual panels from the commercial backdrop, which we shot at their studio with blue-gelled HMI lighting. From there we'd piece the elements together to provide the needed forced perspective in relation to her body, and digitally illuminate the tunnel beyond the original artist rendering.

The first light was the key light on her face. This was a Speedotron grid with diffusion, 7 feet up, no more than 4 feet away, and positioned to her left and slightly forward. We needed to illuminate her abs and highlight their strength and tone, so I placed a grid from behind, 4 feet up and 3 feet away, to hit her at a glancing angle. Both lights had a ½ CTO.

We used two blue-gelled 6-foot Chimera strip lights, on very low power, vertically positioned in front of her—essentially in a copylighting setup—creating a nice highlight along the PVC portions of the costume. We added a "bikini spot," coming from behind at a height of 3 feet, aimed at her inner thigh. This had a green gel, as a contrasting highlight against all the blues. We added two grids on floor stands, also gelled green, aiming them at her boots from behind—one for each boot.

Next came a tight blue grid on a boom 8 feet up, hitting the PocketPak in her hand. Finally, as fill, we had two heads with ½ CTB, each one bouncing into an 8x4-foot L-flat. The two flats were positioned on either side of the camera, at the far edge of the set.

Next we lit the creature's jaws and claws individually, but in a very similar fashion. With the camera 1 foot and 3 feet away, respectively, we switched from a 65mm lens for the jaws to a 110 for the claws. To define the forms, we started with two lights coming in at about a 45-degree angle from behind. The head on the right was gelled green and came in from above; the one on the left had a dense blue gel and came in from below. We added two fills, with light blue gels, bouncing them into L-flats as in the previous setup.

For the packet in the foreground, I used one grid spot from the left, silver bounce cards to the right and above, and one white card for fill. The lens here was a 110mm, with a No. 1 plus-diopter.

To capture the "shell casings," we trained a 110mm lens on a bunch of packets we tossed into the air. Our lighting was similar to what we used for the hand, but without the green touches. Here, we put thin blue gels on the two edge lights, but we had no gels on the lights hitting the flats. We had to be careful not to affect the color of the product too much.

The model's headlamp was part of the outfit, but we couldn't get a good still shot with it turned on, so we added the beam digitally.

Only a few of the countless individual elements that went into the final composite are shown here. But they convey a sense of the painstaking detail the job demanded.

retro

Whether through the **mechanics** of the camera, the darkroom, the **computer**, or the lighting, these photographs succeed in evoking a time gone by, drawing upon the **worlds of art**, cinema, **history**, and TV.

A Mondrianesque painting provided the setting for a high-tech TV, with the lighting adding only a subtle hint of dimension to the shot.

When it comes to an eye for abstract design, Spencer Jones can't be beat. You immediately recognize a Mondrianesque quality in this image, and what strikes you about the lighting is the importance the background illumination plays.

This huge TV monitor was so square and linear that it immediately brought to mind the Dutch abstract painter, Piet Mondrian. I played around with the concept and showed the photo editor some test shots. She gave me the go-ahead and I drew up a detailed layout.

We only needed to shoot the TV once, separately against white seamless and silhouetting it out digitally. The Mondrianesque painting was another shot, which we later digitally composited with the monitor. Brent Wahl and I designed the painting on canvas, attempting to imitate the artist's style as best we could.

PRO TIP You have to know when to pull back—when not to overdo it. One of the things we played around with was whether to add another image to the smallest TV screen. Instead, we chose to pick up one of the colors in the painting and drop that onto the screen. We wanted it all to blend together as much as possible, while still maintaining the subject's separate identity in the picture. This also meant we didn't have to worry about smudges on the screen, since it would not be directly visible in the final shot.

We positioned the TV at waist level, on a 4x8 sheet of ¾-inch plywood resting on four sawhorses, with a seamless sweep draped under and behind this set, 6 feet from the camera. Two people actually stood on the plywood to see if it would hold the enormous television's weight. I used a Sinar 4x5 camera with 210mm lens, loaded with Fuji Velvia, keeping exposures consistent (f/22 at 1/60) for the TV and backdrop. The 210mm lens let me shoot squarely into the set, without invoking any camera movements, for a perfectly flat image.

Our lighting began with the seamless behind the TV. We aimed two 1200 W/S Speedotron heads into the backdrop from either side—at a 45-degree angle and 4 feet from the set—each light with a standard reflector. We taped two sets of 30x40-inch boards together to form 30x80-inch flags, attaching them to C-stands that we positioned at an angle, left and right, in front of the lights, to prevent spill toward the camera.

To evenly illuminate the front of the TV, we used two pairs of 1000 W/S Dyna-Lites, piggy-backed, at a 45-degree angle, one pair left and the other right of camera. We stretched a sheet of diffusion material vertically, 7 feet in front of each pair of lights. The diffusion screen was 4 feet from the front of the set and at a 45-degree angle to the monitor, with the heads pulled back far enough to give

us a nice, even light. Each head ran off its own pack, for a total of 4000 W/S.

Another Dyna-Lite, at 1200 W/S (and right up against the right-hand diffuser), gave the subject shape, form, and gradation. While the effect is subtle, you can see that the left beveled edge on the TV is slightly darker than the right. Just above camera, one undiffused head (dialed way down so it didn't overwhelm the other lights) punched up the set a bit.

The TV seemed to be floating inside a case, and the gap at the bottom was in shadow. More importantly, the logo down there needed more punch. So I added a 3-foot-wide silver card, below the camera and just in front, to pop the logo and fill in the shadow to a degree. We also floated one fill card on top, to bring out the Trinitron logo.

Now it was time to light the painting, which was 4 feet tall by 3 feet wide. We used a standard copy-lighting setup, employing two 1000 W/S Dyna-Lites on each side, each pair set at a 45-degree angle. The camera, fitted with the same lens as for the first shot (to maintain perspective), was 7or 8 feet from the painting.

While the concept won wide acceptance, we were also asked to shoot something more basic, against a black background. As luck would have it, the client felt the simpler shot was a better fit with the publication's editorial style.

Leonardo da Vinci served as inspiration for this digital composite, to help a feature editorial take flight.

JOB SHEET

USAGE: **Editorial**

CLIENT: *Chief Executive* **magazine**

ART DIRECTOR: **Carole Erger-Fass**

FIRST ASSISTANT: **Nan E. Ciuffetelli**

LIGHTING: **Tungsten**

CAPTURE: **Digital**

PHOTOGRAPHS COPYRIGHT ©CARLOS ALEJANDRO.

PRO TIP This image is composed of layers, not separate setups. Through a process called selective masking—that is, putting a layer of the scanned image over the layer of the photographed image, and with a mask in place—I start erasing (or bringing the image back up through) the mask to reveal the underlying layer.

This picture draws from the talent and inventiveness of Renaissance genius Leonardo da Vinci, bringing together various elements that were pivotal to the artist's creations. The lighting may be bare-bones, but it belies the complexity of this image.

The art director approached me with a feature story entitled "The Roots," to appear in a magazine supplement, "The Chief Executive Guide to Enterprise Business Solutions." She wanted an image that represented the creation of a masterpiece painting.

Reflecting on this concept, I turned to one of my art heroes, Leonardo da Vinci. I thought that the story of da Vinci trying to make a man fly would befit this idea—since, with his ornithopter, he laid down the roots for early flight in the industrialized world.

With the art director's approval, I began by scanning drawings by Leonardo from old texts, then printed these scans on watercolor paper. This medium imbued the final work with a truer feel for the original. Photography came next.

My knowledge of birds helped me find a skeleton I could incorporate into the shot. This served as an element that inspired the artist. You're looking at a skull, wing, and breastplate—all sitting on a drawing (the smaller drawings were part of the set). I also introduced some old tools into the picture and, to serve as a backdrop for the photo-graph, an old, wooden barn door. The tools, bird bones, and barn door were all in one shot, captured on a Sinar DCB II Live, with Nikon 105mm Micro lens.

Selective masking allowed us to bring through some of the wood grain from the door during compositing. I added the larger drawings of the winged man as a transparent layer floating over the shot. These larger drawings of the winged man combine elements from two Leonardo sketches, known as "Vitruvian Man" and "Winged Man." I also added a stock scan of checkered paper (from my files), to add some contrasting color and texture.

My lighting began with a Kodak Ektagraphic slide projector, for its hard shadows and bright light. I placed a magenta filter over the light, with the projector positioned to the left of the set. The projector was at a right angle to the camera position. For fill, I positioned a large bank directly overhead, gelling the lights lavender to cool off the shadows produced by the projector light. The White Balance for this shot was neutral, balanced to a gray card.

The layers for this collage include various background elements for color and texture, the scanned da Vinci drawings, and the foreground elements that add dimension to the final image.

CARLOS ALEJANDRO

119

JOB SHEET

USAGE: **Editorial**

CLIENT: *Travel Holiday* **magazine**

ART DIRECTOR: **Lou DiLorenzo**

FIRST ASSISTANT: **Fernando Souto**

LIGHTING: **Strobe**

CAPTURE: **Analog**

PHOTOGRAPHS COPYRIGHT ©HUGH KRETSCHMER.

PRO TIP The art director gave me an idea of the feeling he wanted, specifying that the shot should focus on the wartime conflict between England and Germany and the illicit usage of this tome by the Germans in bombing raids. The idea of using the hand and the bomb itself was mine.

A simple elegance lies at the heart of these images. And aptly so, for they take us back to a simpler time, albeit one ravaged by war. While the techniques Hugh Kretschmer uses are anything but simple, they, too, take us back, and the lighting sustains a historic feel as well.

Travel Holiday magazine asked me to shoot a series of three pictures to illustrate a feature article titled "The World According to Baedeker." The feature focused on the original Baedeker travel guides to Europe, which were published in the 19th century and are now collectibles. Each photograph represented a different aspect of the story. The art director wanted the pictures to have a dated look appropriate to the times. The whole assignment— all three images—took about a week to do. The shot at left took a day and a half. I made all the studio shots with a Toyo View and 180mm lens on Polaroid Type 55 film.

This image was inspired by the fact that both the Germans and the British used these accurate, detailed books during World War II. The hand and puppet strings depict how the German army manipulated the books, changing locations on the maps to throw the British off. And since the books were used to guide bombing runs, we have a bomb in the picture. I used all this information in sketching out the layout.

The book was a mock-up. Original Baedeker guides are today so valuable and delicate that we just couldn't risk damaging one. I made photocopies of selected pages from an original Baedeker edition, then toned and aged them with coffee and rough handling and stuck them in a book of similar size. The curl in the page— created by repeatedly running a pencil over the paper, as when curling a ribbon—is just a small detail I added for interest.

The book, supported by a pole to keep it from swinging around, appears to be floating above the backdrop. The shadow it casts down below is vital to the illusion. We painted the strings black so that they would stand out against the white seamless. We attached them at one end with tape to the book (behind the pages), and at the top end to a C-stand, with enough tension to keep them straight.

Someone pulled the right strings to create this elaborate composite image, combining both studio and stock shots to illustrate how these classic travel guides were manipulated for military purposes.

We had rented an authentic German uniform to add authenticity to the shot. I started by shooting the hand first. That ruled out any variables that might be introduced by the way my assistant held his hand in the shot. Everything would follow from this element. Once I got the right positioning on our first negative, I sketched the hand on the ground glass. I was then able to position the strings where the hand would be, and made the second negative for the book and strings.

The third negative was of the bomb (I believe it's actually a mortar shell), which we rented from a military surplus store. We stood the bomb upright against the seamless, balanced on a washer.

The cloud and travel photos came from my stock collection. I had used a Hasselblad for the cloud shot in Florida, and an old folding Brownie for the scenic in Florence, Italy. We added some vignetting of the clouds and scenic in the darkroom. Everything had to be masked using simple cardboard with an appropriately shaped hole cut out of it.

Our lighting had to support the dated feeling we wanted. After researching old pictures, I mimicked that look for the lighting quality—by simply bouncing one Speedotron strobe light off the ceiling in my studio. The stock shots dictated the direction of the light. I added mirrors and white foamcore for fill where needed, especially around the shell.

In the darkroom, I projected each element, layer upon layer, onto a sheet of paper sized to match the black-and-white paper I was actually going to use. As I successively projected each image, I would trace it on the paper—on top of the preceding image—until the final composite was sketched out to size. Once I was happy with how it all looked, I made the actual composite print. I sepia-toned the entire print, then went in with Marshall dyes and hand-tinted selected areas.

I used a masking system in front of the enlarger, in order to isolate each individual element. Where things overlapped, however, there was a problem. I would get a dark haze in those areas, because the exposures would build on top of one another, so I had to dodge and burn certain areas during the exposure. To achieve a dreamlike quality, I let some elements blend in with each other. So, the final image has a hint of surrealism to it.

Each photograph in a three-shot series illustrated a different aspect of a magazine story about the historic Baedeker travel guides to Europe.

JOB SHEET
USAGE: **Editorial**
CLIENT: ***Premiere* magazine**
ART DIRECTOR: **David Matt**
FIRST ASSISTANT: **Fernando Souto**
LIGHTING: **Strobe**
CAPTURE: **Analog**
PHOTOGRAPH COPYRIGHT
©HUGH KRETSCHMER.

Premiere magazine came to me with a story on the use of computers and how they've changed the film industry. I thought of the magic motif, and designed the picture to look like a movie projector. The numbers represent binary code that computers read. On the bottom is a CD. We constructed the dollar sign out of both film and computer cable, and a magic wand rounds out the elements.

I used in-camera masking for each key element, beginning with a gloved hand and a stuffed glove, which were each photographed separately using two cameras on one sheet of Polaroid Type 55. The glove was stuffed with polyfiber filler to hold its shape. I combined the two images in the second camera. Then I printed that image and cut it out of the photograph, using this cutout on the set with the dollar sign. The lighting here was consistent with the overall lighting used for the later elements. I was now ready to shoot the composite.

Each set on this assignment was first shot and then built up on the same sheet of film, transferring this film and the ground glass to each consecutive camera on consecutive sets. One set held the dollar sign with gloved hand and magic wand, while others held the top hat, the numbers, the projector beam, and the word "magic." The "magic" type is actually a Kodalith negative on a lightbox. The numbers are three-dimensional numbers that are on black velvet shot in perspective, moving away from the camera. The projection beam is created with a gold-painted piece of cardboard that's thrown out of focus and masked. As we photographed each set, that image was added onto the ground-glass sketch. We shot the composite image with a 4x5 Toyo View and a variety of lenses, on Fuji RVP.

We kept the lighting fairly consistent. However, each element did require special treatment. For the dollar sign, I positioned a Speedotron head behind a large scrim, aimed obliquely at the set. Mirrors were added to accent certain areas and pick up little details here and there. We also added a very large white card on the left for fill. I placed a white card above the CD to get a nice, clean surface, without multicolored reflections. Moving over to the top hat, I raised it above the backdrop with a pole, to give it added dimension, as if it were extending outward. I used a wide dish close to the camera. Then I added a sheet of white, 3x4-foot foamcore above the hat to reflect onto the rim, and a mirror to kick light back on each side. The binary numbers used the same lighting, with an extra mirror on the left. The glove was lit with the wide dish, in keeping with the overall lighting. The light beam also used the wide dish, but angled to minimize reflections.

In-camera masking consisted simply of cardboard taped over the lens. I stopped the lens down, viewing through the camera, and masked accordingly as I placed the mask in front of the lens. As I did so, I made sure there were no light leaks, and checked specifically to ensure the mask didn't cut off any of the elements.

N ick Koudis takes a classic TV game show and substitutes audio ampli-
fiers for the male contestants—all to drive home the point a maga-
zine article makes, that manufacturers play games when promoting
their products. His lighting, mimicking that of a live set in a TV studio, helps
recapture the mood, taking us back in time.

Our shoot would illustrate an editorial feature on how makers of amplifier systems play a game with their product ratings and specifications. So, "rating game" . . . "Dating Game." One flowed naturally from the other, so we based our image on this TV game-show icon, doing so tongue-in-cheek.

JOB SHEET
USAGE: **Editorial**
CLIENT: *Sound & Vision* **magazine**
WARDROBE STYLIST: **Bette Demeri**
FIRST ASSISTANT: **Predrag Dubravcic**
LIGHTING: **Strobe and tungsten**
CAPTURE: **Analog**
PHOTOGRAPH COPYRIGHT ©NICK KOUDIS.

PRO TIP When I started in this business, I realized I could gain an edge on the competition by building my own props and sets. That, together with my often fanciful approach, has become a trademark of my work.

We'd be shooting this as separate elements, compositing the scanned film in post. With that in mind, we had to be careful to keep everything in perspective and shoot at consistent angles. We worked on several sets: the game-show stage, the male contestant (the same model shot three separate times), the woman the contestants aspired to date, and the individual amplifiers—plus the overhanging TV studio lights (which did not contribute to our lighting). For this week-long project, which included casting and set building, we shot on a Contax 645AF, loaded with Fuji Velvia.

I shot the game-show set first, which established my perspective for the remaining elements. This set was a miniature, only 3 feet across and 12 inches high. I lit it with my "disco lights" (4-degree spots that use Sylvania AR111 lamps). They were up on a C-stand, rigged to an arm, 6 feet above set and coming down at a 45-degree angle from the front. One light, about 10 degrees over to the right, created the shadow extending from the "T." We had another light shining back on the word "Game," to blow it out a bit. The idea was to get crossing shadows, in mock homage to TV lighting. We shot the left and right parts of the set at the same time, on the same frame.

A classic TV game show set the stage for this shot, with lighting designed to be true to television-studio lighting.

We photographed the male contestant as three archetypes, each one projecting the appropriate body language: the nervousness of a nerd, the coolness of a jock, and the sensitivity of a hippie. The model sat on a stool, but not on the actual set. Our lighting was the same for each of the three shots: two lights from above and slightly behind. The floor underneath the model is actually three separate floor elements, including the shadows he cast onto the floor, picked up from our three separate shots.

I shot the woman separately. Since shadows were falling toward the front, I didn't have to worry about shadows on her. I lit this in typical TV studio fashion, with two spotlights suspended from an overhead track system that I'd rigged. These lights came in on her from slightly behind, giving us those nice highlights in her hair. Our main light, a beauty dish over the camera, came in on her from the front. The flooring here was a green rug.

We shot the amplifiers individually and composited them onto the guys. To make these somewhat bland audio components more pleasing to the eye, we used a beauty light. We couldn't use the same backlighting, because these boxy, angular objects prevent backlight from reaching over to their front side. So I lit each unit with a 12-inch banklight from the left, adding a fill card for good measure.

Tony Arrasmith takes an established work of art and sculpts it into his own creation to help foster a promotional campaign for the arts. His lighting for this multi-capture digital composite blends all the disparate elements seamlessly.

The client wanted an offbeat look at the arts for a fund-raiser awareness campaign, based on the concept "Guess who discovered the arts?" The idea for the scenario we created originated with two lines typed on a piece of paper: "How about a waitress in a cafeteria sculpting mashed potatoes on a tray?" No comps—just two lines on paper. Out of that we came up with the final concept, involving the short-order cook lost in

PRO TIP For these humorous shots, we find models that have had some acting experience. We just let them go and we shoot and shoot and shoot until we get what we want. Then we cut and paste, finding the best expressions and body language. Shooting digital certainly helps.

JOB SHEET

USAGE: **Collateral**

CLIENT: **Fine Arts Fund of Greater Cincinnati**

AGENCY: **Benchmark Marketing Services**

CREATIVE DIRECTOR: **John Carpenter**

ASSOCIATE CREATIVE DIRECTOR: **Jennifer Murtell**

HAIR & MAKEUP: **Jodi Byrne (Illusions in Make-up & Art)**

FOOD STYLIST: **Sarah Miller**

FIRST ASSISTANT: **Mark Wieczorek**

LIGHTING: **Strobe**

CAPTURE: **Digital**

PHOTOGRAPHS COPYRIGHT ©TONY ARRASMITH.

PRO TIP The tricky part was fashioning the Rodin out of mashed potatoes. Here we had some good luck: Among our group was one person who owned a replica of *The Thinker* and was willing to part with it. We found a mashed-potato mix in the dairy aisle at the grocery. Using a palette knife, I applied the mix to the statue, then wrapped the whole thing in wet towels and a bag to keep it moist for the shoot the next day.

sculpting. His medium is mashed potatoes, an idea that reaches back to the memorable food-sculpting scene in the movie *Close Encounters of the Third Kind*—except here the subject of fascination is Rodin's *The Thinker*.

I scouted some kitchens as locations, but none worked for the shot. So we built a set in the studio, based on stills combining the best (or worst?) features from eateries I'd visited. Building the set (35 feet deep by 16 feet wide) took three days. The books were fabricated by the ad agency, with tongue-in-cheek titles and authors, consistent with the lighthearted motif. Our restaurant staff all had acting experience. We wanted people who could ham it up. Once the set was built and propped, I could start on the lighting, leaving the morning of the shoot to finesse the lights and do my tests.

This was a multi-capture digital composite. I shot the cook and the waitress on the left in the kitchen scene, minus the fire and smoke. The second waitress was the same waitress in a different pose.

Naturally, the "waitresses" looked alike, so I gave one eyeglasses in post. I shot the glasses with my Nikon Coolpix digital camera—against a white balloon, then tacked the image onto the second figure.

We captured the main shots in one-shot mode on an Imacon 4040 back (on a Digiflex fitted with a Nikon 17–35mm lens), for an overall exposure of $f/8$ at $\frac{1}{125}$, with the fire and smoke at $\frac{1}{15}$. The camera stood 57 inches high and 38 inches from the sculpture (I take copious notes). On both shots, we left the camera, sets, and lights exactly where they were, from exposure to exposure, to maintain a natural, consistent feel.

When we shot the fire, everyone left the set, except for the creative director and myself. We took rubber cement, stuck it inside the toasters and on the grill—then ignited and photographed it. I dropped in the fire shots later. We made separate exposures of the smoke, using dry ice to create the effect.

For our lighting, we employed four packs with a variety of heads—mostly Profoto, plus one Morris

This assignment proved to be fun for all involved, although considerable time went into building the set and shooting the various elements.

Stand-ins modeled for this preliminary shot to give everyone a clearer idea of what the actual shoot would require.

slave. We began with a 45-inch Wescott Halo Light Modifier fitted over a Profoto head. This light came in on the set from a height of 9 feet above the metal table right in front of the cook. Off this same 2400 W/S pack, at half power, we ran a Profoto with medium Photoflex MultiDome, at the same height, edged ever slightly in the direction of the grill. A blue gel adds a little color primarily for the chrome. We also had a beauty dish running off this pack, with a blue gel covering just two-thirds of the reflector, so that the clean portion is hitting the cook. This added a hint of color to the right side of the set, just off the front right corner.

Our second pack was a Norman 800 Superlite, with a Fresnel focusing spot (actually an old tungsten head retrofitted to fit a strobe). We aimed this spotlight at each of the waitresses in turn from the front edge of the set, about one-third of the way in from the left side. We added a ¼ CTO to emulate lighting from the heat lamp over the window. Another light came off a Pro 6 Freeze with a dif-

fused head. Positioned on a Matthews boom, it was designed to skim across the women and, since it was flagged, gradate off the wall. This light came in from behind and over the shoulder of the waitress on the right.

The next light, which shared the same pack, was for the tree and back wall. We positioned it above the plant and slightly behind so that it also hit the back surface—which hints at a passageway leading to the dining area. The red wall was a flat, and the green wall was an L-flat.

Finally, we had a Pro-3 2400, powered down considerably, to which we attached one head aimed across the top of the grill to light the smoke. This light came in from way in back, to the left of the grill. Notice the small overhead fixture inside the window: That's the so-called heat lamp, which actually has a Morris strobe with ½ CTO inside.

We sculpted the final composite from the various elements, and delivered our masterpiece to the client ready to go.

The letters represent powerpacks; the numbers, light heads.

COURTESY TONY ARRASMITH.

nature

Animals, and animal themes, are always fascinating to photograph. Part of the challenge is devising lighting that shows these creatures off to their best advantage.

Jethro allowed me to get within a couple of feet of him. When he closed his eyes, I captured the moment.

PRO TIP I didn't have much in my book involving animals—but that didn't matter. One thing I've learned about shooting for international clients is that they tend to hire you for your style and give you jobs that may not necessarily focus on what you do normally. What concerns them is how you would interpret a concept. U.S. clients, on the other hand, tend to hire you more for what you have in your book. I always like challenges, doing something I haven't done. It makes me grow as an artist.

This ape—an orangutan named Jethro—was easy to work with. But the light-stealing, shaggy reddish-brown coat presented a distinct challenge.

Jethro and two other orangutans would star in the client's launch of an Internet encyclopedia called *Mypaedia*. The tagline was "Our evolution depends on the tools." These apes were exceptionally well-trained. Still, we had to make some practical choices. One key decision was to shoot on a cyc, instead of using seamless and always replacing the paper, which saved us time and money. Shooting took

Instead of going for the obvious still life or lifestyle shot, Oneida chose a more creative approach, whimsical in some cases, subtler in others, but always appealing to the senses. We worked directly with Oneida's in-house advertising department for this ongoing national ad campaign. From a rough layout, we custom-tailored the ape's wardrobe. Naturally, the client provided the table setting, the featured element in the ad. For the photograph of the ape (opposite page), we selected a paneled wall backdrop and chair and added the 4x6-foot wood table, which stood at a normal height. To fill in the surrounding space, we brought in plants from our studio.

We had the chimpanzee for the entire day, although we used a stuffed toy monkey as a stand-in during setup. We hadn't planned this exact shot. He just happened to raise the glass and look at it, and we captured the moment. The glass was filled with water and red food coloring to give it the appearance of wine.

In setting up the shot, we placed an acetate overlay with the layout on the ground glass of our Hasselblad, so we'd know where the type would be for an $8\frac{1}{2}$ x 11 magazine page. We had an 80mm lens on the camera, setting exposure at f/16 $\frac{1}{2}$ and $\frac{1}{60}$ on Kodak EPP. We added an 81C filter for warmth and Fog 1 for diffusion. It took one day to set this shot up, six hours to shoot.

We wanted to simulate soft sunlight streaming through sheer window drapery, so we used a 2400 W/S Speedotron head with a reflector on it, coming through a silk, as our main light. This gave the shot some sparkle. The "sunlight" was about 8 feet from the ape, coming in over his right shoulder. We added a $3\frac{1}{2}$-foot Chimera bank from the same side, about 4 feet from the simian. On the other side, at an

equal distance, we had a $2\frac{1}{2}$-foot bank, as fill. The two softboxes were at the height of the animal's head.

We wanted to simulate a sconce on the wall as an additional lighting element to highlight the rich paneling. Serving as our sconce light was an amber-gelled head on a C-stand, powered down to 200 W/S so it wouldn't overshadow the other lights. We added a 2x3-foot gobo on the left to block off part of the bank light on that side, with another 2x3-foot gobo to keep light from the right bank off the table surface as well.

The arm you see is from another shot, composited into this one because it was hidden in the selected frame. We further refined the ape's appearance digitally to give him a more civilized look.

Sweet retreat.

ONEIDA

Shown: Camelot goblet in burgundy.

Your table is ready.

This shot, another in the Oneida series, tells a story about butterflies that find a wonderful home inside Oneida glassware. Strobe lighting allowed for some blur in the falling rain, and cooling gels added to the ambiance of this simulated outdoor setting.

Once again Steve Bronstein brings his talent to bear in this inventive treatment of a familiar advertising icon. As we study this serene twilight scene, we see a familiar shape taking form. Achieving this vision required masterful control at every turn, beginning with a true perspective rendering down to the lighting that supports the illusion, bringing us this city of lights.

PRO TIP We shot this against a blue backdrop, knowing that we'd add an early-evening sky in Photoshop. It was much easier to cut the mountain out against a tone close to the actual color that would be dropped in.

JOB SHEET

USAGE: **Advertising**

CLIENT: **British American Tobacco Mexico**

AGENCY: **Lowe, Mexico**

ART DIRECTOR: **Miguel Angel Bolio**

MODEL-MAKER: **McConnell & Borow**

LIGHTING: **Strobe and tungsten**

CAPTURE: **Analog**

PHOTOGRAPHS COPYRIGHT ©STEVE BRONSTEIN.

PRO TIP We often direct-sync (hardwire-sync) the strobes so they don't slave-trigger each other inadvertently.

This is part of an ongoing advertising campaign for the Mexican/Latin American market, wherein we're treating a recognizable icon in new and different ways. Here, the camel shape takes form within the context of city lights, modeled after California's San Fernando Valley.

The first thing I did was discuss with my model-maker, Mark Borow, how we would create the valley-of-lights illusion. Would this illusion be created digitally, or with a prop? What would be the best and most cost-effective way to go? Mark proceeded to make a small prototype, about 2 feet square. Essentially, it was a lightly textured piece of Plexiglas with a grid pattern in forced perspective that had hundreds of tiny holes drilled in it, and then was painted with translucent colors. I did a test with this piece, lighting it from underneath, and looked at it from the appropriate angle. It looked great, very credible and realistic, which enabled us to proceed comfortably.

Next, we needed to determine the shape of the camel icon. If we made it without any distortion, the camel just wouldn't look natural. My client is very particular about how the camel is rendered, so any deviation from the exact shape had to be cleared early on.

First, I rendered an outline of their camel shape from the approved Illustrator file, and overlaid that with a sketch of the prop we were intending to build. I created some distortion in Photoshop, and after showing the art director several options, came up with a shape that was acceptable.

To create the actual relief sculpture, I made a tracing of the approved icon shape on acetate, and placed it on the back of the 4x5 view camera I planned to use. I then set up the camera with a wide-angle lens specifically chosen to express the needed depth and perspective, as if capturing a real scene, and at the necessary angle, one that felt logical.

We then used the camera like a reverse slide projector. Knowing the approximate scale the model-maker was using to make the prop, I focused on a tabletop about that size, approximately 8 feet wide and 6 feet deep. Then, with a tungsten light aimed at the camera back, and with the camera focused on the tabletop, we projected the tracing onto the tabletop.

Capturing this city of lights at dusk was a demanding task, requiring a specially built set and a unique perspective, not to mention the lighting that brought the scene to life—or should we say, to light?

From the camera's perspective, this created a shape that exactly matched the shape of the tracing. If you were to look at the shape straight on, it would be extremely distorted. Using what we had learned from the mock-up, my model-maker began work on the final set. He followed the tracing from the mock-up and drilled thousands of tiny holes using small dental drills. He also sculpted and painted the mountains in the rear. This labor-intensive process took about a week.

I reviewed the set in progress several times at the shop, but it's hard to really make accurate judgments about what is required until you see it through the camera lens. When the set was delivered to my studio, I had to first re-create the angle and perspective we determined from the mock-up stage. (We had carefully measured the camera position and documented it with digital photos to make this easier.) I had to be accurate, or the camel shape would not match the one the client had approved.

Once the camera was in place to match the mock-up position, we began to light the main set—from underneath to express all the city lights, and from the top to define slight surface texture, as well as the background mountains. We used eight heads underneath, aimed upward at a 45-degree angle and running off three 2400 W/S Speedotron packs. I moved the lights around until I got the effect I wanted, my obvious emphasis being on the center of the set with the camel icon.

Each light was heavily diffused so the spread of light would be even. I needed to keep the modeling lights on these heads turned off so that their heat wouldn't warp the set. We also kept a fan running underneath the set to help cool things down. We did several rounds of film tests so I could finesse the look of the underlit city. Based on these tests, I had the model-maker add and subtract holes in the set to enhance the camel shape. We worked hard to make the shape integrate naturally and cohesively with the other background lights.

To light the top of the main set, I used a Desisti Fresnel strobe head off to the right—to throw a big, broad, hard light onto the scene. It came in from a low angle, just skimming the surface, picking up a bit of texture and lighting the mountains. To get an exposure of $f/22$, I had to pop the bottom lights 12 times. The Desisti, gelled blue to suggest nighttime, required only one pop. The sky is a stock shot (on 2¼) that we dropped in digitally, in post.

Our second set served as the foreground—the scenic overlook. Here, I shot in tungsten, using one light—a 1K with 1¼ CTB, coming off the back right corner of the set, about 7 or 8 feet up. This matched the lighting from the main set. Using a net, I slightly reduced the intensity of the light hitting the rocks on the right side, since they tended to be brighter.

PRO TIP We mixed tungsten into this set because it gives you a truly hard light, better translating your intentions than strobe. Tungsten especially gives you better control when you use it as a spot or flood. More to the point, it simply lets me finesse the lighting more. Another advantage to tungsten is that you're seeing the actual light being used—not a substitute, as is the case with modeling lights on strobe. But I couldn't have used tungsten on the city-lights set. It would have thrown off too much heat and damaged the set.

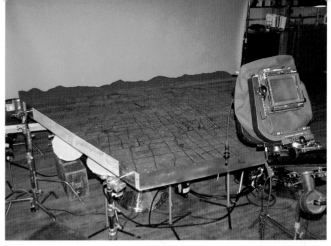

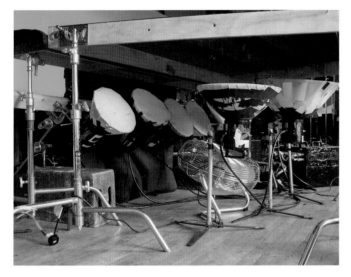

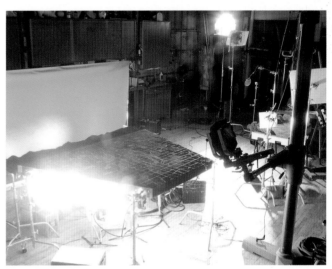

The camel landscape appears vast, until viewed in perspective next to the camera. Still, this landscape of a million lights needed considerable lighting from underneath, with additional lighting to bring out surface areas. The ground-glass view of the tracing and the projected shape show the early steps in the project. Also shown is the overlook terrain for the foreground.

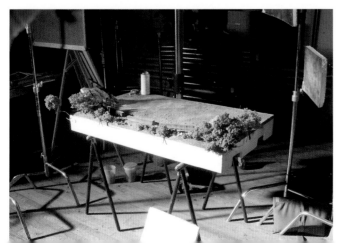

STEVE BRONSTEIN

The lively arts got even livelier in this shot, part of a lighthearted campaign to draw young people to cultural offerings. Multiple elements made the whole, and as often happens with multi-shot composites, it was necessary to pay very close attention to continuity of lighting from shot to shot.

JOB SHEET

USAGE: **Collateral**

CLIENT: **Fine Arts Fund of Greater Cincinnati**

AGENCY: **Benchmark Marketing Services**

CREATIVE DIRECTOR: **John Carpenter**

ART DIRECTOR: **Jamie Stanford-Albert**

DESIGNER: **Joe Napier**

DIGITAL ARTIST: **Julia Collins**

HAIR & MAKEUP: **Jodi Byrne (Illusions in Make-up & Art)**

WARDROBE STYLIST: **Sarah Miller**

PROP STYLISTS: **Wilbur Montgomery and Mark Bealer**

FOOD STYLIST: **Sarah Miller**

FIRST ASSISTANT: **Wilbur Montgomery**

LIGHTING: **Strobe**

CAPTURE: **Digital**

PHOTOGRAPHS COPYRIGHT ©TONY ARRASMITH.

PRO TIP A key to making this composite work lay in keeping the camera and all the lights in exactly the same position to maintain consistency in the shadows and overall feel of the shot.

The client wanted to appeal to a younger audience in this promotional drive, while also making the campaign more family-oriented. We decided to go with an opera theme. Since humor was at the heart of all our shots on this project, we made it look as if the little girl had gotten up and belted out an aria, and that her high notes had shattered the glasses and the aquarium. For this shot, I used an Imacon Express 96 on a Hasselblad, with 40mm lens, for an $f/8$ exposure at $\frac{1}{60}$.

I built this set (12 feet wide by 10 feet deep) and propped it, adding the boat and assorted related trappings. We used a few live lobsters, but most of the crustaceans were props. I photographed one glass aquarium and another made from Plexiglas, with a hole cut in it for water to spill out. Later, in post, the Plexiglas tank was superimposed digitally over the glass aquarium. During the compositing stage, the agency's artist also added the shattering glasses.

This elaborately constructed set required lights of every caliber to capture the sheer volume of activity, particularly the spills and splashes.

The girl, the mom, the dad, and the people in the background were all in one shot. The waiter was in a separate shot; the young boy in a third. I brought the boy in later so I could have better control over the light hitting the little girl and the mom. The place settings were there in anticipation. Once we finished shooting the people, we pulled everybody out and hoisted the boat out of the way for the remaining exposures.

We had multiple Profoto packs and heads on this shot, beginning with a medium Plume on the little girl, with this light coming in from camera left and a little in front of her. A Photoflex MultiDome shared this pack, coming in on the back of the dad's hair from the right. Running off this same pack was a grid mounted inside the back of the boat (which is hanging upside down). It gave the boat definition, while throwing some light on the background.

Another pack had a Briese light on a boom at 11 feet, coming in from the back right corner, to light the aquarium and the back of the set. It was flagged off the woman at the back (the one with her hands covering her ears). From this same pack, we had a head on an 8-foot boom, skimming the side wall and adding fill for the mom.

The next pack was shared by three lights: a barn-doored head off a boom positioned above the fish on the wall; a spot way back at the wall, aimed at the back of the girl's head; and another light with barndoors on a boom, over and a bit forward of the back left corner of the set. The final pack had a grid on a boom, for the waiter, with the light positioned just behind him.

To simulate the leak in the aquarium, I stood above the Plexi tank and poured water into it from a fair height. We used a Pro-6 Freeze at a very short flash duration to capture the spill. We also mounted a Morris strobe underneath the aquarium (and under the Plexi tank) so it wouldn't go dead.

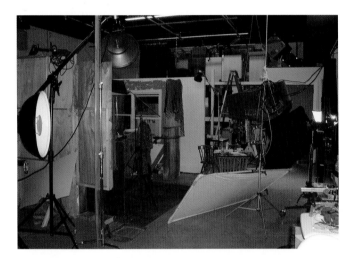

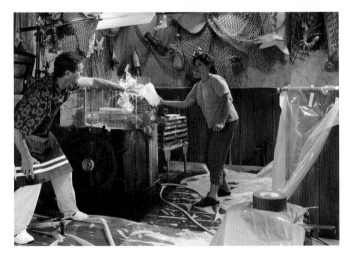

The various angles show the lighting and the multidimensional aspects of this shot, made all the more complicated by a very involved storyline.

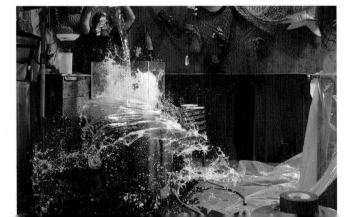

The letters represent powerpacks; the numbers, light heads.

COURTESY TONY ARRASMITH.

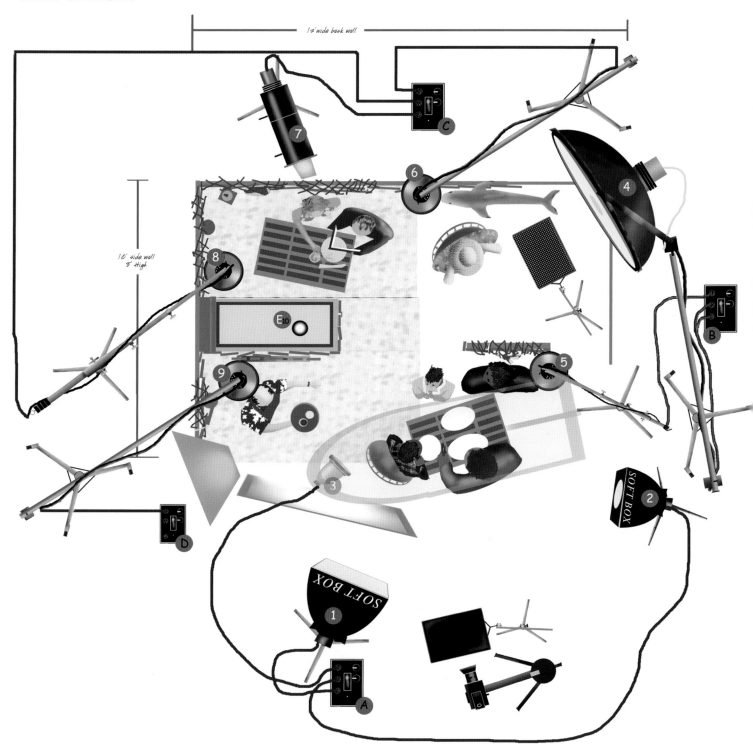

PRO TIP Despite our best efforts, we still had to deal with some reflections. The shiny floor reflects light from inside the diorama back onto the glass, which is angled downward slightly. So our next step involved creating a "negative diorama space" out of black cloth. We suspended this fabric in an arc, extending from a few feet beyond the display edges on one side, running behind camera and back to the other side, reaching over the railing in front and right to the very edge. We also had to drape black cloth over the tripod and light stands.

Existing lighting behind the scenes, mixed with additional lighting front and back, gave this scene a down-home-where-the-buffalo-roam look, re-creating the original feel of the diorama.

W hen the subject is an old, established museum diorama, the challenge is to let us see the exhibit in a whole new light.

In the old days, they removed the glass in front of a museum diorama to shoot pictures. They built a platform on a forklift, and the photographer took the camera onto the platform and moved with it inside the display. We can't do that today. Removing those hulking panes of glass is not practical, so we had to contend with reflections. What's more, with this American Museum of Natural History Bison and Pronghorn diorama, the support struts posed an obstacle as well. One more thing to keep in mind: We wanted to re-create the viewer's experience when looking at this picture in a coffee-table book on the museum dioramas. Achieving that seamless meld between the physical ground inside the exhibit and the painted backdrop was tricky—that's the same challenge James Perry Wilson faced in painting this background scene.

The exhibit measures 27 feet wide by 8 feet high (with a few extra feet to either side of the frame), and a maximum depth of 12 feet. We never step inside an exhibit, never move anything around. Because this is a heavily trafficked area, we had to begin after hours, shooting well into the morning. We worked with the electricians, who shut off the display and surrounding lights—thereby killing most reflections. They turned on the interior lights as necessary. I stood behind camera to direct light placement, communicating by walkie-talkie to another of the museum's studio photographers, who was standing on a narrow catwalk overlooking the diorama, from inside.

JOB SHEET

USAGE: **Editorial and collateral**

CLIENT: **American Museum of Natural History Special Publications**

LIGHTING: **Tungsten and available light**

CAPTURE: **Analog**

PHOTOGRAPH COPYRIGHT ©DENIS FINNIN/AMERICAN MUSEUM OF NATURAL HISTORY.

PRO TIP We try to get as little distortion as possible, which means planting our view camera squarely in front, using just enough camera movements to ensure squared edges and straight lines. Because the diorama glass is tilted downward, it's almost impossible to achieve total success with the struts, which are not perfectly aligned to begin with (since this exhibit dates back quite a few years). But we were close enough.

Behind the scenes, about 15 feet up, the area above this diorama is a complex network of glass panes at a steep angle, along with piping and support structures—and the aforementioned catwalk, which was our staging area for setting up our lights. Our lighting began on the catwalk, with the addition of two 1,000-watt Berkey Colortran 3200K lights, one third of the way in from each end, above the diorama. These were aimed into white flats behind us, reflecting back onto the scene, thereby bathing the entire diorama in a soft light. This in effect replaced the fluorescents that were turned off.

While keeping a half-dozen of the existing floods in place, we replaced another half dozen with 150-watt Photogenic MiniSpots—all tungsten, to bring out specific areas in the scene, among them the back of the bison, the face, the top of the pronghorn, and the little bird perched on the bison's back. As we did so we had to plant our spots so that they avoided support structures in the glass, thereby avoiding casting objectionable shadows onto the scene. We didn't worry about the difference in color balance between our 3200K lights and the floods, since it was minor.

In some instances, where the spots or floods were too hot, we laid down some diffusion over the glass in front of these lights. We used blackwrap as a snoot to tighten the focus of some lights where needed. Our lights were clamped to existing structures, and we ran extension cords up into the crawl spaces. We noticed that the corners at the back of the exhibit were a little too dark. So we added two 150-watt 3200K lamps in a standard reflector, aiming one each into the far corners, left and right.

There were now a few areas that needed attention up front. To keep out reflections, we had to position several MiniSpots outside the display way off to the side. We had two lights far right (goboed off from the camera) opening up the area beneath the buffalo, and another two on the opposite side for the animals on the left. We also had a MiniSpot on the eye of the featured bison for a catchlight, to give it added life. This also came in from the right, positioned near the other two bison lights but much higher up.

If you hold a piece of this display glass sideways, you can actually see how green it is. That's why we used a CC10M filter behind the lens. Once everything was in place, we shot Polaroid type PN55 to help us judge focus, lighting, and exposure.

It's my understanding that when Wilson created this diorama, he painted it assuming an optimum viewing height of 5 feet 6 inches, so that's the height at which we set our camera, to make sure we actually captured what he really intended. The camera we used was a 4x5 Sinar with 75mm SuperWide Nikkor; film was Ektachrome 64T. The shoot, including setup and breakdown, took roughly 10 hours. These exposures ran about 90 seconds, at $f/45$. We push-processed the film by $\frac{1}{3}$ stop to add some snap to the image.

When fantasy rules a photograph, fancy and imagination have to rule the studio. It's also necessary to attend to such real-world basics as the proper lighting required to create a magical glow.

I've done a number of assignments for this Toronto photolab, which always gives me creative carte blanche. This shot, a week-long project for a direct-mail campaign, evokes the wonderment of youth and the fantasy worlds children create for themselves. I like to think the picture also represents how a photographer and a photolab can collaborate imaginatively.

There were a number of elements that went into this composite. I shot the background with a Nikon F5 and 24mm lens, on Ektachrome VS. That was the analog component. The rest was digital.

PRO TIP As I shot various images for the final composite—both the studio and outdoor shots—I continually consulted with my digital artist to make sure that we could get the elements to fit together properly. On a big job, my digital artist becomes part of our entourage, even going on location with us. We set up a mini-studio wherever we are—in a tent or whatever. That way, as I'm shooting, we can compose the shot as we go. When it comes to complex multi-element composites such as this, we map out the shot, essentially making a shopping list. When we get new elements in hand, we roughly fit them into a working image to make sure all the elements mesh.

JOB SHEET

USAGE: **Advertising**

CLIENT: **Colourgenics**

DIGITAL ARTIST: **Tom Klusek (Visual Edge Projects)**

FIRST ASSISTANT: **Connie Chan**

LIGHTING: **Strobe and daylight**

CAPTURE: **Digital and analog**

PHOTOGRAPHS COPYRIGHT ©DON DIXON.

PRO TIP We couldn't go out and photograph dragonflies in flight in the time we had. Having established a working relationship with a local museum, which provided the bugs needed, was pivotal to our success.

We photographed the girl in the studio with a Nikon D1X and 105mm Micro lens. The walnut shell that she's riding in was shot with a Hasselblad, 50mm lens with extension tube, and Phase One back. You can see a little fringe of rope, or trim, running along the top of the walnut shell—also shot on the Phase One. The wings coming out of the side of the walnut were bug wings, photographed with the D1X and 105 Micro.

We photographed the dog in the studio at the same time—also with the D1X. (The dog was about a quarter the size he appears to be in the shot.) The ropes leading to the dragonfly come from the trim on the walnut shell. The girl wasn't hanging onto it. We shot the trim (suspended between a couple of light stands) as a separate element, and shot her holding a rope. We switched them around in post so that she appears to be holding the reins. We aimed a big fan at the child to add movement to her hair and the ribbon at the end of her magic wand. The sparkler effect around the wand tip was added digitally in post.

Our dragonfly is a composite. We photographed a real dragonfly with a Phase One, but up close it looked scary. We wanted it to appear fanciful and friendly. So all you see from the original dragonfly are the wings and tail. The front part is a grasshopper; the eyes are from a beetle. We borrowed the bugs—preserved and mounted—from the Royal Ontario Museum, and brought them into the studio. We locked the camera and setup, to keep everything in place for the next phase. We had three sets running concurrently throughout this shoot.

For the background, our light source was the sun, which you can see in the top left corner. The background image of sky and clouds was shot from an airplane. We used the refraction across the screen, as viewed through the stressed glass of the aircraft window, to enhance the dreamy quality. This now established the lighting we'd be emulating throughout.

Our main studio light consisted of an Elinchrom Octa bank raised above and to the left of the little girl. I aimed a Profoto Acute head with a Balcar grid across her back, to create the impression that she was enveloped in ambient skylight. I took the same approach with the dog as well, although dog and girl were shot separately.

Nothing is as it appears in this shot. Even the dragonfly itself is built up from a mix of bugs, and that only begins to tell the tale.

Because the walnut is such a small element, I employed a smaller light, albeit from the same direction. Here, I used a small dome. For fill on the underside and back of the shell, I added a white card to bounce back some light (but not too much, to avoid creating a distraction). To light the bug wings on the back of the walnut, I used a 2-foot softbox, which gave me a fairly flat light that suited this element. We lit the rope with the same 2-foot softbox, from top left, the same direction as our main light source, with a reflector card bouncing light back onto the rope's bottom edge.

I backlit the dragonfly's wings with a grid coming through these membranous parts, in keeping with our dominant light source, the sun. We used no fill, to maintain the full translucency of the wings. We did numerous bracketed exposures, because the wings have different densities, then sandwiched brighter and darker shots together to level things out.

I used a grid spot for the dragonfly's body, moving it around in front of the proboscis, and a little below, at 8:30 or 9 o'clock. I had a reflector underneath the insect to bounce some light up into the tail.

Then we replaced the dragonfly with the grasshopper on set. I used a gridded light again, at the 8:30 position, hitting the grasshopper in the front. Finally, I put a small, 2-foot softbox above it for fill. We shot the dragonfly, grasshopper, and beetle from the same angle and perspective—then melded these separate elements to create our fantasy "steed." The final digital composite blends all the elements seamlessly, giving us the impression of a winged chariot whisking our little princess away to an imaginary kingdom, or dreamland.

The final composite was comprised of a complex array of
elements, some very tiny.

cars

It's one thing to photograph cars on the road. But it's quite another to shoot them in the studio, where portraits reflect detail and lighting must respond to the needs of the vehicle.

JOB SHEET

USAGE: **Advertising**

CLIENT: **Mini Cooper**

AGENCY: **Crispen Porter Bougouski**

ART DIRECTOR: **Andrew Keller**

SET CONSTRUCTION AND PROPS: **Darrin Littleford**

FIRST ASSISTANT/DIGITAL ARTIST: **Clifton Izui**

LIGHTING: **Strobe**

CAPTURE: **Digital**

PHOTOGRAPHS COPYRIGHT ©RICHARD IZUI.

PRO TIP With the Phase One H 20 digital back, it's important to do a standard grayscale test at the very beginning. Beyond that, the Phase One software did a good job of color-balancing the image to neutral.

The idea was to surround this vehicle in a Hollywood tableau, recalling the moonlit garage where some of the action in the movie *Sabrina* takes place. The lighting had to re-create the essence of a film set while driving home the message "I'm waiting, I'm here, drive me."

The client planned to introduce the sporty-looking Mini Cooper S as an enthusiast's car. Location scouts were sent out to find rustic-looking, brick garages with double wooden doors returned with nothing usable, given the lighting the client had in mind. So we rented a large stage at South Bay Studios in Long Beach, California. This was the cover shot and one of two featured photos for an advertising insert. We used a Sinar 4x5 with 60mm lens and Phase One H 20 single-shot digital back, having brought our own Mac laptops and workstation to the set so that we could all have a live view of the shoot.

The shot actually consists of several separate exposures, which were later composited. The car was in each exposure but was masked out where it wasn't the focus of the picture. Each exposure formed a separate layer in Photoshop.

Our set designer not only built the set but propped it as well. That included tungsten lights suspended overhead, inside the garage. A hint of these lights can be seen on the automobile. He also spray-frosted the garage windows to help diffuse the incoming light, in preparation for the creation of simulated moonlight.

We worked with a production-model car, except that it had all sorts of test gear inside. We avoided showing this gear by ensuring that the lighting didn't penetrate the windshield. Providing overall illumination for the car exposure was a 40x15-foot Fisher light bank. The overhead box crisscrossed the length of the car, with 16 Speedotron heads inside. Each two lights shared one 4800 W/S pack. The bank created an incredibly powerful light that feathered down nicely and let me capture all that detail in the car's headlights.

This shot of the Mini Cooper S is a composite, consisting of several separate digital exposures captured on a Phase One. We custom-built the set to simulate a garage reminiscent of the one in the movie *Sabrina*.

Moving our attention to the lower front end of the car, we positioned lights immediately in front, 3 feet from each tire, at low power. They were aimed low, wrapped in Cinefoil to prevent spill, and bounced into two 4x8-foot foamcores that formed one continuous flat 3 feet from the bumper. This light reflected back into the lower part of the grille, which was 15 feet from the camera. I later retouched out these lights in Photoshop, since they were physically in the picture. The bumper was highlighted from both the overhead box light and from the foamcore down below.

I always shoot as many angles as possible when I have a car on set. And that means adjusting my lighting for each shot, even though the space is the same.

We also had lights skimming the back wall from inside the garage, above window height, with one head far left, another far right, 8 feet from the wall. Behind the windows we added blue-gelled lights to simulate the moonlight. However, since the client wanted a shaft of moonlight beneath the car to extend all the way to the entrance, we took two additional steps. First, we added two 2400 W/S lights on pedestal stands behind the car, one on each side, gelled blue, so that they formed a diverging shaft of light extending for a short distance forward. Second, in Photoshop, I completed this task by digitally extending this beam all the way to the doors.

The camera height was lower than that of the door handle, while the garage door lights were positioned slightly above this level. We reduced the intensity of the light hitting the door on the right with Rosco Tough Spun, and the output was powered down to 100 W/S—just enough to get a hint of the door itself. In contrast, we aimed a 400 W/S head at the left door, at full power. There was one more light far left of camera, aimed into the door on that same side in a raking fashion, creating a nice highlight-and-shadow effect on the wood molding. All the door lights had grids and barndoors.

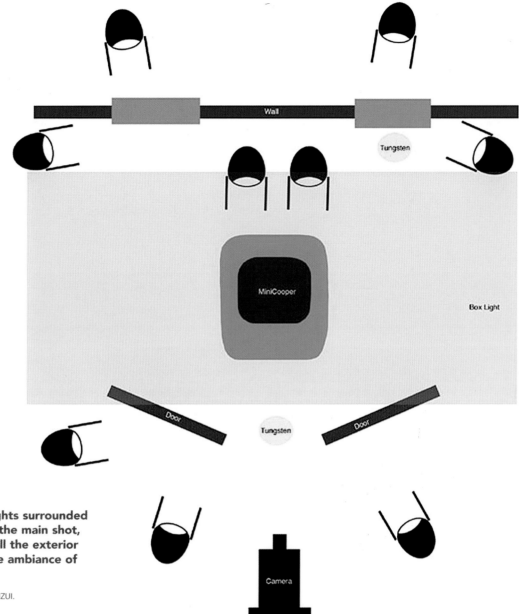

Wall

Tungsten

MiniCooper

Box Light

Door

Door

Tungsten

Camera

An array of lights surrounded the vehicle in the main shot, bringing out all the exterior details and the ambiance of the garage.

COURTESY RICHARD IZUI.

personal vision

"Driving out to Race Track Playa in Death Valley, to get background shots for a *Playboy* feature I was working on, we came upon this vast expanse of cracked mud and set up the Hasselblad and Phase One back, shooting panoramas in all directions. I was so taken with the scene that I later used it as a backdrop for this self promo image with a Ducati motorcycle. It all seemed to fit together perfectly."

Daylight-balanced film exposed under tungsten-balanced Kino Flos gave the car a warmer glow. More conventional tungsten lights served to bring out the tires.

JOB SHEET

USAGE: **Collateral**

CLIENT: **Infinity**

AGENCY: **The Designory**

ART DIRECTOR: **Steve Chow**

FIRST ASSISTANT: **Arthur Karyakos**

LIGHTING: **Fluorescent and tungsten**

CAPTURE: **Analog**

PHOTOGRAPHS COPYRIGHT ©CHARLES HOPKINS.

PRO TIP You may ask: Doesn't the client mind that you painted the car? No, not when it's a "photo car." Most often in advertising and collateral work, this is the sole purpose of these cars, and they're destroyed afterwards. Such vehicles are routinely "strip-painted," meaning the paint job will simply peel off, right down to the primer or whatever state they arrived in prior to being prepped. Of course, all this is established up front with the client.

The point was not to shoot this car awash in light from overhead. Instead, linear tubes simply but emphatically bring out those characteristic features—lines, curves, and shapes—that define the car. The results are quite startling.

The sleek lines in this Infinity FX-45 in part define this vehicle as a fine piece of industrial craftsmanship, and that also defined our task for a 12x12-inch dealership catalog. The art director provided a layout showing the car at various angles, gleaned from what we call a "photo shoot-around," essentially numerous views of the car produced in advance of the shoot (not necessarily taken by the contracted photographer). I was responsible for the 20 or so studio shots, while another photographer handled the location shooting. I had four assistants on this job and shot several views from outside the car, plus details inside and out.

In this shot, the art director had asked for two things: one, that the image convey a sense of power against a black background and, two, that it have an in-your-face attitude, with one proviso: no distortion. That last stipulation called for my Toyo 810G and an 800mm lens so we could shoot from a good distance, maybe 40 or 50 feet from the car. (Wisely, we had rented a very large stage, at South Bay Studios, Long Beach, California.)

Showing the car swimming in a sea of black meant surrounding the stage with a matte black fabric. Also, to ensure that there was black underneath the car, we put the vehicle up on half apple boxes and covered those in black velvet as well. We had to line windows with black velvet to hold back reflections; and we used matte spray on the grille so it wouldn't burn out. In addition, we had to paint highly reflective parts of the car black to reduce visibility.

This art director appreciated my approach to lighting from previous assignments, so my primary lighting—linear Kino Flos—was a given. We shot this car on both daylight and tungsten film, employing tungsten-balanced Kinos. We used the daylight version—it gave the car a warmer, more inviting glow. In fact, we took one more step toward that end by having the prep company buff the car to an extra-fine finish. The extra sheen helped the spread of light from the linear tubes. We based our exposures on Polaroids, which gave us $f/45$ at 20 seconds, with a 1-stop push for added contrast.

We jerry-rigged a speedrail (consisting simply of one overhanging bar) to support our overhead Kino Flos, hanging our first light over the grille to establish the hood's swooping shape. This light was a 2-foot-long, two-bulb Kino Flo, with the barndoors closed down to practically a slit so that we didn't get any spill toward the windshield. In fact, each of our Kinos sported barndoors configured in a similar fashion.

The bar held additional lights. We had two more 2-foot/two-bulb Kinos, one for the fender and another on the headlight on the right side. We had a similar setup of lights on the left side. We didn't want the lighting to be perfectly even on both sides,

so we brought the level of illumination up on the left, while adding ND gels over the bulbs on the right. We next had two smaller lights hitting the mirrors on either side of the car. These were 1-foot Kino bulbs, each, respectively left and right, lighting up the mirrors and the A-pillar—which is the sheet metal that supports the windshield. The final Kino Flo rested on the floor, maybe 4 feet from the vehicle, aimed straight up to the bottom of the bumper and into the air scoop. This was a 4-foot, two-bulb fixture with three layers of diffusion.

Now it was time to bring our Mole-Richardsons into play. Hitting the roof of the vehicle was a 10-

Producing this tight detail required a large, hanging flat, seven 2K lights in various stages of flood or spot aimed into the flat, and one MiniMole aimed through a slit in foamcore to light up the reflector on the car—all set against a black velvet backdrop.

This overhead view was shot from the roof of the studio, which had an opening expressly designed for this purpose.

inch Mole 2K Junior. This light was 12 feet up, aimed straight in from the left, with one layer of Rosco Tough Spun so it was not too harsh. Finally, we added two Mole 250-watt Minis, one per tire—positioned off to camera left and right, respectively, at about 3 feet high. These lights grazed the tires just enough to give them some presence.

While we also shot the vehicle with the wheels turned toward the camera, we opted in the end for this view, since the wheels are a noteworthy feature. With the wheels lost to view, the car would have looked as if it were floating on air.

W e wouldn't normally think of the dash as being evocative, but with Tony LaBruno's lighting, this one becomes as alluring as the lines and curves on the sleekest sports car.

I like to accent the supple contours, the seemingly soft textures, and the graceful forms in an automotive interior. That often involves considerable lighting, allowing the light to embrace and play with a gearshift, a steering wheel, even a dashboard.

This photograph of a 2002 Honda Accord coupe interior was designed for a dealership brochure, from the viewpoint of the driver. Photography was at South Beach Studios in Long Beach, California, where we rented a 60x100-foot stage, with several shots running concurrently.

The art director had stipulated that we go wide enough to include both doors, while keeping distortion to a minimum, and that we shoot on 8x10, for a double-page spread. It was also important that all the gauges on the dash be captured in the shot. After preliminary testing on Polaroid, the art director and I arrived at this viewpoint, captured with a Toyo View and 150mm Schneider lens, with the camera tilted ever so slightly. We added an 81A filter for a little warmth, and a CC025M for color-correction on the 64T film. Exposure was 70 sec. at $f/45\frac{1}{2}$.

Because the car we received was reconstructed for this shoot, we had considerable liberty in how we could light it. Our lighting began with the steering wheel, focusing a projector-aided 150-watt Dedolight on the "H" pattern. We positioned this light outside the vehicle, on a C-stand 5 feet up, beyond the edge of the platform, to the left and about midway between wheel and camera. We had another projector Dedo,

JOB SHEET

USAGE: **Collateral**

CLIENT: **Honda**

AGENCY: **Rubin Postear & Associates**

ART DIRECTOR: **Diane Frederic**

FIRST ASSISTANT: **Kevin Naifeh**

LIGHTING: **Tungsten**

CAPTURE: **Analog**

PHOTOGRAPH COPYRIGHT ©TONY LABRUNO.

PRO TIP I received this car as a "seat-buck." A seatbuck is where the interior of the vehicle is completely removed and reconstructed piece by piece on a low wooden platform, before it even gets to the studio. Everything is functional, from the radio to the dashboard lights. In this instance, there was no rear seat and the front seats were reclined all the way back to provide full access for the camera, which stood on a tripod immediately behind the driver's seat.

also on a C-stand, this one from camera right, aimed at the instrument panel from just behind and outside the passenger seat position.

We added two 300-watt LTM Peppers to camera left, about a foot apart. One was directed at the steering wheel, for overall illumination, and the second to fill in some of the shadows created by the Dedolight on the instrument panel. In between these lights was another 300, for the driver's vent and buttons. All Peppers on this shot were snooted with blackwrap to varying degrees.

We next added a 200 Pepper on a C-stand for the driver's door handle, positioning it behind the projector light. There was also a 300 Pepper positioned in front of the car, coming in from the left, and this was aimed at the top right of the dashboard cowling, with a 200 Pepper coming in from the right and directed at the top left of this same surface. Each of these lights stood at a height of 5 feet.

Aside from using stands, I hang a number of 100- and 200-watt Peppers from a speedrail. This is a 1¼-inch aluminum pipe suspended from high rollers at either end, with the lights attached to it using Magic Arms. It runs across the width of the car, from about

2 feet overhead, forward of the camera position.

These rail lights focused first on the dash and driver controls. We began with a 200 Pepper for the radio, positioned between the seats. Then we added a 200 for the shifter, with this light a foot over to the right. Next to this was a 100 for the left side of the passenger-side vent, which is also hitting the glove box on the upper-right corner. There was another 100, positioned next to the radio light, hitting the right edge of the passenger vent, also serving to highlight the door.

From a section of rail extending outside the car on the left we suspended a 200 Pepper for the inside left edge of the cowling, and on the opposite side, also outside the car, was a 100 for the left side of the glove compartment. Still on the rail, we had a 200 Pepper on axis with the camera, providing additional light on the driver's side door, to highlight the buttons, along with the door handle. There was also a 200 far right, just inside the door, for the passenger-side handle.

Next we directed several rail lights at the seats. We used a 200 Pepper to light the driver's seat, and another just for the right side of this seat, coming respectively from in front of the left edge of the

Giving this dashboard the romantic allure of an outdoor setting under dappled lighting required over 30 lights.

steering wheel and parallel with the right edge of the seat. For the passenger seat, there were three lights. This array began with a 100 from just forward of the seat and to the right. To that we added a 200 for the right side of this seat, ending with a 300 hitting the left corner of the passenger seat and the armrest, positioned farther right. Then we moved off the rail to provide an edge light for the passenger seat, positioning a 100 Pepper on the ground, just in front of the seat.

We added yet more lights on the ground, except these were tungsten-balanced Kino Flo fluorescents. We positioned one six-inch Mini Kino-Flo on the left, for the driver's footwell, and another on the right, for the passenger side. Five 3-foot Kino Flos on turtle stands were aimed at the backdrop to create the background glow effect. These lights were positioned three in front and one on either side, surrounding the front of the car.

We were not done yet. We also had a 15x20-foot flat over the set, angled slightly upward toward the front. We bounced two 2K Moles into this flat from the rear of the set, left and right, to provide a gradated fill. We then had to prevent this light from hitting a 6x20-foot painted backdrop with an array of 2x6-foot cutters (on C-stands about 6 feet up) mimicking the shape of the front of the car and positioned several feet forward.

Lights that would have produced severe hot spots were diffused with Rosco Tough Spun. Depending on the condition and age of the lights, some may have been warmed with ¼ or ⅛ CTO gels. One more thing: I put gray cards up to be reflected in the side mirrors; the cards were angled to pick up the light from the ambient fill. In all, this shot required three assistants and took two days.

JOB SHEET

USAGE: **Collateral**
CLIENT: **Isuzu**
AGENCY: **The Designory Inc.**
ART DIRECTOR: **Wil Conerly**
FIRST ASSISTANT: **Kevin Naifeh**
LIGHTING: **Tungsten**
CAPTURE: **Analog**

PHOTOGRAPH COPYRIGHT ©TONY LABRUNO.

Details often sell a vehicle, and the client felt this gearshift (shifter) should stand out in the dealership brochure. The shifter ordinarily would need little light, when the focus of the shot is the dashboard and driver controls. But when all eyes are on this one feature, the game plan changes. You have to capture all the nuances that might otherwise be taken for granted. Lighting the shifter inside this Isuzu Axiom SUV was a painstaking procedure. It took nearly a dozen lights to deliver this image.

Working with the art director, I took the seatbuck route (outlined in my shot of the Honda Accord, see Pro Tip, p. 163). The camera—a 4x5 Toyo View with 150mm lens—was mounted on a tripod and positioned above the passenger seat, just to the right of the shifter. The shot involved a variety of LTM Peppers—all on C-stands and snooted with black-wrap, adding diffusion where needed. Exposure was 30 to 40 seconds at *f*/32, on 64T.

I directed the first light at the panel beneath the shifter from slightly behind and far left, creating that diagonal highlight, thereby also providing separation. To the right of that I added

a head with ¼ CTB, to add a nice blue edge on the side of the panel. Another light, closer to the gearshift on the left, threw a bluish highlight on the top of the knob. A light directly behind the shifter provided separation for the back of the knob.

We positioned two lights where the driver seat would normally be, about a foot apart. One light was aimed at the stereo, the other at the area just above the cup-holder. Moving counterclockwise, we continued by adding one light in front and a little to the right of the shifter (to the left of camera), for the front of the knob, with a tinge of blue. There was also an additional light to the left of camera, about 6 inches from it, for the brown molded plastic around the gearshift—the control pad where the buttons are.

Moving past the camera, to the right about 3 feet, we had one light for the edge of the panel that the shifter is on, with a touch of blue. This also produced a bluish tinge on the right of the cup-holder. Our final light was positioned to the left and a bit behind this other head, adding some backlighting on the gearshift itself, from 3 feet away.

SUSPENDING DISBELIEF WITH A SHAFT OF LIGHT

JOB SHEET

USAGE: **Advertising**

CLIENT: **Volkswagen Canada**

AGENCY: **Arnold World**

ART DIRECTOR: **JJ Hochran**

DIGITAL ARTIST: **Tom Klusek (Visual Edge Projects)**

FIRST ASSISTANT: **Connie Chan**

LIGHTING: **Strobe, daylight, and flashlight**

CAPTURE: **Analog and digital**

PHOTOGRAPHS COPYRIGHT ©DON DIXON.

PRO TIP The first thing I do to ensure that the combination of elements comes together in a credible fashion is to make sure the angles all line up, creating a vanishing point behind the picture. To successfully achieve that seamless blend, we build the shot one element at a time, from the back forward.

You know how, when you're sitting in a bar, all of a sudden you get a great idea and the only piece of paper available is the coaster? Well, that was the origin of this shot. So begins this tale of a UFO encounter, masterfully played out, with the lighting as the defining element.

The art director knew what I could do and basically let me come up with the idea for a dealership poster promoting this modern-day VW Beetle. All he said to me was that he wanted something exciting and different that would jump out at you. So, I roughed out a sketch.

The most challenging aspect to this picture was getting perspective right for all the elements—and making it come together in a believable fashion, within the realm of *incredulity*. We worked on this picture for a week.

We started with the backdrop, which is a picture of Canadian wilderness, originally shot on 35mm film. Then we shot the vehicle outside, under an overcast sky, using a time exposure for the headlights. All the other elements, except for the road sign, sky, fringe of weeds in the foreground, and birds were shot in the studio. For the birds, we'd

hoped to find vultures, but had to make do with pigeons. To make them more ominous, we stretched their wings digitally.

The UFO is a hubcap off a car we found at a junkyard. We brought it to the studio and attached a Profoto head to the back of it. We aimed the light through it to give us that eerie illumination emanating from the saucer. To catch the light and disperse it evenly, we covered the inside of the hubcap apertures with a sheet of vellum. Then, in a separate exposure, we took foamcore and bounced that light back onto the rim for added effect. The two exposures were digitally blended, while removing all physical evidence of the strobe head. For our "tractor beam," the beam of light descending from the UFO, we used a Mini Maglite, attaching it to a Bogen SuperClamp, with a piece of black velvet behind it. We directed a special spray into the beam

This UFO encounter makes the point that the car remains "down to earth," despite the strong pull of the alien craft.

PRO TIP You shoot a lot of things that you encounter while traveling, never knowing when any of them will be needed. A good filing system is essential. I'd found the road sign when I was on the road one day. It wasn't even for this shot. But I thought, hey, that's a cool-looking sign. I'll grab it and file the picture away. It's only a small part of the picture, but it makes a difference.

for that fog-light effect. In fact, we used a variation of the UFO tractor beam for each of the car beams.

We matched the light source coming from the spaceship in the next phase, which focused on the driver being drawn up into the alien craft. We began with a Profoto dome light above him, up in the ceiling, and added 4x8-foot white reflectors on either side of him for fill. He held the handle—not the brief-case itself—in his hand, and bounced up from a small trampo-line, with a giant fan enhancing the vacuumlike effect of the tractor beam. The Profoto Acute strobes froze the motion. I also had a 9-foot white seamless on the ground, below the trampoline, kicking light back up. I then set the briefcase on a lightstand and shot it in that position with basically the same lighting. We photographed the papers one at a time, with each sheet on a gobo arm, using a 3-foot Chimera from overhead.

The circle of light around the car was generated in post and was designed to hug the shape of the car. Other aspects, such as reflections on the car, were also added digitally, cloning grass and like elements that surrounded the vehi-cle. The fringe of plants in the foreground was shot sepa-rately, on a Fuji GX617, and scanned on a Nikon Coolscan 8000 (which was used for all the scans)—and then just dropped in. When we use a wide format, such as 617, we scan in two separate chunks and then stitch them together.

Finally, we come to the aliens themselves. Actually, that's one woman shot nude, although we put body paint and a bathing cap on her. We used the same light source as for the driver, but with less fill, since she's closer to the ground. I directed her to stand in a lot of wacky positions, like a man-nequin, so we would have a variety of poses at our disposal for the final composite.

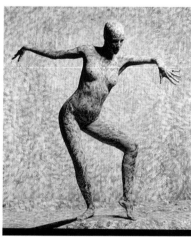

GLOSSARY

Acetate overlay A drawing on acetate that is overlaid onto the ground glass (usually on a view camera) to help define camera positioning for the shot.

AD Art director.

Advertising usage Encompasses print media, including posters and billboards, but obviously extends to any media where products and services are marketed or sold, and may include POP, package design, and direct mail. Ads are usually shot to a layout.

Annual report A corporate financial report that doubles as a capabilities brochure.

Assignment Job Often entails submitting a bid, or estimate.

Bank light Lightbank (also bank). The term is more correctly used to refer to an array of lights banked together to form a singular light source. May also be referred to as box light.

Bare bulb A light head without reflector, or the technique employing such a head. (*See* bare-bulb lighting.)

Bare-bulb lighting A technique in which a light source—specifically, a bare-bulb—head, is employed to throw a very broad but hard, specular light on the subject / scene. Generally designed to simulate sunlight.

Barndoors A set of two or four black metallic or plastic leaves or "doors" (in essence, flags) fitted onto a light head and designed to flag light away from areas of the set or, conversely, to restrict the throw of light to a narrow area.

Beauty dish A relatively large, shallow reflector fitted to a light head and often used in beauty work to give off a specular light largely devoid of harsh shadows on the subject's features.

Beauty shot (1) In product photography, any picture that shows the featured product to advantage. (2) As a genre, beauty work (or simply "beauty") refers to people, not products, with special emphasis on hair and makeup, with the possible addition of various fashion accessories, usually captured in close-up.

Bid An estimate submitted to a prospective client, based on anticipated costs weighed against potential earnings. Day rate, assistants, stylists, modeling fees, rentals, consumables, studio overhead, incidentals, transportation, lodging, travel time, and meals may all enter into it.

Black velvet A black flock fabric that absorbs light and proves useful and very effective as a backdrop.

Blackwrap A heavy-duty, matte black foil used to shape a light and control spill. Cinefoil is a popular brand name.

Boom (or boom arm) An extension arm attached to a heavy-duty, counterbalanced light stand, designed to position a light head so that it overhangs the set without intruding.

Bounce card A reflector added to a set to bounce light back onto the subject in a more or less controlled fashion. Most often used to denote any small reflective surface. Bounce cards are generally rigid and made of white posterboard or foamcore (*see also* flat), but may also be collapsible. Small rectangular or circular mirrors, while not technically bounce cards, give you a harder edge and cover a more defined area.

Bouncing into Jargon among pros for a light head (or lights) aimed into a reflective surface and bouncing off it.

Box light Lightbank.

Campaign A series of ads that run for a period of time (days, weeks, months, or even years) with a common thread or theme running through them.

Capabilities brochure Similar to an annual report, but without the financial mumbo-jumbo, this is a corporate brochure specifically designed to outline and promulgate a company's manufacturing and technological prowess.

Card Bounce card, flag, or gobo. Used as a verb, it refers to flagging a light.

Catalog Promotional brochure designed to sell a variety of products or services. Usually, work shot for catalogs tends to look fairly stylized, but there are exceptions, where the images can get creative, even edgy. Catalog photography generally pays less than national magazine advertising.

Collateral usage Includes catalogs and brochures, circulars and flyers, and online. May generally be thought of as any means used by a business to disseminate information about itself from within (such as annual reports and capabilities brochures) or utilizing company-sponsored media (e.g., corporate Web site).

Comp A sketch or mock-up around which an ad is based. It may be a composite image, hence the name. (The practice of pulling illustrations from copyrighted sources for this purpose is highly questionable.)

Composite A building up of a picture from separately shot elements superimposed on the same frame to form one fully integrated image (film or digital). Also used as a verb.

Cookie cutter (Formally, cukoloris or cucoloris; also cookie or cutter.) Any device with a cutout pattern that is placed in the light path to create dappled light, such as the impression of dappled sunlight through leaves. The degree of focusing on a spotlight used with the cukoloris will produce varying effects, from subtle (defocused) to strong (focused). (*See also* gobo.)

CTB (color temperature blue) Designation for cooling (blue) gel used in lighting.

CTO (color temperature orange) Designation for warming (amber / orange) gel used in lighting.

Cutter Used to refer to a flag or cookie cutter (intent determined by context).

Cyc Short for cyclorama. An often permanent sweeping backdrop built into a studio. Put it in a corner incorporating the ceiling and you've got an eggshell cove.

Daylight-balanced Refers to color balance of film or lighting referenced to a standard daylight color temperature (5500K for film; varies slightly for lighting, as high as 6000K or thereabouts). Typical daylight-balanced light sources include electronic flash (strobe) and HMI.

Dish Parabolic reflector, or simply reflector.

Dragging the shutter A technique employing a longer than otherwise necessary shutter speed in a shot so that the exposure is long enough to include the ambient light with flash; often used to show some motion blur.

Duvateen Variously spelled, this is a flame-retardant, nonreflective black fabric used to block out extraneous light and reflections around a set.

Editorial usage Use of photographs in any noncommercial published content, usually in print, such as magazines and newspapers. Generally pays less than advertising, and is done to a tighter budget. However, the photographer may have more creative freedom here.

EI Exposure index. The film speed or digital gain actually used for the exposure, other than the manufacturer's rated or recommended ISO (ASA) setting.

Feathering the light A technique in which the light just skims or brushes the subject, thereby producing a softer light.

Fill Also called fill light or fill lighting. Any light used to reduce contrast by softening shadows. A fill can be a physical light, bounced light, or even spill.

Flag Any nonreflective black-toned/black-surfaced device used to control or block the throw or spread of light. Most often used with reference to flagging light off a subject or away from the camera. Often used interchangeably with gobo; may also be referred to as a cutter. (*See also* barndoors.)

Flat Any reflective surface added to a set that is of considerable proportions—generally too big to fit on a tabletop—often 4x6 feet or larger in size, and usually made of white foamcore or fabric stretched over board. Flats may be stacked on top of each other or edge to edge. They may also be white on one side to reflect light, black on the reverse side to hold back light. Flats may also be used as walls around a set. (*See also* L-flat; V-flat.)

Flying flat (*See* hanging flat.)

Foamcore Lightweight board available in sheets of varying size and used as bounce cards or flats, especially when white. Foamcore ages with time and use, and should be replaced regularly.

Fresnel (or **Fresnel spot**) Any spotlight employing a Fresnel lens to control the beam.

FSI Freestanding insert. An advertising insert generally found in the Sunday papers.

Full flood (1) Refers to the use of barndoors wide open, thereby enabling you to flood the set with light while retaining some control over spill. (2) Alternatively, indicates a Fresnel spot internally positioned for a wide throw of light. (3) Also used in the context of flooding an area with light.

Gaffer's tape (or **Gaffer tape**) A special tape used for anything and everything, on a set or even on equipment, as well as to safely cover wires and cables on location, with the distinct advantage that it holds yet does not leave any damaging residue.

Gel Loosely, gelatin filter. In lighting, a filter made of thin translucent plastic material (such as acetate) and used over a light head to either color-balance the lighting to neutral or add color effects.

Gobo (1) Any cardlike device used to keep light from flaring the lens. In this context, also referred to as a flag. May be used as a noun, or as a verb (to gobo the light away from camera). (2) A metal or glass mask used within a spotlight to modify the beam by projecting patterns on a set. (*See also* cookie cutter.)

Grid A honeycomb-patterned light modifier normally attached to the front of a light head and used to restrict the spread of light. Also used to refer to spotlighting employing a grid, either as grid spot or, more simply, as grid.

Grip equipment A term borrowed from the movie and theater worlds referring to light stands, booms, clamps, and anything else used to hold lights in place during a shoot.

Hanging flat Any flat that is suspended alongside or over a set. Also called a flying flat.

Hero The actual food or product photographed (as opposed to a stand-in that may be used when shooting tests prior to arrival or preparation of the real item on set).

HMI (hydrargyrum medium arc-length iodide) A versatile and powerful daylight-balanced form of continuous lighting.

Holding focus Keeping focus centered on the subject or a key area in the shot. (*Compare with* pulling focus.)

Hotlight Applies solely to any 3200K tungsten- (or quartz-) halogen continuous light source.

Hot spot Any glaring reflection that must be toned down, especially in highly reflective surfaces.

In-camera masking A mechanical method of combining two (or more) images on one sheet of film.

Job Photo assignment.

Joules (*See* W/S.) European unit of measurement for strobe power output.

K Thousand. (1) In this book, primarily used with reference to light output—and usually with whole numbers; for example, a 1K light. (2) Also used with reference to color temperature of a light source or film (e.g., 3200K tungsten-balanced).

Key light Main light. Often the light used to establish a base exposure, the mood of the shot, or the principal lighting direction.

Kicker light A light used to elevate an area from oblivion and direct some attention that way. Usually low-power and possibly snooted. Also known simply as kicker or as accent light.

L-flat (or V-flat) A pair of hinged flats, in an L- (or V-) shape, used as reflectors or to block off the set or part of it (or for both purposes at the same time).

Lightbank Often used interchangeably with softbox and banklight. Any light modifier attached to or encompassing a light head, with a reflective interior and diffusion fabric surface to soften the light. Originally used to simulate window light, hence the rectangular (or square) shape, but today a lightbank can be long and narrow (striplight) or even octagonal. Lightbanks generally require an adapter plate to fit onto the front of a head. A few designs open and attach to the head like an umbrella. Because the head is fully contained in the bank, proper ventilation is required.

Light painting A form of lighting involving a fiber-optic wand (or even a narrow-beam flashlight or penlight) to "paint in" areas of a subject or backdrop for the purpose of selectively highlighting or filling in various areas on a subject in a tightly controlled fashion, or to add lines or squiggles or definable shapes in either white or tinted light.

Lock off (or lock down) the camera To keep the camera on set (possibly for an extended period) in a single position so that different elements of a shot can be photographed or composited in registration with one another.

Mock-up (1) A scale-model replica used for testing before the finished model is produced. (2) A layout.

Modeling light Any incandescent or fluorescent light source used to preview the lighting effect in a studio flash unit. The modeling light should be self-quenching or self-dimming to avoid contaminating the exposure when the flash pops, and preferably proportional to the actual strobe output to better assist you in assessing contrast and the overall effect.

Monolight Also monobloc. A self-contained studio flash that plugs directly into an AC outlet and comes with the flash head and power supply in one integrated housing (in contrast to a powerpack system). A central control panel is found on the side or back. Select units have a battery option. Key advantages: ease of use, fast setup, and modest price.

Optical spot A focusable spotlight, with zooming capability, often used to project patterns onto a set. (*Compare with* Fresnel.)

Parabolic reflector (Often simply reflector.) A parabolic dish fitted to a light head and designed to throw light in a preconfigured pattern.

Personal work Any work generated as tests or not specifically shot for clients. This may involve trying out new styles, novel techniques, experimental lighting, or new gear in an attempt to carve a new niche for oneself.

Photographic umbrella Often simply called an umbrella. A light modifier that usually features a white or silver underside to reflect back light. The fabric is somewhat opaque, with the light head aimed into it and the parabolic interior-reflecting surface aimed at the subject. The central shaft is supported on the head's dish or clamped elsewhere at the base of the head. White umbrellas produce a softer, more neutral light, whereas silver umbrellas output a slightly harsher and cooler light that might have to be gelled to bring it to neutral balance. "Shoot-through" umbrellas use a translucent fabric, with the head aimed through them and at the subject. Select umbrellas have a diffusion baffle that further softens the light, similar to what you can get with a softbox. The spread of light from umbrellas results in considerable spill outside the subject area, in contrast to what might be achieved with a softbox, which provides tighter control. Key advantages of the umbrella: inexpensive, compact, easy to use, and sets up quickly.

Plexi Short for Plexiglas, a proprietary name for acrylic plastic sheets. In translucent milk-white form, one of the most useful surfaces in tabletop photography. Also used to diffuse lights.

POP Point-of-purchase, or place where purchase decisions are made. In this context, refers to promotional displays and flyers in retail outlets.

Post Short for postproduction. The phase following capture (whether analog or digital) during which the shot is retouched, corrected, manipulated, or otherwise worked on to get it to a usable stage or prepare it for final publication.

Powerpack Also called generator. The central power supply to which flash heads are attached and through which they are controlled and monitored. Because the power supply is located apart from them, flash heads for this system are smaller, lighter, and less expensive than comparable-output monolights. Key advantages: Powerpacks tend to be more robust than monolights, with perhaps shorter recycling times and possibly shorter flash durations. But they may be pricey, and require a longer learning curve.

Pull Using lower ISO film speeds or reduced digital gain. With film, it further involves compensating in the processing times. Pulling the film would be used to reduce contrast, either for effect or where it is excessive, and possibly for tighter grain structure. (*Compare with* push.)

Pulling focus Setting focus and *f*-stop to ensure as much depth of field as possible. (*Compare with* holding focus.)

Push Using higher ISO film speeds or increased digital gain. With film, it further involves compensating in the processing times. Pushing the film would be used to enhance contrast, either for effect or where the scene is too flat, with possibly an increase in grain texture. (*Compare with* pull.)

Reflector (1) A reflective (generally white or silver-toned, or metallic or mirrored) surface used to bounce light from its source onto a set or subject. May also take the form of a collapsible disc or panel. (2) Parabolic reflector. (*See also* bounce card; flat; parabolic reflector.)

Ringlight A circular light that fits over the camera lens, with the overall effect of a beauty dish, but more specular. Called a ringflash when a flashtube is used.

Seamless Paper backdrop, available in rolls, that is very versatile and often economical. A bar suspended between two poles holds the roll, with the paper sweeping forward onto the floor of the set or just hanging, weighed down with heavy clips.

Scrim While it may have more esoteric uses in the theater and movies, in still photography this term generally (if not entirely correctly) refers to a finely woven or mesh fabric used in front of a light source to hold back light, much like a neutral-density (ND) filter on a lens. May also be referred to as a net. Also used as a verb, such as to scrim light off the subject.

Shoot A photo session. It could be an actual job or simply revolve around tests.

Shooting table Also called a sweep table. A tabletop surface with a milk-white Plexiglas or Plexi-like surface that sweeps up toward the back. Provided the lighting is used appropriately, the sweep produces a graduated backdrop resulting from light falloff. The translucent nature of the shooting table means that subjects can also be lit through the plastic, notably from underneath, when needed.

Shot A picture, but specifically the one you're hired to capture or that you do as a test. One assignment or shoot may involve one shot (or many) focusing on one aspect (or more). Each shot may consist of numerous takes.

Silk A mesh fabric, usually white, primarily used to soften and diffuse the light, or maybe to hold back light (in effect, a scrim or net).

Snoot A cone-shaped device that attaches to a light head, with the narrow, open end directed at the subject, providing an economical way to restrict the light into a tight beam. Blackwrap may be used in its place, or in combination.

Softbox Lightbank. A device designed to produce a soft, even light, usually with one light head positioned inside and behind a diffusion baffle. Softboxes are often time-consuming and sometimes troublesome to set up. A few open much like an umbrella, with a central shaft. Key advantages of a softbox: Compared to an umbrella, it allows a more controllable spread of light and produces a more pleasing catchlight in a subject's eyes.

Sourcebook Any publication, usually produced annually, in which a photographer advertises his or her services largely by means of pictures representative of a current shooting style. It's not cheap.

Specular In lighting, a hard light producing an effect similar to sunlight.

Speedrail Any overhead or sidelong rail designed to easily move attached gear to a more advantageous position.

Spill light (May simply be referred to as spill.) Any light that "spills" out from a light source and onto areas of the set where it was not originally intended to go. Sometimes spill light serves as fill, when used judiciously.

Spotlight (May simply be referred to as spot.) Any light head that focuses down to a tighter beam by internal or external means. It may be a Fresnel or optical spot, or it may employ a grid or snoot to achieve the effect. Focusable spots are the most efficient, but grids and snoots provide an economical and expedient alternative.

Subtractive lighting An effect achieved by pulling light off the subject through the use of black cards or black fabric to remove light and reflections and add contrast and depth.

Sweep Any sweeping backdrop.

Sweep table Also shooting table. A self-standing tabletop set with a milk-white Plexiglas sweep. Designed for lighting from any angle, even underneath.

Tabletop photography Any photography of a product or still life subject on a table-like surface, possibly, but not necessarily, involving a sweep table.

Tacky wax Any of various tacky substances used to hold tabletop items in place, preventing them from rolling, sliding, or shifting. These products generally have "tack" or "tac" as part of the brand name.

Test (1) Personal work. (2) A picture (on instant film, conventional film, or digital media) that provides a preview of the set, composition, lighting, exposure, and contrast, possibly involving models (or an assistant standing in) or hero product (or stand-in). During or prior to a shoot, this may be a step carried out for the benefit of the client or art director.

Theatrical lighting A form of lighting used in theatrical and television productions designed to show characters on stage to advantage, often resulting in double shadows.

Tough spun Popular diffusion material for lighting.

Track lighting Lighting that is repositionable along overhead rails; often designed as a grid running over the staging area.

Tungsten lighting Applies to the use of tungsten-halogen and quartz-halogen 3200K lights. Sometimes, if erroneously, more broadly applied to incandescent light sources of a warmer color temperature.

Umbrella (*See* photographic umbrella.)

Umbrella lighting Any lighting employing a photographic umbrella.

V-flat (*See* L-flat.)

W/S Watt-seconds. This is the power rating for studio strobes. (*See also* joules.)

INDEX

A

aerobatics, 80–83
Alejandro, Carlos, 10, 116–119
 job sheets, 117
 pro tips, 117, 119
Arrasmith, Tony, 10, 32–35, 126–129, 142–145
 job sheets, 33, 35, 127, 143
 more lighting solutions from, 35
 pro tips, 33, 126, 127, 143

B

Bearzatto, Thierry, 10, 66–67
 job sheets, 67
 pro tips, 67
Brandt, David Allan, 10, 76–77, 102–105, 132–133
 job sheets, 77, 103, 133
 personal vision of, 105
 pro tips, 77, 102, 103, 132, 133
Bronstein, Steve, 10, 40–43, 94–97, 138–141
 job sheets, 41, 95, 139
 pro tips, 41, 94, 95, 96, 138, 139, 140

C

Cheung, Jennifer, 10, 48–51
 job sheets, 49
 pro tips, 49
Collins, Chris, 10, 24–27, 134–137
 job sheets, 25, 135, 136
 more lighting solutions from, 137
 personal vision of, 27
 pro tips, 25, 26, 27, 135
Couto, Dan, 11, 108–111
 job sheets, 109
 pro tips, 109, 110

D

De Leon, Katrina, 11, 28–31
 job sheets, 29, 31
 more lighting solutions from, 31
 pro tips, 29, 30
Dixon, Don, 11, 148–151, 166–169
 job sheets, 149, 167
 pro tips, 148, 149, 167, 168

F

Farris, Neal, 11, 86–87
 job sheets, 87
 pro tips, 86, 87
Finnin, Denis, 11, 78–79, 146–147
 job sheets, 79, 147
 pro tips, 78, 79, 146, 147

G

gems, 78–79
Green, Jeffrey, 11, 20–23
 job sheets, 21, 23
 more lighting solutions from, 22
 pro tips, 20, 21
Greenberg, Jill, 11, 88–91
 job sheets, 89, 91
 more lighting solutions from, 91
 pro tips, 89, 90
Greenfield, Lois, 11, 80–83
 job sheets, 81
 personal vision of, 83
 pro tips, 81, 82

H

Hopkins, Charles, 12, 158–161
 job sheets, 159
 pro tips, 159

I

Izui, Richard, 12, 154–157
 job sheets, 155
 personal vision of, 157
 pro tips, 155, 156

J

jewelry, 86–87
Jones, Spencer, 12, 46–47, 114–115
 job sheets, 47, 115
 pro tips, 47, 115

K

Katvan, Moshe, 12, 52–53
 job sheets, 53
 pro tips, 53
Koudis, Nick, 12, 98–99, 124–125
 job sheets, 99, 125
 pro tips, 98, 125
Kretschmer, Hugh, 12, 120–122
 job sheets, 121, 123
 more lighting solutions from, 123
 pro tips, 121

L

LaBruno, Tony, 12, 162–165
 job sheets, 163, 165
 more lighting solutions from, 165
 pro tips, 163
Lahdesmaki, Markku, 12, 106–107
 job sheets, 107
 pro tips, 107

lighting
 action-stopping, 80–83
 adding flair with red cyc and colorful, 88–91
 background, defining shot, 114–115
 a buzzing tabletop, 32–34
 challenges of, with animals, 132–133
 complex, for complex set, 142–145
 creating city of lights with, 138–141
 creating warm tone with, for large sets, 102–105
 for a cyber feel, 62–65
 dappled, for dashboard, 162–165
 dramatic, telling story with, 76–77
 fast, with hair-trigger, 70–73
 fine desserts delicately, 28–31
 for forced perspective, 40–43
 high-key, for luster, 86–87
 for high-tech polish, 66–67
 history, 120–122
 for hot entrees, 20–23
 linear, defining vehicle, 158–161
 making monsters menacing, 108–111
 minimalist, evoking Renaissance genius, 116–119
 for multiple layers, 16–19
 museum diorama, 146
 by the numbers, 48–51
 off-the-wall, 98–99
 playing with senses, 52–53
 pours and splashes with high-speed strobe, 36–39
 re-creating bygone era with stage, 124–125
 recapturing, high in the clouds, 148–151
 scheme as template, 48, 49
 sculpting, for sake of art, 126–129
 shimmering, 58–61
 silver on silver, 46–47
 to simulate moon landing, 94–97
 simulating lightning, 26, 100–101
 snakes, 134–136
 soft, and rich color underwater, 84–85
 somber, 106–107
 surround-, re-creating film's ambience, 154–157
 suspending disbelief with, 166–169
 window, with alpine flavor, 54–57
liquids
 pours and splashes with high-speed strobes, 36–39
 using gels to color splashy backdrop, 68–69
luster
 high-key lighting for, 86–87

M

McDonald, Jock, 12, 100–101
 job sheets, 101
 pro tips, 101

P

Pellegrini, Joe, 13, 58–61
 job sheets, 59, 61
 more lighting solutions from, 61
 pro tips, 59
perspective, lighting for forced, 40–43
props, miniature, 42

R

reflections, 58–61

S

Schatz, Howard, 13, 84–85
 job sheets, 85
 pro tips, 84, 85
Shapps, Greg, 13, 54–57
 job sheets, 55
 pro tips, 55, 56
strobes
 high-speed, for aerobatics, 80–83
 pours and splashes with high-speed, 36–39

T

textures
 in gems, revealing unknown, 78–79
Tremblay, Pierre, 13, 16–19
 job sheets, 17, 19
 more lighting solutions from, 19
 pro tips, 16, 17, 18, 19

V

Van Petten, Rob, 13, 62–65
 job sheets, 63
 personal vision of, 65
 pro tips, 63
Vincent, Chris, 13, 70–73
 job sheets, 71
 pro tips, 71

Z

Zimmerman, David, 13, 36–39, 68–69
 job sheets, 37, 39, 69
 more lighting solutions from, 39
 pro tips, 37, 68, 69

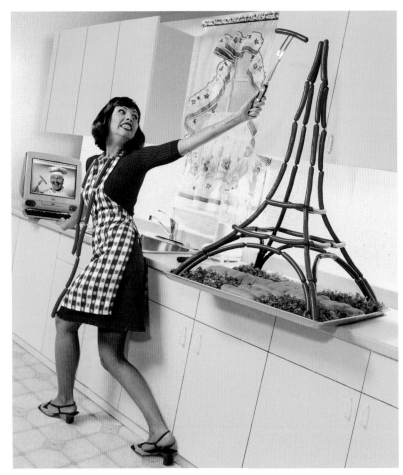

PHOTOGRAPH COPYRIGHT © NICK KOUDIS.